Fabric

Glossary

FOURTH EDITION

MARY HUMPHRIES, B.A., M.A.

Fellow, Institute of Textile Science

PEARSON

Prentice Hall

Upper Saddle River, New Jersey 07458

Library of Congress Cataloging-in-Publication Data

Humphries, Mary, 1925-
 Fabric glossary / Mary Humphries.— 4th ed.
 p. cm.
 Includes bibliographical references and index.
 ISBN-13: 978-0-13-500597-2
 ISBN-10: 0-13-500597-3
 1. Textile fabrics—Terminology. 2. Textile fibers—Terminology. I. Title.
 TS1445.H84 2004
 646′.11014—dc22

 2007036908

Vice President and Executive Publisher: Vernon Anthony
Associate Managing Editor: Alex Wolf
Acquisitions Editor: Jill Jones-Renger
Editorial Assistant: Doug Grieve
Project Manager: Alicia Ritchey
Design Coordinator: Diane Ernsberger
Cover Designer: Kellyn Donnelly
Cover Photo: Rose E. Dee International, Design: 970–40 FLORIANA
Operations Specialist: Deidra Schwartz
Director of Marketing: David Gesell
Marketing Manager: Jimmy Stephens
Marketing Coordinator: Alicia Dysert

This book was set in souvenir by Laserwords. It was printed and bound by Bind-Rite Graphics/Robbinsville. The cover was printed by Phoenix Color Corp./Hagerstown.

Pearson Education Ltd.
Pearson Education Singapore, Pte. Ltd.
Pearson Education. Canada, Ltd.
Pearson Education—Japan

Pearson Education Australia Pty. Limited
Pearson Education North Asia Ltd.
Pearson Educación de Mexico, S.A. de C.V.
Pearson Education Malaysia, Pte. Ltd.

10 9 8 7 6 5 4 3 2
ISBN-13: 978-0-13-500597-2
ISBN-10: 0-13-500597-3

Contents

Preface

This *Fabric Glossary* Fourth Edition, has been designed to be a vital complement to the wealth of technical information on textiles found in *Fabric Reference,* although it can be enjoyed on its own. It adds a perspective to textile science by leading directly from a detailed discussion of fibers, yarns, fabric constructions, and finishes to application of all these by its focus on the fabrics themselves, and in particular, their names.

The study of textiles should lead to more assured navigation among the hundreds of names and terms encountered by anyone working with cloth. *Fabric Glossary* offers a unique guide—a ready and well-illustrated source of this most used and most appealing part of textile study. It provides a full treatment of individual "name" fabrics, their characteristics, and background, with present-day variations and uses. It is these names we must be familiar with when we move outside the classroom or laboratory: in fabric manufacturing and distribution; textile, fashion, and interior design; apparel and furnishings merchandising, including visual merchandising; costuming from the theater to the "living museum"; and of course, communication in any of these fields.

Fabric Glossary offers instant instruction and clarification, whether used as part of or aside from formal textile study courses. It is well suited to business staff training and can be of help to dry cleaners; it is of interest in museums and libraries, or to textile craftspeople and home sewers. Its main purpose, however, is to link the mass of detail on how fabrics behave and why found in textbooks such as *Fabric Reference* to actual materials by name. This is the ultimate question asked by those fascinated but confounded by fabrics: "*What is it called?*"

In using *Fabric Glossary,* the index can guide you to the File you need, or you may start with the lists of fabrics established as suitable for use in such categories as lingerie, suits, workwear, slipcovers, drapes, upholstery, or accessories.

These Fabric Files have been selected to illustrate all stages of fabric makeup: fibers typically used, characteristics of yarn and fabric construction, plus the effect of finishing procedures, including coloring by dyeing and printing.

There is an indication in each File of the weight range and uses of the material, and something of the origins of that fabric—the natural fiber family it belongs to, plus whatever I have been able to discover of the derivation of its name. This can help in understanding its character, and can also be of immense importance in promotional work, or in marrying fabric with garment or interior design.

It also reflects my interest in the history of textiles. I have yearned to spend much more time in this study of the past, whereas my working life until now has concentrated on the behavior of current fabrics, with a few minor excursions at Seneca College into teaching History of Textiles and textiles as a Liberal Studies subject ("Clothing the 'Naked Ape' ").

So *Fabric Glossary* and *Fabric Reference* together provide the background to understand more fully the selection of fabrics, with their behavior in use and care, and to appreciate the truly wonderful diversity of useful and pleasing materials developed by human ingenuity. They are "companion books" for all who study, are interested in, work with, or inform others about textiles.

Acknowledgments

First Edition

There are fewer individuals to thank for contributions to this book than with *Fabric Reference,* since the text is much less detailed and technical, and nearly all the illustrations are of fabrics from my own collection. Most of the pictures are computer scans of these samples, selected and prepared by me for Prentice Hall, but a number are from slides taken for me by Alistair Stewart.

As to the fabrics used, it is impossible to acknowledge all those from whom my most-valued, precious, or special samples came: students, colleagues, family, friends, manufacturers, and others. (I should note that "valued" means showing the characteristics of the fabric well in a black-and-white picture.) Some who do come to mind for sharing extraordinary fabrics with me are: Ellen Peterson, Anne Roberts, Françoise Rioux, Mary Stewart, Gen Keen, and Rosemary Webber. (Rosemary also checked the Use Category fabric listings.) Beyond these are hundreds, back through many years of teaching in Fashion Retailing, Visual Merchandising, and especially Fashion Arts, back much further through my years in fabric testing and communicating with consumers through talks, print, radio, and television, all the way to gathering and mounting my own fabric swatch collection. For this, nothing was provided by the University of Toronto department, and class members would share or trade special items; in one case I provided a scrap of double-woven silence cloth from under the table cloth in a dine-and-dance establishment in exchange for a bit of genuine mohair woven plush sliced from the upholstery in a railway carriage bringing my classmate back from a visit home to rural Ontario!

Many pages of this *Glossary* are like a material autograph album; the double cloth pictured on page 89 is from the 1970s, one side purple fulled wool, the other a teal green basket weave, woven together with a third set of warp yarns—an expensive, unusual fabric. But when I look at it I see also the graduating Fashion Arts student who made it up in a skirt and short coat (her own design and pattern), finishing the coat edge by taking apart the two layers and turning them in on themselves—no facing needed. This couture operation, inspired by my discussion of this fabric construction some terms earlier in her formal textiles study, gave her a lot of trouble since the basket weave layer raveled easily! The silk chiffon sample evokes the difficulties of another talented and ambitious senior design student, making this lively, floating stuff into a three-layered skirt with a scalloped edge. And so it goes for me ...

The picture of a Venetian lace fan was used to announce an exhibition sent from the Consorzio Merletti di Burano, which is headed by Dott. Annibale Tagliapietra. These exquisite laces were shown at the Italian Cultural Institute of Toronto (Istituto Italiano di Cultura di Toronto), and permission to use the picture was obtained by Dr. Francesca Valente. The drawing of a paisley motif in all its wondrous detail appeared in an article on chintz in *Textiles,* Vol. 20, No. 1; permission to use it was given by Arthur Sanderson & Sons through Tony Tenkortenaar.

My thanks also to the expert editors at Prentice Hall and the reviewers of the manuscript: M. Kathleen Colussy, Art Institute of Fort Lauderdale, Florida; Kay S. Grise, Florida State University, Tallahassee, Florida; David Harrington, Bauder Fashion College, Atlanta, Georgia; Joan Laughlin, University of Nebraska, Lincoln, Nebraska; Ruth MacEachern, Emery Collegiate Institute, Toronto, Ontario; Joanne F. Magoldi, Mount Ida College, Chamberlayne School of Design and Merchandising, Newton Centre, Massachusetts; and Katie Parham, Cabot College, St. John's, Newfoundland.

Second Edition

The Bata Shoe Museum: Edward Maeder. Hilary Radley Coats: Carol Outram. Johnstons of Elgin: Ned Harrison. Pine Crest Fabrics: John Sheils. Sommers Plastics Products Co. Inc.: Fred Schecter. Wanger International: Diane & Bob Wanger.

My thanks again for the superlative attention and guidance of my editors, especially my production editor Laura Cleveland—my book and I have been in very good hands.

Third Edition

Canadian Celtic Arts Association, Paul Federico. Culp, Inc., Ticking Division: Iv Culp. Fabrics.net-Vintage Fabrics: Joan Kiplinger. The John Forsyth Company: Phyllis Gordon. Grotz Beckert AG: Harry Jetter. Huntingdon Mills Canada Ltd.: Raouf Mikhail. The Lace Merchant: Elizabeth Kurella. Maxwell's Men's Shop: Steven Smith. Seneca College Fashion Resource Centre: Bev Newburg. Swift Denim: Roger Plamondon, VP Canadian Operations. Textile Human Resources Council: Alan Athey. Textile Museum of Canada: Marijke Kerkhoven. Vollmer Cultural Partnerships Inc.: John Vollmer. WestPoint Stevens: Alan Kennedy. The Woolmark Company: Sue Tolson.

I owe particular thanks to Rhoda Cooper, Manager, Decorative Fabric Development for Rose E. Dee (International) Ltd., for contributing one of their registered designs in two colorways for the covers of *Fabric Glossary* and *Fabric Reference* plus three other designs for the title page and two section headings.

I would like to thank the many instructors I have talked with, especially in Interior Design, for helping me strengthen or clarify any area of information of particular interest to them and their students, and my reviewers: Christine Mardegan, The Illinois Institute of Art Apparel Center, Chicago, Illinois;

Kathleen Mores, International Academy of Design and Technology, Chicago, Illinois; and Barbara Chidsey, Kent State University, Kent, Ohio.

My thanks as well for the inspiring guidance of Vern Anthony, Executive Editor, Career & Technology Division, Prentice Hall/Pearson Education; the patient and expert preparation help of Joanne Vickers of Ohlinger Publishing Services; the outstanding skill and precision of my copyeditor, Shirley Ratliff; and the experienced, effective guidance of production editor Ann Mohan of WordCrafters Editorial Services.

Fourth Edition

City of Toronto Culture Division, Museums: Marguerite Newell. Fabric Research Manager, Dillard Store Services, INC.: Murali Gopalakrishnan. Textile Conservator, Catherine Vernon.

I thank Rose E. Dee (International) Ltd. again this edition for contributing their registered designs for the cover, title page, and two section headings.

Experts who have greatly helped me prepare a better book are: Vernon Anthony, Editor-in-Chief and ReeAnne Davies, Editorial Assistant, Career & Technology Division, Prentice Hall; the constant and encouraging guidance and careful eye of Joanne Vickers, development editor; and Alicia Ritchey, production editor.

SECTION ONE

Overview

Guide to Using This *Glossary*

This *Glossary* is designed to provide:

- help in selecting fabrics for particular uses or markets, whether it is by the student, consumer, retailer, wholesaler, manufacturer, or designer of textiles, clothing, or interiors, domestic or contract.
- detailed descriptions in Files of classic fabrics, arranged alphabetically under one major name or term, but representing over 600 individual names or terms of standard textile vocabulary. (Further discussion of these and many other terms is found in the companion book, *Fabric Reference*.)
- background in each File on the history of that fabric and its names, and which natural fiber was traditionally used to make it—its "fiber family."
- photos that show the characteristics of many fabrics, and space to mount representative samples or swatches (see Notes on Mounting Swatches).
- quick and easy location of terms in the index. (The comprehensive index to *Fabric Reference* covers and cross-indexes both *Reference* and *Glossary*.)

Fiber Families

Nearly all of our classic famous-name fabrics were originally made using one of the natural fibers. These served, then, from prehistoric times until nearly 1900, when manufactured (MF, also called man-made) fibers were developed. Many natural fibers were tried and used, but the "Big Four" were and still are: flax (linen), wool, silk, and cotton (until 2000, "King" as our most-used single fiber, but since then deposed by a manufactured fiber, polyester).

Therefore, a primary classification of a fabric is whether it looks and feels "linen-like," "woolly," "silky," or "cottony," even though it may be made 100% of a manufactured (MF) fiber today! We have also used, and still treasure, hairs of animals other than the domestic sheep, like cashmere (goat) and alpaca (South American camelid), plus wiry mohair (goat) and horsehair. Coarser plant fibers, mainly hemp and jute, have also filled important uses.

These files, then, refer to a "name fabric" as being of the family of one of the main natural fibers, since it is literally descended from one of them—the one that was used to make it in times gone by.

Look at the examples . . . There has been a lot of transfer in our minds from the flax (linen) column to what we consider cottons today; this happened when flax, the predominant plant fiber in Europe, was pushed into a minor role as cotton surged into dominance with machine processing and the Industrial Revolution. This started in the 1700s but really got underway in the 1800s. So although the true family of chambray, for example, is flax, we definitely consider it a cotton in our marketplace. You will note a few other such transfers. A notable one is damask, known to many of us primarily as a fine table linen. Its family, however, is silk, as the name derives from Damascus, in Syria, on the old Silk Route from China, where the wonderful filament fiber and the elaborate weave were developed.

The following are lists of fabric names according to natural fiber family, e.g., the major natural fiber historically used to make the fabric, in general terms *pre–1900*; they may be made today all of or blended with MF fibers.

Flax, Linen	Cotton	Wool	Silk
Linen—must be made 100% of flax; if other fibers present, name is *linen-like*.	bandanna	beaver	bengaline
	calico	blanket cloth	brocade
	chino	broadcloth	chiffon
	chintz	cavalry twill	China silk
	corduroy	challis	chirimen
Fabrics now considered "cottons," originally made of flax:	cretonne	coachman	ciré
	denim	covert	cloqué
	drill	duvetyn	crepe de chine
	dungaree	elysian	damask
batiste	eyelet	étamine	faille
cambric	farmer's satin	flannel	fuji
chambray	flannelette	fleece	gazar, gauze
huckabuck	gingham	frieze	georgette
lawn	jean	gabardine	habutae
ticking	madras	homespun	honan
	muslin	lumberjack	marquisette
	nainsook	jac cloth	matelassé
	organdy	jersey	moiré
	oxford cloth	kersey	mosquito net
	percale	mackinac (-aw)	mousseline de soie
	sateen	melton	
Originally	seersucker	molleton	ninon
Flax or Hemp	terry cloth	overcoat fabrics	noile
canvas, duck, etc.	turkish	peau de peche	organza
crash	toweling	polo	ottoman
	velveteen	serge	peau de soie
		tartan	pongee
Jute, Hemp		tropical	poplin
burlap	**Mohair**	worsted	satin
hopsack	**Horsehair:**	tweed	shantung
	(wiry fibers)	Venetian	surah
	braid—hem,	whipcord	taffeta
	millinery	worsted suiting	tussah
	tailor's or	zibeline	velvet
	hair canvas		velour

Range of Fabric Weights—Sheer to Heavy

Weight is a significant factor in selecting a fabric for particular uses, along with **quality** and **price**. As such, Weight is listed in the Fabric Files in this *Glossary,* usually with Uses.

Fabric weight is expressed as grams per square meter (g/m²) or ounces per square yard (oz./sq. yd.). A rule of thumb for conversion is: 100 g/m² is close to 3 oz./sq. yd.

Here is a general outline and summary—for specific fabric suggestions see following Fabrics According to End-Use Categories:

Weight Range (not standard divisions)	*Trade Terms; Typical Uses*
Sheer: 0–50 g/m² (0–$^1/_2$; oz./sq. yd.)	Lingerie, bridal, evening, millinery, women's hosiery, sheer curtains
Light: 50–150 g/m² ($1^1/_2$ – 4 $^1/_2$; oz./sq. yd.)	"Top Weight"; shirts, blouses, dresses, linings
Medium: 150–300 g/m² (4 $^1/_2$ – 9 oz./sq. yd.)	"Bottom Weight"; slacks, skirts, most suits, sports denim, drapes, slipcovers, bed and table "linens," some terry towels; bantam, super bantam, featherweight see Harris under Tweed.
Medium-Heavy: 300–600 g/m² (9–18 oz./sq. yd.)	"Bull denim," workwear, best terry towels, some suits, many over-coats, many drapes, slipcovers, bedspreads, mattress covers
Heavy: 600 g/m² (18 oz./sq. yd.)	Winter coats, upholstery, mats, rugs, carpets

Grams per running meter (g/m) or ounces per linear yard (oz./yd.) will be greater than grams per square meter or ounces per square yard in proportion to the difference in fabric width from one meter (100 cm) or one yard (36 in.). It used to be common for cotton fabrics, in particular, to be about a meter (36 in.) wide, but with wider looms today, most cottons and other fabrics for apparel are 115 cm (45 in.) wide, except those for interior furnishing use and those in the wool family, which have always tended to be even wider—140, 150, or 165 cm (54, 60, or 66 in.). Here the weight per running unit can be nearly double that per square unit.

Some fabrics, e.g., single knits, are noted in the United States in linear yards per pound, which gives a measure of yield for garment production.

Momme is a Japanese unit of weight (4.33 g/m²) used for silk fabrics such as habutae, China silk (see Silk, Cultivated). The higher the momme, the heavier the fabric (heavier yarns or closer weave).

Fabrics According to End-Use Categories

Use Category	Fabrics Used	
Casements Sheer, semi-sheer casement cloth, glass cins, "sheers"	batiste cambric casement cloth curtain grenadine dimity dotted Swiss eyelet "fishnet" tricot gauze georgette gingham lace lawn leno	Madras gauze Malimo® marquisette net ninon nonwoven organdy organza point d'esprit raschel stitchbonded tricot tulle voile
Bed "Linens" Sheets, pillow cases For lighter bedspreads, covers for comforters and duvets, flounces, consult this list, plus **Casements,** plus Interiors	damask dobby jacquard jersey linen muslin ottoman peached (as peach skin) percale	sateen sheeting (muslin & percale) waffle for cold weather: cotton flannel flannelette
Mattress Covers	coutil damask satin	ticking tricot
Mattress Pads	compound, often quilted nonwoven	tricot
Towels	crash damask huckaback linen, linen-like	terry cloth terry/velour waffle cloth
Table "Linens" Tablecloths, napkins	crash damask gingham homespun	lace linen, linen-like oilcloth & other coated, glazed
Interiors—Light to Heavy Fabrics Bedspreads, cushions drapes, slipcovers, upholstery (Continues)	armure bark cloth, bark crepe basket weave bengaline bouclé broadcloth	brocade, brocatelle burlap candlewick (chenille, tufted) canvas check chenille yarn, woven (Continues)

Fabrics According to End-Use Categories

Use Category	Fabrics Used	
Interiors—Light to Heavy Fabrics (_Continued_) Bedspreads, cushions, drapes, slipcovers, upholstery	chino chintz cloqué coated corduroy crash cretonne damask dobby double face drill faille flocked suede-like, velvet-like frisé (also _mis_named friezé, freizé) gingham honan hopsacking jacquard woven lampas leather, leather-like linen, linen-like Maliwatt® matelassé moiré monk's cloth moquette muslin osnaburg ottoman peached (as peach skin) percale piqué	plaid plissé plush pocket cloth polished cloth pongee quilted repp sailcloth sateen satin satin/crepe satin/shantung seersucker shantung sheeting stitchbonded suede, sueded, suede-like taffeta tapestry tapestry velvet tartan toile de Jouy tricot tufted pile tweed velour knit velour woven velvet velveteen waffle
Floor Coverings Carpets, mats, rugs	braided felt (Numdah) hand-hooked Oriental hand-tied stitch-knit	tufted warp pile woven: Axminster, Brussels, tapestry, Wilton, and velvet carpet weaves weft pile woven: chenille
Lampshades	muslin percale satin sheeting	taffeta Plus many of the sheer **Casements** and **Table "Linens"** fabrics.
Trims Passementerie (fabrics made narrow, as a rule, so edges finished) (_Continues_)	ball fringe braid cord eyelet	fringe gimp "braid" grosgrain ribbon lace

Use Category	Fabrics Used	
Trims **(Continued)** Passementerie (fabrics made narrow, as a rule, so edges finished)	ribbon rick-rack braid soutache braid	Plus binding or piping of almost any material; if woven, usually bias cut.
Art, Needlework including "Swedish weaving"	**Fabrics Used** ada, aida canvas or cloth burlap canvas crash diaper cloth	hessian huckaback java canvas or cloth leno (lockweave) monk's cloth natté
Linings Lining, interlining, interfacing (fusible or sew-in) costume support	batiste braid—"mohair or "horsehair" (for hems) broadcloth (cotton) buckram (especially for accessories—hats, purses) cambric canvas canvas—hair (for interfacing) China silk crepe crepe de chine crinoline dobby lawn	lining fabric ("no name"!) marquisette mull muslin net nonwoven organdy organza sateen satin souffle taffeta tricot tulle Vilene®
Insulating lining, interlining (in drapes also can be room-darkening)	"chamois" leather coated compound, including batting, foam "fleece" "lamb's wool"	leather quilted satin, brushed-back or flannel-back Thinsulate™ waffle
Lingerie Slips, teddies, also nightgowns, nightwear, peignoirs	batiste cambric charmeuse chiffon China silk crepe de chine crepe marocain damask fuji georgette habutae	lace (Chantilly, Val, etc.) lawn ninon satin satin/crepe taffeta tricot voile (filament) Plus many of the **Eveningwear** fabrics for warm weather.
Leisurewear Dressing gowns, loungewear (Continues)	blanket cloth candlewick (chenille tufted)	corduroy flannel, including check, plaid (Continues)

Fabrics According to End-Use Categories

Use Category	Fabrics Used	
Leisurewear (*Continued*)	fleece knit, two face	plush
	tartan	terry
Dressing gowns, loungewear	*knit or woven:*	velour
	panne velvet	Plus **Lingerie** fabrics.
Track suits, etc. (knits)	interlock knit	simplex
	jersey	tricot
	knit fleece	
Shirtings	batiste	lawn
Shirts (dress), also	broadcloth (cotton—classic	madras (shirting)
pajamas (tailored)	dress shirt fabric)	muslin
	calico	oxford cloth
	cambric	percale
	chambray	pinpoint
	chintz	piqué (formal)
	crepe de chine	plissé
	damask (formal)	poplin
	flannel (top weight)	satin
	gauze	seersucker
	gingham	shirting ("no name")
	handkerchief linen (or linen-like)	twill
	herringbone	voile
	jacquard	
For cooler weather	challis	cotton flannel, Canton flannel,
	étamine	kasha flannel
	flannelette	
Sportswear	basket weave	linen, linen-like
Children's wear, rainwear,	bedford cord	lumberjack (jac) cloth
sportswear, "windbreakers"	canvas	mackinac (-aw)
	cavalry twill	muslin
Also some headgear	chambray	osnaburg
(see **Accessories**)	chino	parachute cloth
	ciré	percale
Also handbags, luggage	coated	piqué
	compound	plaid
Also umbrellas	corduroy	poplin
(lightweight fabrics)	crash	ripstop
	denim	satin
	drill	sharkskin (filament—not worsted)
	duck	suede, suede-like
	dungaree	taffeta (ciré, ripstop)
	élastique	tartan
	fleece knit, two face	ticking
	galatea	waterproof, water repellent
	jean	Plus **Suitings, Workwear**
	leather, leather-like	(*Continues*)

Use Category	Fabrics Used	
Sportswear (*Continued*)	Plus *knit fabrics* from Leisurewear **Leisurewear,** including track suits, etc.	Plus lisle Plus boiled wool
Power Stretch Articles Contour fashions, foundation garments, compression garments, and activewear (for cycling, exercising, swimming, etc.)	interlock powernet (raschel knit) raschel simplex tricot	Fabrics containing a elastomer— rubber or spandex (elastane) yarn or fiber, up to about 50% (usually less)
Dressy Wear After five wear, blouses (dressy), bridal wear, evening wear, girls' party dresses	barathea bengaline brocade chiffon China silk cloqué crepe de chine crepe (weave) crepe knit (interlock or jersey) crepe marocain crepon damask "double jersey" épingle faille georgette givrene gros de Londres, de Paris, etc. grosgrain holograms illusion net jersey lace (Alençon, Chantilly, guipure	point de Venise, rosepoint, etc.) lamé Malines net marquisette matelassé moiré mousseline de soie net ninon organza ottoman point d'esprit repp satin satin/crepe satin/shantung taffeta tapestry tricot tulle velvet voile (filament) watered silk
Daywear—Women's Wear Dresses (daywear), slacks, skirts, jackets, suits (*Continues*)	top or bottom weight: bark crepe bouclé (knit or woven) challis corduroy (feather-, pin-, or midwale, as a rule) crepe (plain or figured) crepe de chine crepon "double jersey" doubleknit douppioni (dupion) éponge étamine georgette (especially wool) honan	interlock jersey leather, leather-like linen, linen-like lisle muggah noile piqué pongee ratiné satin/crepe satin/shantung silk "linen" simplex suede, suede-like tricot (*Continues*)

Fabrics According to End-Use Categories

Use Category	Fabrics Used	
Daywear—Women's Wear (Continued) Dresses (daywear), slacks, skirts, jackets, suits	tussah velour (knit or woven) velvet	velveteen Plus **Suiting** fabrics, many of the **Dressy Wear** fabrics.
Suitings Blazers, coats, jackets, skirts, slacks, suits, tailcoats, tuxedos	bottom weight: barathea (also called basket twill, twilled hopsack) basket weave bedford cloth birdseye blazer cloth broadcloth (wool) cavalry twill check, including glen, houndstooth, etc., in tweed or worsted corduroy (thickset, wide wale) covert covert cloth crash dobby double face, double woven doubleknit élastique flannel	gabardine herringbone homespun hopsack leather, leather-like linen, linen-like, linen-look melton nailhead pincheck or pinhead sharkskin (worsted) simplex suede, suede-like tartan tricotine tropical worsted tweed twilled hopsack twill, steep whipcord worsted suiting
Workwear Children's wear, uniforms, workwear	bottom to medium-heavy weight: bedford cord blazer cloth canvas cavalry twill chino corduroy coutil covert cloth denim drill	duck dungaree gabardine jean piqué (birdseye, bullseye, etc.) poplin ticking tweed twill, steep
Overcoats Cool and cold-weather coats, jackets Also blankets (Continues)	usually medium-heavy to heavy weight, substantial, "woolly": astrakhan beaver bedford cord blanket cloth (e.g., Hudson's Bay point) boiled wool	bouclé, woven broadcloth, wool buffalo check cavalry twill check, herringbone (Continues)

10

Use Category	Fabrics Used	
Overcoats (Continued) Cool and cold-weather coats, jackets Also blankets	usually medium-heavy to heavy weight, substantial, "woolly" :	
	chinchilla cloth	mackinac (-aw)
	coachman	melton
	compound	molleton
	doeskin	mouflon
	double cloth, double face	overcoat fabrics
	duffel	peau de pêche
	duvetyn	plush
	élastique	polo cloth
	elysian	poodle cloth
	fleece	quilted
	frieze	ratiné
	fur, fur-like (knit or woven)	suede, suede-like
	homespun	tricotine
	kersey	tweed
	leather (including sheepskin), leather-like	velour (napped) zibeline
	loden	
Accessories Gloves, mittens, hats, headgear, millinery, mufflers, scarves	braid	raschel
	cable knit	rib knit
	doubleknit	shaker knit
	felt	simplex
	flannel	thermal cloth
	fleece knit, two face	tricot
	jacquard knit	waffle cloth
	plain knit	Plus many of the **Sportswear, Overcoats** fabrics.
	poor boy knit	
	purl knit	
Neckwear Ties, scarves	challis	homespun
	chiffon	linen, linen-like
	crepe	repp
	crepe de chine	satin (may be jacquard)
	étamine	surah
	faille	taffeta
	foulard	tweed
	georgette	

SECTION TWO

Fabric Files

Notes on Using Fabric Files

1. Files, as well as being paged, are arranged alphabetically under one major name or term, although each usually represents a number of individual fabrics or variations of one type. These Fabric Files actually cover over 600 names or terms; use the index to identify the File pages that cover the one you wish to look up.

2. This *Glossary* uses many of the basic terms of textile structures. If you do not know what a term means, or if a File description does not clarify it for you, or if it is not in the index to this *Glossary,* consult a general textiles text such as the companion *Fabric Reference*, which is very condensed and indexes this *Glossary.*

3. MF is an abbreviation for "manufactured" fiber (often called "man-made").

4. Origin and derivation of fabric names are given for most. This can be of immense importance in understanding the character of a fabric and the historical "aura" it carries. This, in turn, can be significant in selecting the right fabric for a garment or interior design, and it helps in promotional work to be aware of the image the name can call up in the client's or consumer's mind.

Notes on Mounting Swatches

1. This book has been printed on paper that gives a firm mounting surface for actual swatches.

2. What to use to fix a piece of fabric to the page?

 After many years of working with fashion students' swatch books, I recommend tape, double-sided tape or invisible tape, such as Scotch Magic Tape®. The latter is best formed into a circle with the sticky side out, to imitate double-sided tape, rather than taping *over* a sample—see page 15. You can then look at the back of a sample, or take the sample off the page and replace it, both important for you to get a good look at how it is made.

 Other means are less satisfactory: Regular (transparent cellulose) tape gets yellow and dry with heat or age, and since paper usually becomes brittle in the same way, pins or staples tend to come away after some time—you want this book to last! Rubber cement or stick glue will do a fair job but will yellow, and you cannot easily remove samples for examination. *Do not* use white glue, as it will soak through fabrics and a sample cannot be shifted at all without ruining the page.

 If you wish to move or remove a sample that has been taped on a printed page, for instance, over a picture that identifies it, *do not* try to pull the tape off the page or you will remove print; simply cut the tape, smooth it down, and leave in place. If you wish to "cancel" double-sided tape, put invisible tape over it.

3. Distribute samples in different positions on mounting pages. Placement may be determined by an identifying picture, but when not, fix some bulky samples at the top and some at the bottom of the page, and toward the inside as well as the outside. Such varied positioning will prevent the

book from bulging open as it does if all samples are placed in roughly the same area of the page; this is the reason for varying the placement of the mounting templates in our pages.

sticky side
of tape

Swatch mounted on sticky tape can be examined face and back, or removed and replaced.

4. Many fabrics have a definite right side (usually the same as the technical *face*). When you mount sample swatches in the *Glossary,* it should be with the *right side up.* You will notice that some illustrations show the wrong side of the fabric turned up in the picture, where this shows special differences; in cases such as these you will wish to mount samples to show both sides.

One situation where the right side is not the technical face occurs with plain stitch knits which have a special lay-in that is intended to be the right side; three cases are included: sliver-knit fur-like fabric, a knit lamé, and a bouclé knit loop yarn. Sweatshirt fleece knit (single face) is an exception, the back of the fabric with laid-in yarn which is napped being usually intended for the "wrong" side, although occasionally turned to the right side. Tricot knit is often brushed or printed on the technical back, which then becomes the right side.

Many fabrics, of course, have no built in difference between the face and back; if not printed or given other applied design on one side, they are *reversible.* These are most often plain weave fabrics, and may have yarn-dyed stripes or checks, e.g., batiste or gingham. Others may have a difference between face and back but have been purposely made reversible, e.g., dobby compound weave.

General guides to the right side of fabrics and particular guides to fabric face are discussed in the *Fabric Reference* or most other textile textbooks.

5. When you enter your own sample swatches, it is a good idea to prepare them so they show the fabric structure. First, it is far better to have edges cut straight, *not* pinked; you can then dissect the fabric to see its construction. With a woven fabric, this often involves raveling off warp and weft yarns to show their relative number, size, and type. You will notice that a number of illustrations show this, for instance, that in the Broadcloth (Cotton) File. It is also a good idea to cut swatches as a rectangle, rather than a square, such that the longer side shows the lengthwise of the fabric (warp in a woven, wales in a knit). Swatches should then be mounted in the book with this direction vertical on the page (see mounting templates). With swatches cut and mounted like this, your book can provide the most valuable guide to illustrate the wonderful world of fabrics.

Following are the Fabric Files, arranged alphabetically according to a (major) name listed first; however, 80% of the Files record a number of similar or related fabrics, rather than a single name.

Basket (Mat, Matt) Weave, Hopsack (Hopsacking), Monk's Cloth, Natté, Panama (*see also under* Canvas, Chambray, Oxford Cloth, Worsted Suiting)

FABRIC CONSTRUCTION

Basket weave is a variation of plain weave that resembles the fairly open interlacing seen in plaited baskets. It is also known as *mat (matt)* weave, as in floor matting, and *natté*, French for matting or plait. Two or more yarns are woven as one, and the weave is described as: number of warp × number of weft, e.g., 2 × 2 (two by two) (see photo of hopsack suiting below, and bottomweight chambray under Chambray); or 4 × 4 (four by four) (see photo of monk's cloth).

In another version, what might be termed "half-basket" but is usually called just "basket," two or more yarns of one set only are woven as one, in most cases, 2 × 1: two finer warp, single thicker weft. (See photos of hopsack linen-type below, and lighter canvas under Canvas, as well as oxford cloth under Oxford Cloth.)

Basket weave is rarely 1 × 2: single warp, double weft, though that is found in barathea (see Worsted Suiting).

The name *natté* is connected not only to basket (plain) weave, but also to a more stable, open structure given by a much more complex, dobby-controlled yarn interlacing (see photo of natté effect under Dobby Weave—Openwork Effects).

Three major basket weave fabric names are treated separately here: **(1) Hopsack, (2) Monk's Cloth,** and **(3) Panama.**

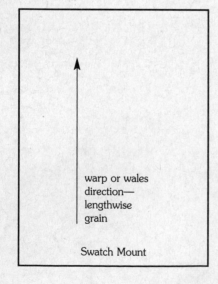

warp or wales
direction—
lengthwise
grain

Swatch Mount

Fabric Name

warp or wales
direction—
lengthwise
grain

Swatch Mount

Fabric Name

(1) Basket Weave Hopsack

(Hopsacking), *both* Linen Type *and* Wool Type (Worsted) (*See also* Worsted Suiting for Barathea, called Basket Twill *or* Twilled Hopsack)

FIBER CONTENT

Family: Hemp or jute (sacking).

Present: Linen type: Cotton, flax, blends for fabric like the original sacking.

Wool type: Wool and blends for hopsack suiting.

YARN, FABRIC CONSTRUCTION, WEIGHT, USES

Linen Type: Carded only yarn; basket version of plain weave, usually 2 × 1, bottom weight, used for sportswear because of the increased porosity (for comfort, wrinkle resistance) given by the basket weave, or for curtains, furniture covers because of wrinkle resistance.

Wool Type (Worsted). Worsted yarn, bottom weight, 2 × 2 basket weave, used mostly for slacks, suits, coats, here, Worsted Suiting.

Hopsack, Linen-type (cotton)
2 × 1

Hopsack, Worsted suiting 2 × 2

NAME

The linen type of hopsacking was originally used as sacking for dried hops, an ingredient in beer-making.

ESSENTIALS

Linen type: A sturdy, basket plain weave fabric, often 2 × 1 or 2 × 2 weave.

Wool type: Worsted yarn, 2 × 2 basket weave.

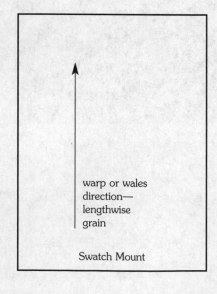

warp or wales
direction—
lengthwise
grain

Swatch Mount

Fabric Name

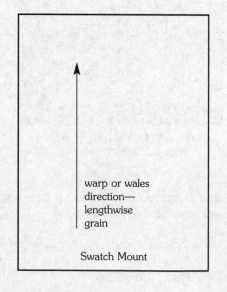

warp or wales
direction—
lengthwise
grain

Swatch Mount

Fabric Name

(2) Basket Weave

Monk's Cloth (*also called* Abbot's, Belfry, Bishop's, Cloister, Druid's, Friar's, *or* Mission Cloth)

FIBER CONTENT	**Family:** Hemp or jute.
	Present: Cotton, usually 100%, though flax, hemp or even jute may be used for the weft.
YARN, FABRIC CONSTRUCTION, WEIGHT, USES	Carded only yarn, low twist, sometimes 2-ply, in natural, oatmeal color. Basket plain weave, from 2 × 2, through 4 × 4 (shown in photo), 8 × 8, and even more exaggerated basket weaves. It is used for drapes, furniture covers and throws, table and wall coverings, and blankets. However, the weave is so loose the fabric tends to sag. Monk's cloth is also used for the embroidery called "Swedish weaving," more associated with huckaback (see Dobby Design I).
NAME	Monk's cloth is obviously associated with monasteries, probably used for various coverings including warm outer clothing. The rough, coarse "haircloth" worn for penitence was likely closer to tailor's canvas.

Monk's cloth 4 × 4 basket weave

warp or wales direction—lengthwise grain	warp or wales direction—lengthwise grain
Swatch Mount	Swatch Mount

Fabric Name _____ **Fabric Name** _____

(3) Basket Weave

Panama

Panama is the name of several fabrics. First, there are panama hats, skillfully hand-plaited (mainly by women, and in Ecuador, not Panama). Straw from leaves of a palm-like plant is used for these distinctive and high quality hats. For the plain weave worsted suiting, panama, see Tropical Worsted.

Panama is a also a form of natural colored cotton or linen basket weave canvas used for embroidery. It is made in a dobby-woven natté effect as well (see Dobby—Openwork Effects).

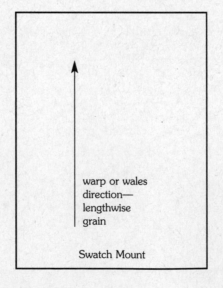

Fabric Name Fabric Name

Batiste, Cambric, Casement Cloth, Jaconet, Lawn, Mull, Nainsook

FIBER CONTENT

Family: Batiste, cambric, lawn originate with flax; jaconet, mull, nainsook with cotton.

Present: Usually made of cotton or blends, but fine batiste, cambric, and lawn are still made of flax. Best quality in cotton is long staple. There are also wool batiste and silk batiste, though these are rare.

YARN, FABRIC CONSTRUCTION, OTHER

Fine yarns, best-quality cotton will be combed, may be mercerized. Usually balanced plain weave. Finish is usually soft, may be more crisp, or may have a slight luster.

WEIGHT, USES

Top weight, may be sheer. Used for blouses, shirts, dresses, underwear, night-wear, handkerchiefs, curtains.

NAMES

Batiste is recorded as being the name of a Medieval linen weaver in the town of Cambrai, France, from which the name *cambric* comes. Another French linen center, Laon, gives its name to *lawn*. Three other names relate to fine, plain weave cottons made in India, deriving from Hindi words: *jaconet* through French from jagannath = light cotton material; *mull* from *mulmull* = a light, soft Bengalese type of muslin; *nainsook* from *nain* = eye + *sukh* = delight.

Batiste

Lawn (Liberty of London)

Slight differences are noted for each of these names: how light or fine, whether soft or crisp, dull or with luster. Since various sources are not consistent or in agreement, these six fabrics have been grouped as virtually the same: *fine handkerchief fabric.*

Casement cloth is a general name for these light fabrics used as curtains; French *encasser,* meaning to frame (casement windows specifically those hinged at side).

ESSENTIALS

Light, top weight; fine yarn; balanced plain weave.

warp or wales
direction—
lengthwise
grain

Swatch Mount

Swatch Mount

Fabric Name

Fabric Name

Braid (Braided, Plaited), Horsehair *or* Mohair Braid, Passementerie, Ric-Rac (Rick-Rack), Soutache

FIBER CONTENT

Family: Any. Light, stiff braids used wiry hair fibers such as horsehair (mane, tail) and mohair.

Present: Any. In light, stiff braids, coarse monofilaments of MF fiber (often nylon or polypropylene) replace wiry hair fibers.

YARN, FABRIC CONSTRUCTION

Any (see Fiber Content, Present). Braided, i.e., a single set of yarns is interlaced or plaited parallel to each other, lying diagonal to the fabric edges; may be a circular fabric. Braids are never very wide, and so provide narrow fabrics with finished edges, which have some stretch or "give" lengthwise, like woven cloth cut on the bias.

WEIGHTS, USES

Light to heavy. Sheer, stiff braids are used to hold hems out, and to make hats (millinery braid). The latter can be pulled up to form a circle, by a separate yarn along one edge. Braids are used extensively for bindings and for trim, as well as for rugs. Shoelaces, flat or round, are often braided, as are lamp and candlewicks.

Millinery braid **Rick-rack** **Soutache braid**

NAMES

Millinery and hem braid are still referred to as "horsehair braid" or "mohair braid," although made today of clear, thick MF fiber monofilament. A zig-zag-shaped flat braid is called *rick-rack* or *ric-rac*. The classic apparel trimming braid is *soutache,* from French = braid. *Passementerie* is a general term now for edgings and trims, including beads, cord, braid; see also trims called braids, in Gimp "Braid."

ESSENTIALS

Fabric never wide; yarns interlaced diagonal to edges.

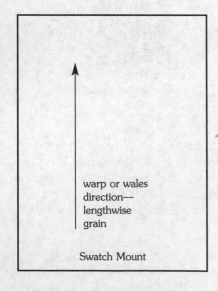

warp or wales
direction—
lengthwise
grain

Swatch Mount

Fabric Name

warp or wales
direction—
lengthwise
grain

Swatch Mount

Fabric Name

Broadcloth (Cotton), *includes* Silk Broadcloth. *See also* Broadcloth (Wool) *under* Overcoat Fabrics (*see also* Poplin, Shirting)

FIBER CONTENT

Family: Not a historical name.

Present: Cotton (best quality will use long staple) or blends, often with polyester. There is also a similar fabric made of silk: silk broadcloth.

YARN, FABRIC CONSTRUCTION, OTHER

Yarn is fine; best quality in cotton will be 2-ply or even 3-ply, combed, and mercerized; weft may be twist-on-twist to enhance the rib. Warp and weft yarn almost the same thickness, but there are nearly twice as many warp as weft, in a close plain weave (thread count from 150 for good quality to 230 for superb—best custom shirts). Such a high quality shirt may be described as using "2-ply 160 yarn"—stronger because 2-ply, and fine—equivalent to a single 80 count yarn. Fabric is gassed to give a smooth finish. The result is a firm fabric with a very fine crosswise rib. In the United Kingdom, *poplin* is an equivalent name; in the United States and Canada, poplin is taken to be heavier, with a more prominent rib. Broadcloth is usually given a Durable Press finish when used for tailored articles such as dress shirts.

Cotton broadcloth

WEIGHT, USES

Top weight. The classic dress shirt fabric, also used for pajamas, dresses. Similar to, but finer than, poplin.

NAME

Once applied to any fabric wider than "narrow" (70 cm or 27 in.).

ESSENTIALS

Cotton or blends; close plain weave; firm fabric, fine crosswise rib; woven with about twice as many warp as weft (see photo); fine yarn, usually combed, mercerized; warp yarns not much finer than weft.

```
                    ↑                              ↑
                    |                              |
                    |                              |
                    |                              |
                    |                              |
                    |                              |
                    |  warp or wales              |  warp or wales
                    |  direction—                 |  direction—
                    |  lengthwise                 |  lengthwise
                    |  grain                      |  grain

                       Swatch Mount                  Swatch Mount
```

Fabric Name **Fabric Name**

Brocade, Brocatelle, Épingle Brocade, Lampas, Liseré Brocade

FIBER CONTENT

Family: Silk.

Present: Brocade: silk or MF filament, often with metallic; occasionally made of cotton. Wider choice of fiber with the heavier brocatelle: may be wool, cotton, flax, as well as MF fibers.

YARN

Usually filament for brocade, often includes metallic; filament or spun for brocatelle.

FABRIC CONSTRUCTION

Brocade is a jacquard weave, with an elaborate or intricate pattern, giving a raised effect as if embroidered. Lampas is woven with two sets of warp, one set of weft, usually in several colors, the extra warp forming the design. Brocatelle is a firm compound weave, with more than one set of weft; extra warp may also be used, to give a padded as well as raised-outline surface, for an embossed effect. These fabrics are not usually reversible, as there are often long floating yarns on the back of the fabric (see photo in *Fabric Reference* under jacquard weave). Épingle brocade shows a raised jacquard pattern on a rep (cross rib) ground (see Rib Woven, All over). Liseré has a brocade design on a satin or corded ground.

WEIGHT, USES

Bottom weight to heavy, brocade is used for all kinds of formal wear and accessories; both brocades and brocatelle are used for drapes and upholstery. Lampas is mainly used for drapery, upholstery, and other interiors applications, including accessories and wallcoverings.

Brocade

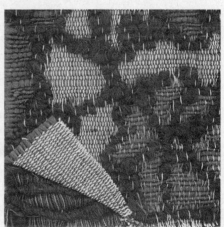

Brocatelle

NAMES Latin *brocare*, meaning to figure. Liseré, French for border, edging. Épingle,
 French for pin.

ESSENTIALS Jacquard weave, raised effect in the pattern, as if embroidered. Bottom
 weight and heavier fabric. Raised, padded effect in the heavier brocatelle.

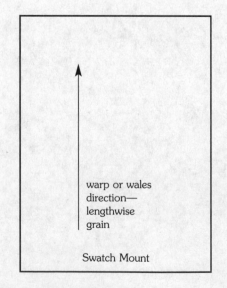

Fabric Name **Fabric Name**

Burlap, Gunny, Hessian

FIBER CONTENT **Family:** Coarser plant fibers: jute, hemp.

 Present: Jute usually, sometimes hemp.

YARN Coarse, uneven.

FABRIC CONSTRUCTION Fairly open, balanced plain weave.

WEIGHTS, USES Bottom weight. Used for hangings, inexpensive drapes, upholstery, covering (including wallcovering), and needlework, sacking, linoleum backing.

Burlap

NAMES *Hessian* to do with Hesse, Germany; *gunny* from Indian *gun* = a coarse sail-cloth of jute. *Jute* itself is from a Sanskrit (Indian) word for matted hair.

ESSENTIALS Rough, open fabric of coarse plant fibers; balanced plain weave.

warp or wales direction— lengthwise grain	warp or wales direction— lengthwise grain
Swatch Mount	Swatch Mount

Fabric Name **Fabric Name**

Calico

FIBER CONTENT

Family: Cotton.

Present: Cotton and blends, usually with polyester.

YARN, FABRIC CONSTRUCTION

Carded-only yarns, balanced plain weave.

OTHER

Printed, small design, usually bright colors. Printing of classic designs with small repeats, such as calico, is usually done by rollers, one for each color. The print paste in each color is held in areas etched or engraved into the roller; the general name for this type of printing is *intaglio*. See *Fabric Reference* for more information on roller printing.

WEIGHT, USES

Top weight, used for shirts, dresses, curtains, accessories (typical fabric for patchwork quilts, rag dolls).

Calico

NAME

From the town of Calicut on the southwestern coast of India, in Tamil Nadu State. This was Vasco da Gama's first Indian port of call, 1498. Fabric first block printed, with *calico* in those days being a general term for this type of cotton fabric.

ESSENTIALS

Inexpensive cotton family fabric, balanced plain weave, small-scale (usually roller) print.

warp or wales direction— lengthwise grain	warp or wales direction— lengthwise grain
Swatch Mount	Swatch Mount

Fabric Name **Fabric Name**

Canvas, *also* Awning, Duck, Sailcloth, Tarpaulin (*see also* Aida [Ada] *or* Java Canvas *or* Cloth *under* Dobby—Openwork Effects and Basket Weave)

FIBER CONTENT

Family: Originally flax, hemp, or other bast fiber.

Present: Usually made of cotton or blends, except for sails (the original use), where MF fibers, notably (special ultraviolet resistant) nylon, are used.

YARN, FABRIC CONSTRUCTION

Carded-only yarns, close plain weave. Fairly well balanced for greatest strength, but may also be ribbed. Sportswear canvas is often a 2 × 1 basket variation of plain weave, to give porosity and wrinkle resistance.

WEIGHT, USES

Usually bottom weight or heavier, used for sportswear, workwear, slipcovers, drapes, art- and needlework ground, awnings, deck chairs, tents and other shelter or protective coverings, sails.

Workwear canvas Lighter canvas 2 × 1 basket weave

NAMES

Canvas probably comes from the Latin *cannabis,* meaning hemp; *duck* possibly from the Dutch *doek,* meaning linen canvas; *tarpaulin* is derived from the fact that it was traditionally treated with tar or oil, + Latin *pallium,* meaning cloth.

ESSENTIALS

Strong, firm plain weave fabric, most today of cotton.

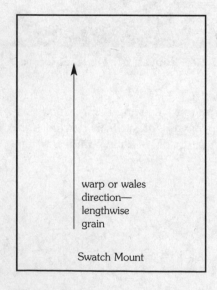

warp or wales
direction—
lengthwise
grain

Swatch Mount

Fabric Name

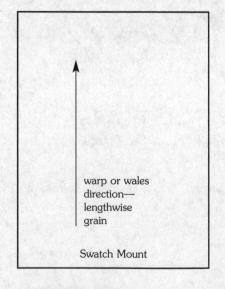

warp or wales
direction—
lengthwise
grain

Swatch Mount

Fabric Name

Canvas, Hair *or* Tailor's

FIBER CONTENT

Family: Wool and wiry hair fibers.

Present: Better quality still made of wool, plus a stiff, wiry fiber in the weft—mohair or horsehair. In cheaper interfacing, there may be a flat tape rayon in the weft for springiness; this type cannot be molded by steam in tailoring.

YARN, FABRIC CONSTRUCTION

Carded-only yarns, wiry fiber in weft yarns. Fairly close plain weave, narrow fabric (70 cm or 27 in.).

WEIGHT, USES

Interfacing in tailored suits and coats, especially for the lapels; weight suitable to main fabric. (Old-fashioned haircloth for upholstery had cotton or flax warp, wiry hair weft, for a smooth and durable covering. This is also the [itchy] cloth of the hair shirt worn by monks doing penance.)

Hair canvas

NAMES

Canvas probably comes from the Latin *cannabis,* meaning hemp; *hair* refers to mohair or horsehair; *tailor's* for specific use today in tailoring.

ESSENTIALS

Firm plain weave, wiry fibers in weft yarns.

warp or wales direction— lengthwise grain	warp or wales direction— lengthwise grain
Swatch Mount	Swatch Mount

Fabric Name **Fabric Name**

Challis (Challi, Challie, Chanlinet, Challys, Shallie), Étamine,
plus reference to Mousseline de Laine

FIBER CONTENT

Family: Cashmere goat hair with silk.

Present: Wool, MF fiber (especially acrylic, polyester, or rayon), may be cotton or blends.

YARN, FABRIC CONSTRUCTION

Challis, étamine are made of spun yarn, carded, whereas mousseline de laine is made of worsted (combed) yarn. Balanced plain weave, not close, with étamine the most open (see photo).

OTHER

Challis, étamine have a soft finish, may be slight nap, especially with cotton or rayon challis. These fabrics also usually have a small flower print, often on a dark ground. The best quality has traditionally been discharge printed, to give a solid, dark ground, but today challis is usually silk screen or roller printed. Mousseline de laine is a firmer fabric, not necessarily printed.

WEIGHT, USES

Top weight, light, open (especially étamine), drapes well. Used for women's and children's nightwear, dressing gowns, blouses, dresses, shirts, scarves, ties. Mousseline de laine has slightly more body than wool batiste (see Batiste); other similar wool fabrics use higher-twist yarns; see wool voile, nun's veiling in the Voile (cotton type) File.

Challis

Étamine

NAMES

Challis is derived from Anglo-Indian *shalee*, meaning soft; it was originally made of fine cashmere (Himalayan goat underhair) and silk. French *étamine*, meaning a sieve; étamine is a very open weave. French *mousseline de laine*, meaning wool muslin (see Muslin in the Sheeting File).

ESSENTIALS Light, open plain weave, wool family; challis and étamine have a slight nap and generally dark prints, to give light yet cozy fabrics for cool weather.

Fabric Name

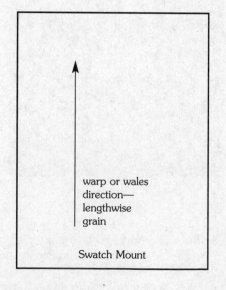

Fabric Name

Chambray *plus reference to* Oxford Chambray

FIBER CONTENT

Family: Flax.

Present: Cotton and blends, often polyester, may be rayon.

YARN, FABRIC CONSTRUCTION, OTHER

Carded or combed yarn. Chambray is usually a fairly balanced plain weave; oxford chambray is 2×1 basket weave. Warp yarns are dyed, weft yarns are undyed, although the fabric may be woven in checks or stripes as well.

WEIGHT, USES

Often top weight (e.g., oxford chambray), used for shirts, dresses, sportswear, children's wear, home furnishings (see Oxford Cloth File); may be bottom weight, used for sportswear, workwear, furnishings (see photos below).

Topweight

Bottomweight, 2×2 basket weave

NAMES

Chambray is from the French town of Cambrai, a linen-weaving center near the border with Belgium (same as cambric).

ESSENTIALS

Plain weave; warp dyed, weft undyed.

warp or wales direction— lengthwise grain	warp or wales direction— lengthwise grain
Swatch Mount	Swatch Mount

Fabric Name **Fabric Name**

Check, Twill Weave (Wool Family) *many also called Estate Tweed includes* Badenoch, Ballindalloch, Buffalo, Coigach, Glen, Glenfeshie, Glenmorriston, Guard's, Gun Club, Houndstooth, Lochmore, Nailhead, Pin, Prince of Wales, (Scottish) District, Shepherd's, Tattersall, Windowpane (*see also* Overcoats for Mackinac [Buffalo Check]; Plaid; Tartan; Tweed) *See also* plain weave checks—cotton family—Gingham, Madras

FIBER CONTENT	**Family:** Wool for twill weave checks.
	Present: Any, often wool or blends.
YARN, FABRIC CONSTRUCTION	Carded or combed yarns, warp and weft the same. All of the twill weave checked fabrics listed above are woven in a 2/2 (even) right-hand twill, with the same numbers and order of dyed and undyed yarns used in warp and weft in almost every case; this is called an *even sett*. Authentic tartan follows the same type of weave, except that tartan is multicolored. See Types and photos.
OTHER	A check is woven with fine lines or groups of dyed yarns with undyed white or light yarns; most have only one dyed color, but some checks have two or three colors with undyed (see Plaid, Tartan). For the distinction of check from plaid or tartan, see Tartan.
TYPES	Types are treated here, not alphabetically, but according to increasing complexity of the combinations of dyed and undyed yarn in the weave.

shepherd's check [sometimes called *shepherd's plaid,* or referred to as the original *tartan.* See Tartan—Name]. Does not show the tooth effect where the dyed yarns meet the natural when the groups are five or more. The color used to be light blue, but today is often black. *Glenfeshie* has a red over-check on a six black, six white shepherd's check.

houndstooth (dogtooth) check. (see photo) Four dark, then four light yarns, producing the familiar pointed extension of the solid dark block, that looks like a four-pointed star, or the tip of a canine (dog) tooth; tiny versions have been called puppytooth. An apt French name is *pied de poule,* which means chicken foot!

gun club check. Results when two colors are used, each alternating with the light color (see photo); some examples are: Ballindalloch, Coigach, Glenmorriston, and Lochmore.

buffalo check. Of the same construction as the shepherd's check, except that it has black and usually red yarns alternating in groups large enough to give a very bold check; see Mackinac in Overcoats file. This check, developed in wool blankets, is also made today in a plain weave and of cotton, e.g., in shirting or dress fabric, taking it into the gingham type.

warp or wales
direction—
lengthwise
grain

Swatch Mount

Fabric Name

warp or wales
direction—
lengthwise
grain

Swatch Mount

Fabric Name

guard's check. Results if two dark alternate with two light yarns; vertical or horizontal effects can be produced.

windowpane check. A fine outline over-check or crossbar.

tattersall check. Similar to windowpane, except that two, or sometimes three, colors are used. This is another check that has crossed to the cotton type, being most used today in plain woven shirtings; see Oxford Cloth. It did start in wool, from the pattern of horse blankets, the name derived from a famous horse auction house in London's Belgravia, on a corner of Brompton Road and Knightsbridge (now at Newmarket).

glen checks [sometimes called *glenplaids* or *(Scottish) district checks*]. Combinations of the possibilities listed above. One of the best known is Glenurquhart (see photo), named from the Great Glen, where the ruined Castle Urquhart stands on the shores of Loch Ness in Invernesshire. This check combines blocks of the elements of houndstooth and guard's check. Another well-known glen check is the Prince of Wales, which is a large version of Glenurquhart, often with a fine line over-check in a contrasting color (see photo); Badenoch has two colored over-checks.

pin check, pinhead, pinpoint, or nailhead. A tiny check effect, almost like dots in rows; some "pick-and-pick" gives a similar effect, seen in the photo of sharkskin suiting, in the Worsted Suiting File.

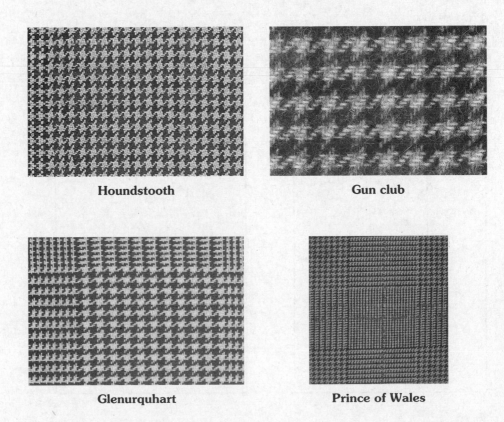

Houndstooth

Gun club

Glenurquhart

Prince of Wales

WEIGHT, USES	Usually bottom weight to heavy, but can also be made in top weight. Used for suits, slacks, skirts, jackets, dresses, coats, scarves, blankets, and countless other applications.
NAMES	Scottish district check names often derive from a region, especially the deep Highland valleys (*glens*), or from use of these patterns in classic clothing (guard's, gun club). Definitions of a number of checks are included in this File.
ESSENTIALS	Limited colors in both warp and weft, woven in block patterns; most "name" checks are (originally) 2/2 right-hand twill weave.

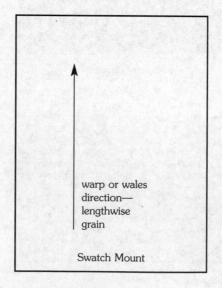

Fabric Name

Fabric Name

Chenille Yarn

FIBER CONTENT	**Family:** Possibly silk.
	Present: Any in clothing, wool for carpets.
YARN	Classic chenille is a novelty yarn made by slitting a specially woven fabric into strips. The fabric is woven with double leno crossings of fine warp (see Leno) with spaces between; the weft is thicker and soft. When the strips are cut, the ends may be brushed to one side or protrude all around (see photo). Mock chenille yarn, produced by less costly methods, is also often used. One type results when two or more spiral or corkscrew novelty yarns are plied.
FABRIC CONSTRUCTION, WEIGHTS, USES	Chenille yarn can be used as (usually part of) weft to weave a pile for upholstery, drapes and some (very high-quality) carpet, or it can be knitted. Stitched onto fabric, it can give a Persian lamb fur-like fabric, or it can be raschel-knitted in (see photo). It may also be used in embroidery and trims, such as fringes.

Chenille yarn

Upholstery fabric, chenille yarn in weft

Persian lamb look, raschel knit

NAME	French *chenille,* meaning caterpillar, which the fuzzy yarn resembles.
ESSENTIALS	Classic chenille is a fuzzy yarn with fine yarn leno crossings holding cut ends, used to create pile surface.

warp or wales direction—lengthwise grain	warp or wales direction—lengthwise grain
Swatch Mount	Swatch Mount

Fabric Name **Fabric Name**

Chiffon; *also* Georgette Crepe

FIBER CONTENT

Family: Silk.

Present: Silk, MF fiber, often polyester. There is also wool georgette.

YARN, FABRIC CONSTRUCTION, OTHER

Filament (unless of wool), fine, very high twist (crepe twist). Balanced plain weave, highest-twist crepe yarns used in both warp and weft. In georgette, the direction of twist (S and Z) is alternated every one or two yarns, giving a very pebbly, crepey hand, developed in wet finishing.

WEIGHT, USES

Both fabrics are sheer; chiffon is very soft, light, and fragile; georgette has a little more substance, with a "cloudier" look; both are dull, lively, very drapable. Used for lingerie, nightwear, blouses, dresses, evening and bridal wear. Georgette may be used as a casement fabric in window treatments.

Chiffon

Georgette

NAMES

French *chiffon,* meaning a rag, scrap (in this case, an elegant one). Georgette is said to be named for a French milliner, Mme. Georgette de la Plante, who used this fabric a great deal.

ESSENTIALS

Fine filament yarn, highest (crepe) twist, balanced plain weave, sheer, with chiffon lighter, and softer than georgette.

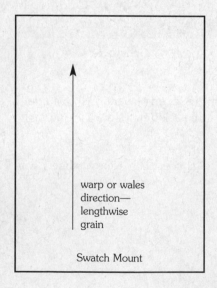

warp or wales
direction—
lengthwise
grain

Swatch Mount

Fabric Name

warp or wales
direction—
lengthwise
grain

Swatch Mount

Fabric Name

FIBER CONTENT	**Family:** Cotton.
	Present: Cotton (long staple) and blends, usually with polyester.
YARN, FABRIC CONSTRUCTION, OTHER	Combed yarns, often ply, steep twill weave (may be left- or right-hand); all-cotton is usually mercerized; preshrunk, fast dye.
WEIGHT, USES	Bottom weight, used for hot-weather sportswear, uniforms.

Chino

NAME	Fabric bought in China for use in hot-weather uniforms, eventually made in England and exported to the East. Originally was dyed only khaki color.
ESSENTIALS	High-quality, strong, cotton family twill fabric, smooth and lustrous.

warp or wales
direction—
lengthwise
grain

Swatch Mount

warp or wales
direction—
lengthwise
grain

Swatch Mount

Fabric Name

Fabric Name

Chintz, Cretonne, Polished Cotton

FIBER CONTENT	**Family:** Cotton.
	Present: Cotton and blends, usually with polyester.
YARN, FABRIC CONSTRUCTION	Yarns usually carded only; firm balanced plain weave (polished cotton is sometimes a sateen or even a cotton satin warp sateen).
OTHER	Usually printed (see Names), design is often a fairly large floral. Chintz often has a glossy surface from glazing or pressing (calendering), while cretonne is usually unglazed and somewhat heavier than chintz. Some glazed fabric today is called chintz even when it is a solid color. Polished cotton may be printed or not; there is no surface glaze applied—the lustrous surface comes from pressing (friction calendering), and if the weave is weft-face satin, the floats also contribute sheen (see Sateen).
	The traditional chintz design of the sixteenth and seventeenth centuries from India is a "Tree of Life" style with elaborately intertwining flowers, foliage, and birds, handpainted on fine cotton fabrics—"painted calicoes." These were imitated in Europe on cotton fabrics, block printed, then starched or waxed.
WEIGHT, USES	Usually bottom weight, may be top weight, used mainly for drapes, slipcovers, accessories, some apparel.

Glazed chintz

55

NAMES Hindi *chint,* plural *chintes* = varied in color, also from Sanskrit *citra,* meaning spotted, from which the word *cheetah* also comes. *Cretonne* takes its name from the French village of Creton.

ESSENTIALS Firm, plain weave cotton family fabric, large-scale print usual on chintz and cretonne; glazed finish usual on chintz but not on cretonne; luster on polished cotton is from pressing (calendering).

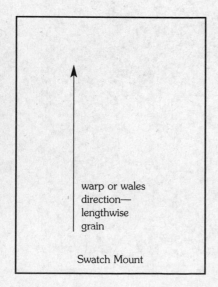

warp or wales
direction—
lengthwise
grain

Swatch Mount

Fabric Name

warp or wales
direction—
lengthwise
grain

Swatch Mount

Fabric Name

FIBER CONTENT	**Family:** Silk.
	Present: Usually nylon.
YARN	Filament, fine, more warp than weft. Rip-stop has heavier yarns woven at intervals in both warp and weft (see photo).
FABRIC CONSTRUCTION	Basically a taffeta, i.e., close plain weave, with fine crosswise rib (see Taffeta). Parachute cloth is a very similar fabric but with a balanced plain weave (see China silk under Silk, Cultivated).
OTHER	Crisp, with a shiny finish, achieved with thermoplastic fibers like nylon by flattening the surface with heat and pressure (calendering). Silk and rayon types, used in the past, were given a wax finish, pressed to a gloss. With other fabrics, a similar calendering gives a "satinized" finish.
WEIGHT, USES	Top weight, in nylon used for sportswear, like ski and squall jackets, where a strong, lightweight, water repellent fabric is needed. Also used for tents, sails, rainwear.

Rip-stop ciré

NAMES	French *ciré,* meaning waxed; *rip-stop* suggests the strengthening contributed by the occasional heavier yarns.
ESSENTIALS	Light taffeta (crisp, close plain weave, fine cross rib), glossy or shiny finish.

warp or wales direction— lengthwise grain	warp or wales direction— lengthwise grain
Swatch Mount	Swatch Mount

Fabric Name **Fabric Name**

This File includes a variety of fabrics with a **visibly coated surface**, **face or back**. A liquid is applied to a woven (usually plain weave) or knitted fabric; for purposes where some give is an advantage, as for upholstery, a jersey or tricot knit is often used as the backing. Coatings that give waterproof fabrics are covered in the Waterproof File.

Leatherette or Leather-Like: This is often a medium-heavy fabric. The coating is usually PU (polyurethane) or PVC (polyvinyl chloride, or vinyl). It may be embossed to give the top grain appearance of leather, such as that of pigskin, cowhide, or other (see photo). Used for clothing, accessories (shoes, handbags), coverings, including furnishings. PU-coated fabrics do not wear as well as leather and are damaged much more easily by cuts and abrasions.

Other Decorative Effects: See Pattern, Applied—Pressure

Metallic Particles: A coating of metallic particles, usually dispersed in a resin, may give:

- a decorative effect (see Lamé).
- a reflective material for insulating coverings, linings, and interlinings.
- safety reflectives, by applying a coating of clear beads.
- a color that alters with temperature changes; see also *Color Variable.*

Oilcloth: Used for table covers, originally coated on one side with linseed oil and pigment; today such coated fabrics are produced using a plastic, often PVC.

Foam: Foam is coated on the back of drapes to darken rooms and insulate.

**Coated: embossed
snakeskin look**

ESSENTIALS Obvious surface coating. This may give a shiny, reflective, or insulating fabric; when embossed, it can give a leather-like material.

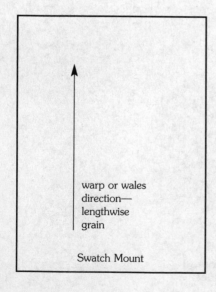

warp or wales
direction—
lengthwise
grain

Swatch Mount

Fabric Name

warp or wales
direction—
lengthwise
grain

Swatch Mount

Fabric Name

Color Variable, *includes* Chameleon, Changeable Dye, *Changeant,* Hologram, Iridescent, Luminescent, Ombré, Opalescent, Pearlescent, Shot (Taffeta), Thermochromic (*see also* Pattern in Yarns)

Chameleon, *Changeant*, Iridescent, Luminescent, Opalescent, Pearlescent, Shot (Taffeta): A fabric made of filament yarns (silk or MF fiber), shows the changeable color better than spun. However, in any woven fabric, when the warp yarns are a different color from the weft, the color will change as the fabric is moved—an effect which is called chameleon, *changeant*, iridescent, opalescent, or pearlescent or with taffeta, "shot" (see also Velvet: nacre). A coated fabric can also show this changeable effect. It may be any weight or use, but often gives a fairly glamorous or "showy" effect, good for evening wear, but is used in many other applications as well. Flat fibers made of many layers of differing refractive indexes can give a subtle glitter or iridescence.

Hologram: A changeable, three-dimensional effect, that catches and reflects light in striking ways, especially when printed on foil or plastic film, with, in some cases, embossing as well. Holography is making use of a hologram.

Changeable Dye: Fabrics have been developed which change color with temperature **(thermochromic),** or in response to other conditions (see photo). These feature a coating containing very small capsules of a color which will change reversibly, for instance, with temperature fluctuations—*see* hand imprint on T-shirt in the picture.

Ombré, Ombred: This is a shaded stripe effect, where one color changes gradually to another depth or to another color (see photo).

Hand print produced by reaction of thermochromic dye

Ombré

Hologram (courtesy of Sommers Plastic Products)

NAMES

The symbol of the goddess Iris, messenger of the gods in Greek mythology, was the rainbow, hence *iris,* plural *irides,* for the visible spectrum of colors seen in a rainbow or from a prism, and *iridescent* for a play of colors. This effect is also seen when an *opal,* a *pearl,* or a shell ("mother of pearl") is moved. When an iridescent fabric (often taffeta) is moved, the changing color seems to "shoot" along a yarn, hence *shot* silk or taffeta. The *chameleon* is a small lizard which can change the color of its skin. French *changeant,* meaning changing. Hologram, a three-dimensional image from a pattern of interference produced by a split beam of laser or optic rays. Luminescent suggests emission of light. Spanish *sombra* meaning shade; hence *ombré* means shaded color.

ESSENTIALS

For all but ombré: As a fabric is moved, or as conditions change, its color changes.

Fabric Name

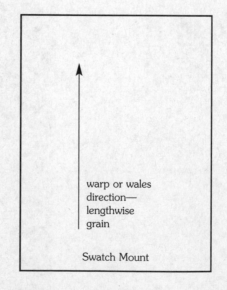

Fabric Name

Compound (*also called* Composite, Layered Joined, Multi-Component), *includes* Bonded, Fused, Laminated, Quilted, Sandwich, Stitched, Trapunto

This File includes a variety of materials with two or more components (often different) joined durably or permanently, in a kind of sandwich; the resulting layered fabric is used as one.

FABRIC CONSTRUCTION METHODS (SEE PHOTOS)

Bonded, laminated: Layers

- are jointed with adhesive.
- are fused with heat or chemicals.
- are held by a layer of foam.
- are heat-fused to other components, often tricot, used to provide a "self-lined" fabric.
- incorporate a stiff component, as in foundation garment "sandwich" materials.
- are made for insulating fabrics by incorporating (1) a layer of microfibers (as in Thinsulate™); (2) a cellular layer (e.g., foam); or (3) a microporous film to make the compound fabric water- and windproof, yet allow moisture vapor (perspiration) to go through (as in Gore-Tex® fabrics).

Stitched: Layers are joined by stitching; quilted involves fabric on one or both sides of a layer of fiber batting, stitched in a pattern, giving the padded effect (see photo). Trapunto (Italian quilting) has only the areas of a design motif padded and stitched around. An effect similar to quilting can be achieved with "stitching" by chemicals or heat from ultrasound (Pinsonic®). A mock matelassé can be achieved in layered fabric by having the top layer joined in a pattern to a backing, which can be shrunk, making the top layer go up in puffs.

Heat "stitched" quilted effect

Batt quilted to muslin

Thinsulate

Matelassé look

NAMES Latin *lamina,* meaning thin plate of metal; Latin *culcita,* meaning stuffed sack or mattress, evolved through Old French to *quilt;* Italian *trapunto,* meaning quilted, embroidered, studded.

ESSENTIALS Two or more layers of fabric joined durably or permanently and used as one.

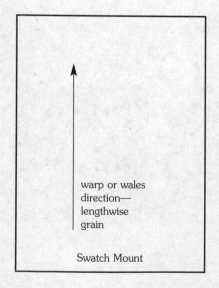

warp or wales
direction—
lengthwise
grain

Swatch Mount

Fabric Name

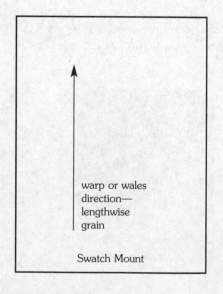

warp or wales
direction—
lengthwise
grain

Swatch Mount

Fabric Name

Corduroy, *includes* Corduroy—Uncut, Corduroy—Cut (*see also* Velveteen)

Corduroy is woven with one set of warp and two sets of weft, in such a way that the extra weft can be cut and brushed up into a pile. However, the uncut corduroy has been used on its own, and under a variety of names, so both uncut and cut are discussed in this file.

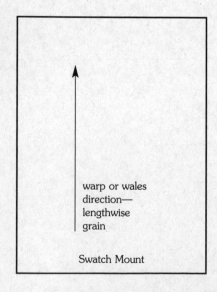

warp or wales
direction—
lengthwise
grain

Swatch Mount

Fabric Name _____

warp or wales
direction—
lengthwise
grain

Swatch Mount

Fabric Name _____

Corduroy—Uncut: Bannigan (Barragon), Beaverteen, Fustian, Moleskin

Corduroy—Cut: *includes* "Waleless," Featherwale, Pinwale, Midwale, Thickset, Widewale, Sculptured, Hi-Lo, Thick & Thin, etc.

FIBER CONTENT

Family: Cotton.

Present: Usually cotton and blends, best quality is long staple cotton; occasionally other fiber, even silk.

YARN, FABRIC CONSTRUCTION, OTHER

Yarn for the best quality is combed and mercerized, most are carded only. The weave uses one set of warp and weft for the ground or back, usually in plain weave called *tabby back;* the best have twill weave ground, called *twill back, jean back,* or *Genoa back.* Extra weft yarns are interlaced to form vertical rows of crosswise floats (see photo). At this stage of **uncut corduroy,** the fabric is a sturdy, compound-woven material, one of a family called *fustian* in older times. By the seventeenth century in France, the fabric was used with the floats cut and brushed up to form the vertical pile wales that are characteristic of corduroy. Cutting today is done using sharp discs, guided along the rows of floats; corduroy with the wales very close together may be put through cutting twice. Brushing and other finishing treatments follow cutting.

Uncut corduroy

warp or wales
direction—
lengthwise
grain

Swatch Mount

Fabric Name

warp or wales
direction—
lengthwise
grain

Swatch Mount

Fabric Name

WEIGHT, USES Bottom weight to heavy (feather- and pinwale approach top-weight fabric), used for a very wide variety of men's, women's, and children's wear, including dresses, slacks, suits, jackets, sportswear, playclothes, workwear, coats, as well as accessories, and for home furnishings, e.g., drapes and upholstery. Uncut corduroy can be used as a firm sportswear or furnishing fabric with a corded effect. Under the name "moleskin" it is used in tough points as underlay in the seat, thigh, and calf areas for warmth and softness.

TYPES Classified by the number of vertical rows of cut pile (wales) per inch (never converted to metric) across the fabric, as follows:

Corduroy Name	Wales per Inch
featherwale	18–21
pinwale	16–18
midwale	14
thickset	11
widewale	2–9

Featherwale

Pinwale

Midwale

Thickset

Widewale

69

So-called "waleless" corduroy has barely visible wales, almost like velveteen. There are also a number of types of "novelty" corduroy: sculptured, high & low (hi-lo), thick & thin, etc. The fabric may be one color (piece dyed) or printed.

NAMES

French *corde du roi,* meaning King's cord; corduroy was used in the seventeenth and eighteenth centuries to give a hard-wearing fabric for livery and menservants' uniforms in the royal households. *Fustian* was a general term, from the Old English *fustane* or *fustyan* and the Latin *fustis,* meaning stick; the cloth was beaten with a stick in finishing. Other fustian fabrics were moleskin and beaverteen. They were made with one set of warp and two sets of some kind of weft (some forms called bannigan or barragon, from Arabic *barrican*, meaning strong cotton cloth). Corduroy and velveteen were the main ones in which floating picks were cut to give a pile surface (see also Velveteen). Moleskin was woven with a weft-face satin weave, with two picks face weft to one pick back weft. The fine, soft surface given by napping resembled the fur of a mole.

ESSENTIALS

One set of warp and weft yarns to weave the back; extra weft interlaced in vertical rows of floats, which are later cut.

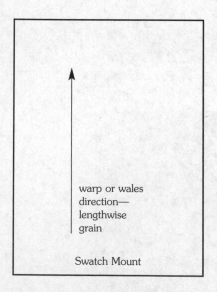

warp or wales
direction—
lengthwise
grain

Swatch Mount

Fabric Name

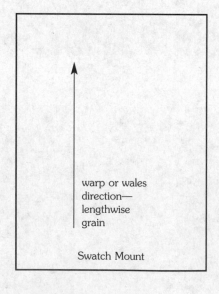

warp or wales
direction—
lengthwise
grain

Swatch Mount

Fabric Name

Crepe (crepey, crepiness) may identify any fabric with a pebbled, crinkled, grainy, or puckered surface, given by:

- high-twist yarns (Chiffon).
- shrinking textured set MF filament yarns.
- crimped yarns.
- Crepe Weave and Crepon. See following Crepe by Weave.
- Seersucker.
- Shrinkage in wet finishing.
- Pattern Applied—Chemical (plissé).
- Pattern Applied—Pressure (embossed).

NAME

French *crêpe*, meaning crimped, frizzed. Archaic spelling *crape*.

Following are the fabrics that may be considered crepes, with references to the Files that describe them in more detail:

bark crepe. *See* Crepon.

Canton crepe. *See* Crepe de Chine.

charmeuse. *See* Satin/Crepe.

chiffon. *See* Chiffon.

chirimen. Japanese term for crepe.

clokay, cloqué. *See* Matelassé.

crepe-back satin. *See* Satin/Crepe.

crepe de chine. *See* Crepe de Chine.

crepe marocain (Morocco). *See* Crepe de Chine.

crepon. *See* Crepon.

crinkle cloth (crinkle crepe). Cotton. See Pattern Applied, Chemical (plissé); Sheeting.

flat crepe. Crepe Weave. Least "pebbliness" of any crepe.

georgette. *See* Chiffon.

granite cloth. Rough surface from crepe weave and tight yarn twist.

matelassé. *See* Matelassé.

momie cloth. *See* granite cloth above.

moss crepe. Crepe weave + crepe twist yarns.

mummy cloth, pebble cloth. *See* granite cloth above.

plissé. *See* Pattern Applied—Chemical (plissé).

sand crepe. May be cotton; yarns medium twist or crepe twist; crepe weave.

satin-back crepe. *See* Satin/Crepe.

seersucker. *See* Seersucker.

Crepe by Weave, *includes* Crepe, Granite, Momie (Mummy), *and* Pebble Weave *or* Cloth, Flat Crepe

FIBER CONTENT **Family:** Silk.

 Present: Any: silk or MF filament, wool, cotton, various MF fibers, often acetate and/or rayon.

YARN Spun or filament; low, medium, or highest (crepe) twist.

FABRIC CONSTRUCTION Dobby controlled, short floats scattered over surface of fabric, looking almost random, but with pattern repeat every 16 or 20 wefts.

WEIGHT, USES Usually top weight, may be bottom. Used for dresses, blouses, suits, loungewear, drapes.

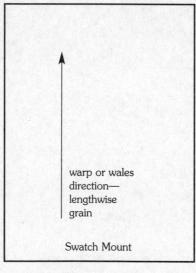

warp or wales direction— lengthwise grain

Swatch Mount

Fabric Name

Crepe weave

NAMES Hard, pebbled surface suggests granite; *momie* (mummy) origin not known.

ESSENTIALS Pebbled surface, small bumps, crinkles, puckers given by short floats in irregular (crepe) weave.

72

Crepe de Chine, *also* Canton Crepe, Crepe Marocain (Morocco)

FIBER CONTENT

Family: Silk.

Present: Silk or MF filament, today often nylon or polyester.

YARN, FABRIC CONSTRUCTION, OTHER

Filament yarn, plain weave, the warp yarn is low twist, finer, and many more than the weft, which is highest (crepe) twist, often alternating directions (S with Z). This gives a very fine, subtle crepe de chine; Canton crepe is slightly heavier, with crepe marocain (Morocco) the most substantial, having somewhat heavier weft crepe yarns, giving more of a crosswise rib effect. These crepes develop pebbliness in wet finishing. All may be solid color or printed. A fabric in a jacquard weave with this background construction might be called, for instance, figured crepe de chine.

WEIGHT, USES

Usually top weight, used for blouses, dresses, lingerie, neckwear.

Crepe de chine

NAMES

French *crêpe de chine,* meaning crepe of China (see Silk, Cultivated); use of silk from Canton in South China gave the name *Canton crepe;* crepe woven in French Morocco gives crepe marocain or crepe Morocco.

ESSENTIALS

Plain weave; warp uses many fine, low-twist filament yarns; weft uses very high (crepe) twist yarns, giving a fine pebbled (crepe) effect.

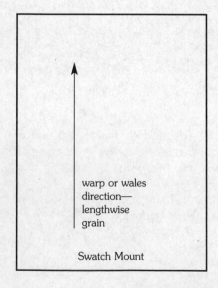

warp or wales
direction—
lengthwise
grain

Swatch Mount

Fabric Name _____

warp or wales
direction—
lengthwise
grain

Swatch Mount

Fabric Name _____

74

Crepon, Bark Cloth or Crepe (*see also* Bark Cloth, Tapa *under* Nonwoven)

FIBER CONTENT

Family: Probably silk.

Present: Crepon often silk or MF filament, may be wool, cotton, or other staple fiber. Bark crepe usually cotton, flax, or rayon.

YARN, FABRIC CONSTRUCTION

Yarn may be filament or spun, as noted under Fiber Content. Weave is compound (dobby- or jacquard-controlled), gives a lengthwise wrinkle or ripple.

WEIGHT, USES

Top or bottom weight, firmer than other crepes. Used for blouses, dresses, slacks, suits, neckwear, drapes.

Crepon Bark cloth, crepe (woven)

NAMES

Crepon from French *crêpe*, meaning crimped. *Bark crepe* from its tree bark wrinkle effect. For real "bark cloth," see cloth made from bark (tapa) under Nonwoven.

ESSENTIALS

Compound weave, surface raised on face in lengthwise wrinkle effect, like tree bark.

warp or wales direction— lengthwise grain	warp or wales direction— lengthwise grain
Swatch Mount	Swatch Mount

Fabric Name **Fabric Name**

Damask (*see also* Jacquard Woven)

FIBER CONTENT

Family: Silk.

Present: Silk still used, or MF filament (*see* photo), but much damask today is table "linen," made of flax, cotton, rayon, and blends (identified as "spun type" in photo.

YARN, FABRIC CONSTRUCTION, OTHER

"Silky" version uses filament yarns, low twist as a rule, while better-quality spun yarns will be smooth and fine (cotton will be combed). The firm weave is jacquard, with large, sweeping designs, set off from the ground by the luster of satin weave floats. In any damask there are more weft than warp. *Single damask* is woven with a 5 shaft satin weave; *double damask* is an 8 shaft satin weave, which allows more yarns to be packed in to give a firm fabric. The fabric is reversible, with areas lustrous on one side being duller on the other; when two colors are used, these reverse from front to back. Linen damask can be given a permanent soft and lustrous finish by *beetling*, hammering for many hours with wooden blocks.

WEIGHT, USES

Usually bottom weight, as the weave must be close (firm) for good quality. Used for dressy wear, neckwear, table linens, drapes, upholstery, bedspreads, towels.

Linen-spun type

Filament type

NAME

The city of Damascus, Syria, close to the Middle East end of the ancient overland trade route from the Far East, became associated with this one of many fabulous silk textiles carried to the outside world from China. From the fifteenth century, in northern European countries, linen damask was made to simulate silk fabrics, so damask is more associated now with table "linens." The French is *damas*, or *damasse*.

ESSENTIALS Figured jacquard woven fabric, reversible design set off from the ground with satin weave floats.

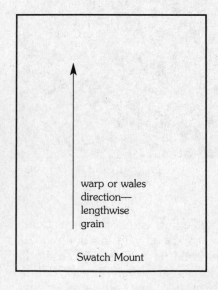

warp or wales
direction—
lengthwise
grain

Swatch Mount

Fabric Name

warp or wales
direction—
lengthwise
grain

Swatch Mount

Fabric Name

Denim, Dungaree, Jean, *includes* Galatea (*see also* Drill; Twill, Steep)

FIBER CONTENT

Family: Cotton.

Present: Usually cotton, blends, often with polyester, but also with lyocell (e.g., Tencel®). A small percentage of spandex gives "comfort stretch," for a less rigid fabric.

YARN

Carded only. Denim has warp yarns dyed (indigo blue), weft yarns undyed. Jean or dungaree is very similar, but may be solid color (as is the similar fabric Drill). Galatea is like a lighter version of jean.

FABRIC CONSTRUCTION

Warp-face twill weave, often 2/1, sometimes 3/1 for very tough denim, traditionally left-hand twill (especially North American woven) but may also be right-hand. Since more warp is on the face, that side is darker; worn denim shows lighter, as more of the weft yarns are exposed.

As fashion fluctuates, denim shows many variations, from straightforward twill with indigo blue warp (see photo) to "novelty" versions, which may incorporate glitter yarn, or be woven to show checks and stripes. Many are solid in color and so, if twill weave, properly called *jean*, or if plain weave, *sailcloth*.

OTHER, WEIGHTS

Heavy, all-cotton denim is stiff, while well-used fabric is softer and conforms more closely to the body. Much unused denim is finished to give a "worn," "distressed," even "seriously distressed" look; this includes stone-washed, acid-washed, mud-washed, even shot (to leave bullet holes)! Terms like *frosted* or *whiskered* also mean a worn look. Bottom weight, medium to heavy; 100% cotton "bull denim" may be up to 18 oz. per sq. yd. (600 g/m²) for greatest strength, while blends of cotton with polyester can be somewhat lighter weight but still very tough. Finishing can give anything from a tie-dye effect to a waterproof finish.

Galatea is lighter than denim, jean, or dungaree, and may be printed, characteristically showing colored diagonal, ticking-like stripes (see photos).

Denim—3/1 left-hand twill

Galatea—2/1 left-hand twill, middle and lower printed

79

USES Used for almost any clothing purpose, but especially for casual, play, sports, and work clothing (e.g., overalls); along with two other names of equivalent fabrics, jean and dungaree, the fabrics have given names to casual pants: denims, jeans, and dungarees. Used also for household furnishings. It is reported that about a quarter of the U.S. cotton crop is used for the manufacture of denim.

NAMES *Denim* is a contraction of the French *serge de Nîmes* (Nîmes serge), a twill sail fabric used by sailors of Nîmes, France, for pants; *jean* is from Genoa, in northern Italy; Hindi *dungri,* meaning a cotton twill fabric, which might have both warp and weft dyed blue, gives *dungaree.*

ESSENTIALS Rugged cotton family fabric, warp-face twill weave; in traditional denim, warp is yarn dyed indigo blue, weft is undyed.

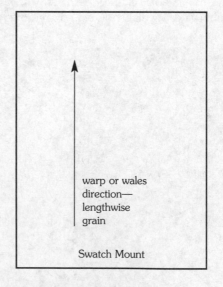

Fabric Name **Fabric Name**

Dobby (Dobbie) Weave (*see also* Crepe by Weave, Crepon)

Fairly complex weaving can be accomplished with a *dobby (dobbie)* attachment on a loom, which controls up to 32 harnesses. This allows a pattern repeat of up to 32 rows of weft. However, this yields a relatively small design, straight-edged, not curving. A number of well-known fabric names with this type of design are described and illustrated in (1) Dobby Design and (2) Dobby Weave—Openwork Effects which follow.

Dobby control also produces many *compound-woven* fabrics, where three to five sets of yarns are involved; in contrast, plain, twill, and satin weaves use only two sets of yarns. For fabrics of this type, see (3) Dobby Compound, Single Face and (4) Dobby Compound, Double Face.

warp or wales
direction—
lengthwise
grain

Swatch Mount

warp or wales
direction—
lengthwise
grain

Swatch Mount

Fabric Name

Fabric Name

(1) Dobby Design, *includes* Armure, Chain Mail, Diaper Cloth, Honeycomb, Huckaback, Madras Shirting, Thermal Cloth, Waffle Cloth (*see also* Dobby Weave— Openwork Effects, and Dobby Compound Weave [Single Face *and* Two Face]) (*see also* Crepe by Weave; Crepon [Bark Cloth]; Birdseye *under* Worsted Suiting)

FABRIC CONSTRUCTION

Woven with dobby harness control (see above) which can produce only relatively small, hard-edged designs or figures, not curving or intricate, in contrast with jacquard. Fabrics with such designs typical of dobby weave are described and shown (see photos) in this File.

Armure has a small, roughly circular design on the surface, which suggests chain-mail armor; French *armure,* meaning armor. Often cotton family, used for drapes, slipcovers, bedspreads. May also be silk family (filament), fairly heavy, for drapes and apparel.

Honeycomb and waffle cloth have cells woven in the fabric, with raised edges suggesting the names. Waffle cloth is also called waffle piqué. Many thermal fabrics have a similar cellular weave, used for underwear, sportswear, and blankets.

Diaper cloth is a toweling fabric, of which huck or huckaback is the best known. These have short floats on both sides, for absorbency. These are also useful in embroidery, done on this toweling; one simple type is called "Swedish weaving." Huck was originally made of flax, but is now usually of cotton, in (narrow) hand towel width.

Lining fabrics may have dobby designs for interest.

Madras shirting similarly has stripes with a small dobby design, usually in the same color as the stripes of plain weave, and so is quite distinct from plaid madras.

Armure

Waffle cloth

Huckabuck

Madras shirting

ESSENTIALS

Design woven in, rather small, usually geometric (hard-edged, not curving).

warp or wales
direction—
lengthwise
grain

Swatch Mount

Swatch Mount

Fabric Name

Fabric Name

(2) Dobby Weave—Openwork Effects, *includes* Aida (Ada) *or* Java Canvas *or* Cloth, Mock Leno, Natté (Basket) Look, Panama (*see also* Basket Weave)

FABRIC CONSTRUCTION

See Dobby Design for discussion of dobby control in weaving. This File shows particular applications which produce openwork effects.

Mock leno, as the name suggests, gives the latticed effect of a leno weave (see Leno), but warp yarns are not crossed in pairs. Rather, groups of yarns are interlaced so as to create spaces in the weave, while holding those yarns firmly in place. Like leno itself, mock leno may be used in summer shirting and dress fabrics to add interest to otherwise plain fabrics and contribute to coolness. Mock leno can also give a mesh effect. The precise openings woven by this means make a ground suitable for art needlework. One durable, stiff, open mesh fabric of hard-twist yarn is called aida (ada) or Java canvas or cloth and is sold as piecegoods or packaged ready for needlework projects.

Natté effect (basket weave look) has fairly complex interlacing controlled by dobby producing a more porous weave, as the basket variation of plain weave does; the yarns are held much more firmly in place, however, so the fabric is much more stable and will sag or bag much less than simple basket weave (compare fabric shown in photo to monk's cloth in Basket Weave File). One of the fabrics called *panama* is a natté effect (see under Basket Weave).

Mock leno

Natté (basket) effect

NAMES

Imitation of leno or basket weave; French *natte,* meaning plaited.

ESSENTIALS

Openwork, latticed, mesh effect without the crossing of warp yarns involved in leno weave, or a basket (natté) effect in weaving much more stable than simple basket weave (see Basket Weave). Both are achieved by dobby loom control.

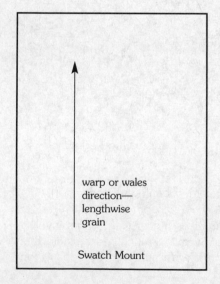

warp or wales
direction—
lengthwise
grain

Swatch Mount

warp or wales
direction—
lengthwise
grain

Swatch Mount

Fabric Name

Fabric Name

(3) Dobby Compound, Single Face, *includes* Bedford Cord, Cord Weave, Piqué (Birdseye, Bullseye, Weft, Warp, etc.) (*see also* Crepon; Matelassé)

FIBER CONTENT

Family: Perhaps wool or silk.

Present: Any, wool and blends for coat fabrics and bedford cord, cotton and blends for piqué.

FABRIC CONSTRUCTION

Woven with more than one set of warp and/or weft yarns, creating layered fabrics, with some yarns entirely or partly on one side. Effects described here are produced mainly using dobby weave control (see photos); matelassé is more often jacquard woven.

Bedford cord is a firm wool family fabric which may have extra *stuffer warp* held in the back to pad the vertical cords (see photo). Used for slacks, suits, uniforms, coats, and sportswear.

Piqué is a firm cotton family fabric, made in a compound cord weave (except for waffle piqué—see Dobby Design). The cord in piqué may be vertical, as in bedford cord (warp piqué), or horizontal (weft piqué) or outline a tiny diamond (birdseye piqué), a large oval (bullseye piqué), or other shape.

Bedford cord + stuffer warp

Weft piqué, face and back

Warp piqué, face and back

Bullseye piqué

Birdseye piqué

NAME	French *piqué,* meaning quilted, padded.
ESSENTIALS	Three or four sets of yarns; weaving differences between one side and the other; definite face one side.





↑

warp or wales
direction—
lengthwise
grain

Swatch Mount





↑

warp or wales
direction—
lengthwise
grain

Swatch Mount





Fabric Name **Fabric Name**

(4) Dobby Compound, Double Face, *includes* Double Cloth, Double Face, Pocket Cloth, Reversible

FIBER CONTENT

Family: Probably wool.

Present: Any, wool and blends for coats and suits.

FABRIC CONSTRUCTION

Woven usually with two sets each of warp and weft yarns, maximum five sets (three warp, two weft); creates layered (compound woven) fabrics. Some yarns may be entirely or partly on one side, and so the fabric is reversible. Effects described here are produced mainly using dobby weave control, occasionally jacquard.

Double face (two face) is usually woven with four set of yarns: a set of warp and weft in each of two colors; these change sides at intervals, creating a mirror-image-patterned reversible fabric. This may show pockets that can be separated, hence one name, pocket cloth.

Double cloth (double woven) has five sets of yarns: One warp and weft set weave one side, a second warp and weft set weave another, while a third warp set weaves them together (see photos). In this (expensive) way, a reversible fabric can be completely different on each side, and can be picked apart, for instance to turn in for a finished edge. A thick coat fabric is lighter, warmer, and more pliable using many sets of finer yarns.

Double cloth—fabrics can be completely separated

Double face—pockets of fabric separate

ESSENTIALS

Four or five sets of yarns; weaving differences between one side and the other. Some are reversible, some not.

warp or wales direction—lengthwise grain	warp or wales direction—lengthwise grain
Swatch Mount	Swatch Mount

Fabric Name **Fabric Name**

FIBER CONTENT

Family: Cotton.

Present: Cotton, blends.

YARN, FABRIC CONSTRUCTION

Ground is light (the best is sheer), usually a fine, balanced plain weave fabric like batiste (see Batiste), and there are small dots all over. Dotted muslin is a finer fabric than we usually think of today as muslin, but the name *muslin* has historically covered a wide range of balanced plain weave cotton fabrics. Dots are also added to leno curtain fabrics (see photo here and Leno File).

Methods of introducing the dots are listed below, from the most expensive, most durable (original method) to the cheapest, least durable (see photos).

Swivel dot on leno curtain fabric

Swivel woven: Original dotted Swiss developed in Switzerland, each dot woven in by extra weft yarn carried on a small shuttle. Most expensive method, but since there are only two cut ends of yarn in each dot, the dots are most firmly anchored.

Clip-spot, clip-dot, spot-dot woven: Extra weft yarns are interlaced with warp to form the dots and float between, across the loom; the floats are later cut. This method is sometimes called **American dotted Swiss.**

Lappet woven: A lappet attachment weaves in extra warp yarns to form various figures which can have the appearance of having been embroidered, with floats in the back between the figures. With dotted Swiss, the floats are cut on the face; if the cut warp yarns are as long as 5 mm or 1/4 in., they are referred to as *eyelash effect.*

Clip spot

Flocked: Dots of glue are printed onto the ground, then short fibers are applied. This is much quicker and cheaper than weaving the dots in, but they are not as pliable and may not adhere well.

Printed: Dots may be printed on the ground. Like flocked dots, those printed are much less expensive and less durable than dots woven in.

Lappet

Flocked

Printed

WEIGHT, USES Light (sheer). Used for blouses, party dresses, millinery, curtains.

ESSENTIALS Batiste character ground, small dots all over.

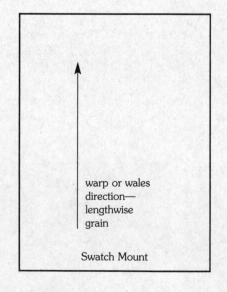

Fabric Name **Fabric Name**

Doubleknit, Bourrelet, Crimpknit, (Double) Piqué, Ponte di Roma
(*see also* Interlock)

FABRIC CONSTRUCTION

Weft knit, made on a circular rib machine, which has two sets of needles, allowing separate yarn feeds to loop on either set—literally, two fabrics knitted together. (Interlock is also a doubleknit fabric, which has a distinctive character—see Interlock.) A doubleknit can, of course, be made of any fiber or yarn type and can be any weight from top weight to heavy. It may have a very firm character, with yarns distributed fairly evenly on both sides; a design (often jacquard controlled) is usually clearer on the face, while the back may show a birdseye look (see photo). Bourrelet has a corded effect on the surface. Double piqué is knit in a kind of honeycomb stitch, to look rather like a birdseye piqué, while ponte di Roma is another doubleknit stitch. A doubleknit may also have a layered, blistered, puffed, or pocketed look, where each yarn feed knits mostly on one side or the other (see photo). For crimpknit, see Names.

USES

Doubleknits have the comfort, stretch, and wrinkle resistance of all knits, especially weft knits, but are much more stable than single knits; that is, they ravel, curl, sag, stretch, and shrink less readily, and are therefore suitable for more tailored garments, such as slacks, skirts, and suits, and for sportswear.

**Houndstooth look face,
birdseye back**

Corded look

NAMES

Doubleknits of textured set (crimped) filament polyester yarn have been called crimpknit. Birdseye back has the same derivation as birdseye woven, see Dobby Design. See Dobby Compound, Single Face for piqué. French *bourrelet,* meaning a pad or fold. Italian *Ponte di Roma,* meaning a Roman bridge, suggested to someone by the arrangement of loops.

ESSENTIALS

Weft knit on circular rib machine, using at least two yarn feeds, looping now on one set of needles, now on the other, to knit two fabrics together, creating a doubleknit.

warp or wales direction— lengthwise grain	warp or wales direction— lengthwise grain
Swatch Mount	Swatch Mount

Fabric Name　　　　　　　　　　**Fabric Name**

Drill, Pocket Cloth (*see also* Denim; Ticking, Twill Steep)

FIBER CONTENT	**Family:** Cotton.
	Present: Usually cotton, blends, often polyester.
YARN, FABRIC CONSTRUCTION	Carded only yarn, 2/1 or 3/1 warp-face twill weave. Traditionally left-hand twill but may also be right-hand. Because the twill line is steep, with much warp on the face and warp yarns are strong, this is a tough fabric.
WEIGHT, USES	Bottom weight to heavy. Used for workwear, sportswear, bags, durable furniture covers, etc. Unbleached drill (close to *greige* or unfinished goods) may be used for pockets, hence pocket cloths.

2/1 or 3/1 Warp-face, left-hand twill

NAMES	Greek *drillich,* meaning three (warp) threads; French *coutil,* meaning drill (for the fabric called coutil see Ticking).
ESSENTIALS	Rugged cotton family fabric, 2/1 or 3/1 warp-face twill weave.

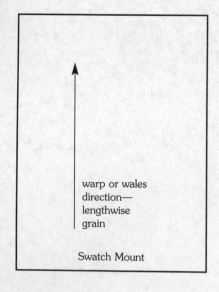

warp or wales
direction—
lengthwise
grain

Swatch Mount

Fabric Name

warp or wales
direction—
lengthwise
grain

Swatch Mount

Fabric Name

Eyelet, Broderie Anglaise, Madeira Work

FIBER CONTENT **Family:** Flax or cotton.

Present: Cotton, flax, blends.

YARN, FABRIC CONSTRUCTION, OTHER Ground is often a light or sheer, fine, balanced plain weave fabric like batiste or organdy, but can be cotton broadcloth, poplin, dimity, linen, or even piqué. The fabric is embroidered, either all over or in a border, with small holes or areas within the pattern cut or punched out. Eyelet may be any color, whereas broderie anglaise (Madeira work) is usually white embroidery on white ground. Intricate and elaborate patterns can be embroidered on huge machines such as the Schiffli, using hundreds of needles (see Lace Embroidered).

WEIGHT, USES Top weight, used for hot-weather lingerie, nightwear, blouses, dresses and for trim, bedding, curtains, table linens.

Eyelet

NAMES Eyelet got its name from the reinforced holes or eyes for lacing. Cutwork with hand embroidery still done on the Portuguese island of Madeira was begun as an industry in 1856 by the daughter of an English wine importer, who taught the women and girls English methods, hence the French *broderie anglaise,* meaning English embroidery, and the name *Madeira work.*

ESSENTIALS Ground of batiste, organdy, broadcloth, linen, or similar, with embroidery around small cut-out holes.

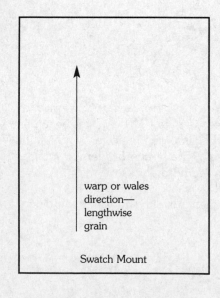

warp or wales
direction—
lengthwise
grain

Swatch Mount

Fabric Name _____

warp or wales
direction—
lengthwise
grain

Swatch Mount

Fabric Name _____

Felt (*includes* Velour Felt) (*see also* Nonwoven-"Needlefelt")

FIBER CONTENT

Family: Wool or other hair or fur fiber.

Present: Wool or other hair or fur fiber which can felt, often mixed with cheaper, nonfelting fibers, but there must be about 50 percent of the fiber which felts.

YARN

None; fabric is made directly from fiber.

FABRIC CONSTRUCTION

In felting, a layer of loose fiber (batt) is held together by the matting of the wool fibers; when agitated with moisture, heat, and pressure, fibers move in one direction only, because of projecting outer scales; the layer thickens, shrinks, and mats together to form felt.

OTHER

Felt may be brushed, sheared, or stiffened; velour felt is finished to leave a soft surface that feels like velvet.

WEIGHT, USES

Top weight to *very* thick and heavy. A principal use is in hats since it can be molded with steam to give a durable shape to the hat. The basic cone of felt from which many hats are shaped is called a *hood* (see photo). (See more on this under Felt in *Fabric Reference*.) Felt is also used for interlining, insoles, accessories, bags, slippers, table padding, pennants, trim, and in many craft applications. Felt does not drape well, and with a lower content of wool it does not have much tear strength, but it does not ravel, and it has considerable insulating value as well as sound-, vibration-, and shock-absorbing properties, all of which make it suitable for many odd consumer and industrial uses.

Felt "hood" from which a hat is shaped
(Courtesy of Seneca College Fashion Resource Centre)

NAMES

Felt has the same root as *filter* (Teutonic into Old English). Velour *see* Velour Knit.

ESSENTIALS

Fabric made from a layer of loose fibers, held together by felting of wool or other hair or fur fiber.

warp or wales
direction—
lengthwise
grain

Swatch Mount

Fabric Name

warp or wales
direction—
lengthwise
grain

Swatch Mount

Fabric Name

Film is a sheet of polymer with no structure—no fibers, no yarns. Film may be made of cellulose (cellophane), PVC (vinyl), polypropylene, polyethylene, or other. Film by itself is used as a fabric for shower curtains, for covers such as tablecloths, appliance covers, wrapping, etc., and for inexpensive rainwear. Thickness is identified by a gauge number.

One very thin and unusual film is the expanded polytetrafluoroethylene (ePTFE) film used in Gore-Tex® fabrics. It has billions of tiny pores (microporous) which allow water vapor to pass through but not liquids; it has another component to prevent contamination by oily substances, and which makes the film windproof. This film is not used by itself, but is laminated to other fabrics (see Waterproof).

With a layer of woven or knitted fabric to strengthen it, a supported film is really a coated fabric (see Coated).

Foam in a thin layer may also be considered a fabric, though it is seldom used unsupported. Foam is usually bonded or laminated to fabric, and can act as the bonding agent when it is heat fused to a fabric. Because it incorporates a great deal of air with very little substance, foam is an extremely light and effective insulator, or can provide cushioning. Both of these characteristics are useful, for example, in book and shoe liners A foam-backed fabric can perform well as upholstery, and in drapes can also give a room-darkening effect. The poor strength of foam can be offset when it is laminated to a layer of something like nylon tricot. Foam has particularly low strength when it is wet.

One of the most common foam layers, polyurethane (PU), tends to yellow with age. A special type of foam is made when PU is applied as a *microporous* foam coating.

Film

Foam laminated to tricot

warp or wales
direction—
lengthwise
grain

Swatch Mount

warp or wales
direction—
lengthwise
grain

Swatch Mount

Fabric Name

Fabric Name

Flannel, *also* Baize, Billiard Cloth

FIBER CONTENT

Family: Wool.

Present: Wool, blends, often with cotton; if entirely cotton it should be called cotton flannel (*see also* Flannelette).

YARN, FABRIC CONSTRUCTION

If yarn is carded only (woolen spun), fabric will usually be plain woven; if yarn is combed (worsted—finer, more twist), fabric will usually be woven in 2/2 right-hand twill. The worsted flannel will be finer and firmer, will take a crease or hold its shape better, and will wear longer.

OTHER

Light but definite nap on face of flannel. Baize has nap on both sides, and when made of wool is heavily felted/fulled; it is usually dyed green, originally also a brownish red.

WEIGHT, USES

Bottom weight for slacks, skirts, suits, coats; also made in top weight for sleepwear, loungewear, shirts, sportswear, but this would normally be described as top-weight or shirting flannel (the Viyella trademark was long used only for a top-weight, twill weave flannel made of 55% lamb's wool blended with 45% cotton). Baize used for billiard or card table covers, drawer or display case linings.

Worsted, twill weave

NAMES

Welsh *gwlan,* meaning wool; *gwlanan,* fabric of wool, later called *flannel.* Bay (pl. bayes), from Old French *baie,* meaning brownish red, hence *baize* (Spanish *bayetta*).

ESSENTIALS

Wool family fabric, soft nap.

┌─────────────────────┐ ┌─────────────────────┐
│ ↑ │ │ ↑ │
│ │ │ │ │ │
│ warp or wales │ │ warp or wales │
│ direction— │ │ direction— │
│ lengthwise │ │ lengthwise │
│ grain │ │ grain │
│ │ │ │
│ Swatch Mount │ │ Swatch Mount │
└─────────────────────┘ └─────────────────────┘

Fabric Name **Fabric Name**

Flannelette, *also* Canton *or* Cotton *or* Kasha *or* Outing Flannel, Chamois, Cotton Duvetyn

FIBER CONTENT

Family: Cotton, imitating wool.

Present: Cotton, blends.

YARN, FABRIC CONSTRUCTION, OTHER

Carded-only yarn, weft thicker and softer twist than warp. Flannelette is plain weave, some of the others may be twill weave (firmer, stronger). All will be napped, on one or both sides.

WEIGHTS, USES

Flannelette is top weight, used for infants' wear, nightwear, sheets; the other names are connected with better-quality, closer-weave fabric and are used as well for shirts, sportswear, children's wear, linings, gloves.

Flannelette

Kasha flannel

NAMES

Flannelette, cotton flannel, cotton duvetyn all indicate the use of the cheaper fiber, cotton, to imitate wool family fabrics (see Flannel; Overcoats [2] Duvetyn). Canton flannel is similar, first made in Canton, China. Kasha flannel pushes the wool-like connection even further, suggesting cashmere fiber, while chamois suggests soft leather (see Leather).

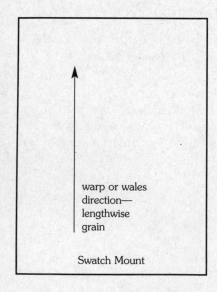

warp or wales
direction—
lengthwise
grain

Swatch Mount

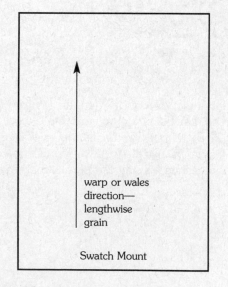

warp or wales
direction—
lengthwise
grain

Swatch Mount

Fabric Name

Fabric Name

Fleece Knit, Single Face (Sweatshirt Fabric), *includes some* Fleece (Lamb's Wool) Interlining (*see also* Fleece Knit, Two Face) (Fleece Woven see Overcoats)

FIBER CONTENT

Family: Cotton (not a historical fabric).

Present: Cotton and blends, usually with polyester, acrylic also used; the coat fabric boiled wool is made of wool or specialty hair or blends; a knitted or woven interlining fleece is made of wool, especially lamb's wool.

YARN, FABRIC CONSTRUCTION, OTHER

Simple sweatshirt fleece is made of carded yarn, weft knit on a special circular plain stitch machine, usually with extra-soft-twist yarn laid in to the back of the (finer) yarn doing the looping (see photo). The technical back of the fabric is later napped to give a soft, fuzzy surface.

Interlining fleece (also called lamb's wool) may be knit or an open weave, of soft spun yarn, napped (see photos).

WEIGHT, USES

Top to bottom weight, best known as sweatshirt fabric, and used for much other sportswear, loungewear, liners, toys. Another type of fleece (lamb's wool) is very light and sheer, used as interlining in winter coats.

Sweatshirt fleece

Interlining

NAME

Fleece is so named from the coat just shorn from a sheep, reflecting the fluffy softness of the wool on the inside of the fleece; lamb's wool is especially soft and light.

ESSENTIALS

Single face knit fleece is a circular weft knit, plain stitch with thicker, soft-twist yarn laid in the back, later napped.

107

warp or wales direction— lengthwise grain

Swatch Mount

Fabric Name

warp or wales direction— lengthwise grain

Swatch Mount

Fabric Name

Fleece Knit, Two Face, *includes* Berber, Boiled Wool

FIBER CONTENT

Family: Possibly wool.

Present: Much made of 100% polyester, some of it microfiber; cotton, acrylic may be used; the coat fabric, boiled wool, is made of wool or specialty hair or blends.

YARN, FABRIC CONSTRUCTION, OTHER

Usually carded (spun) yarn, weft knit on circular single knit loop machines that allow loops of pile yarn (extra to yarns knitting the ground) to be formed on one or both sides of the fabric; this gives a thick but light weight fabric. The many varieties of this type of fleece result from the yarns used, and (mainly) the subsequent finishing operations (see photo). Both sides of the fabric are usually sheared and/or napped to give a soft, fuzzy surface, but one side will probably have a more appealing finish than the other; this should be marked in working with the fabric, and of course, laid out in one direction as pile and napped fabrics must be. Some makes are treated to be pill resistant, and some others to be bacteriostatic (anti-odor). Finishing renders this knit fabric nonraveling.

Berber has become a term for a number of fabrics with pebbly or nubby surface textures, and so is used for some versions of two face knit fleece.

Boiled wool has a thick, soft-twist loop yarn, and is heavily fulled (felted) in finishing to give a warm and wind-resistant knit fabric that provides more wearing ease (comfort stretch) than woven overcoat fabrics.

WEIGHT, USES

Medium to medium-heavy weight, used for outerwear, sportswear, loungewear, casual wear, headwear and other accessories, liners, toys, interiors (cushions, footwarmer strip for bed, blankets and throws).

**Fleece Knit, Two Face
Solid Color**

Fleece Knit, Two Face printed

Boiled wool coat fabric

NAMES

Fleece is so named from the coat just shorn from a sheep, reflecting the fluffy softness of the wool on the inside of the fleece. Most of the many trademark names for two face knit fleece suggest the circumpolar regions and/or suitability for cold weather! One of the best-known has been Polartec® (by Malden) (see *Fabric Reference* under Knit Pile fabrics for a more detailed description of some of this type of knit). Berber is the name of a number of indigenous peoples of North Africa, mainly Morocco and Algeria, and who have made hand-woven wool carpets with a bumpy texture. Boiled wool is named from the vigorous finishing process.

ESSENTIALS

Two face knit fleece is a plain stitch weft knit, with loops laid in on one or both sides. The front and back can look and feel similar or different, but the fabric will be light and soft. Both this fleece and boiled wool, because knit, have more comfort "give" than woven outerwear or coat fabrics.

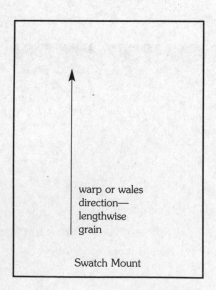

warp or wales
direction—
lengthwise
grain

Swatch Mount

Fabric Name

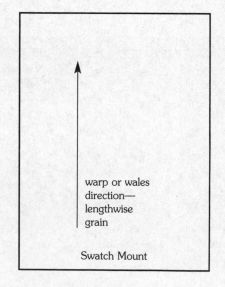

warp or wales
direction—
lengthwise
grain

Swatch Mount

Fabric Name

110

Flocked, *also* Suede-Like, Velvet-Like, Velveteen-Like

FIBER, YARN, FABRIC CONSTRUCTION

Flocking is a procedure in which short fibers are made to adhere to a fabric of any fiber, yarn, or fabric construction. Adhesive is either coated over the whole surface or printed on in a pattern, and then short fibers (*flock*) are shaken on, using mechanical agitation, or are aligned using an electrostatic field.

WEIGHTS, USES

Any weight, any use (see photos in this and the Dotted Swiss File). Flocked designs on fabric are used in dress and curtain fabrics, toys, shoes, hats. Novelty flocked designs are often not very durable, and flocked suede-like, velvet-like, or velveteen-like fabrics are usually quite stiff. However, modern adhesives can give very durable, flexible flocked fabrics, used for blankets, changing pads for infants, upholstery, etc. One example is the compound fabric with a flocked surface, Vellux® (by WestPoint Home, formerly WestPoint Stevens, see photo). Vellux is especially widely used for light, warm blankets, not only in home use, but particularly commerically, as in hotels.

Flocked ninon

Suede-like flocked

Vellux® (courtesy of WestPoint Stevens)

NAME

Old French *floc,* meaning a lock of wool, a small particle. Trademark name Vellux® from "vel," for velvet and "lux," Latin meaning light.

ESSENTIALS

Short fibers held to fabric surface with adhesive.

warp or wales direction— lengthwise grain	warp or wales direction— lengthwise grain
Swatch Mount	Swatch Mount

Fabric Name _____ **Fabric Name** _____

Fur-Like, Fake Fur, Faux Fur—Sliver-Knit Pile

FIBER CONTENT

Family: Not a historical fabric.

Present: Pile for coats, mats is usually acrylic/modacrylic blend, for flame resistance; nylon is also much used, e.g., for toys. The backing yarn may be cotton or polypropylene.

YARN, FABRIC CONSTRUCTION, OTHER

Sliver-knit pile, with the ground knit of carded yarn or split-film polypropylene. Weft knit on special circular plain stitch machines, with loose fiber from sliver knitted in to the back of the plain stitch. Dark-colored sliver, used to produce, e.g., a faux leopard effect, is usually solution-dyed fiber so that the color will not bleed if the fabric is over-dyed to give a range of background shades. A realistic look of real fur can be achieved with MF fibers, to give coarser fibers like "guardhairs" on the outside and fine fibers like "underhair" beneath. This is done by blending coarser fibers that have been stabilized with finer fibers that will shrink when steamed; after knitting, the fabric is steamed, and when the fine fibers shrink, they lie under the coarser ones. A coating is applied to secure the pile fibers.

Heat tumbling will tangle a long pile, giving a look like Mongolian lamb. Other effects can be produced in finishing, e.g., an embossed or sculptured surface.

There are other methods of producing knit fur-like fabrics: cutting (shearing) loops of pile yarn (see Velour Knit) and using a cut-pile yarn method on a raschel machine. There are also woven deep-pile fabrics, usually using a warp pile method.

Sliver-knit

Shearling, sheepskin look

WEIGHT, USES	Bottom weight and heavier; fur-like fabrics are used for loungewear, slippers, liners, coats, toys, mats.
NAMES	When marketed fabrics may be called, e.g., shearling look, or simply given the name of the fur being imitated, especially in this group: shearling, sheepskin, or sherpa (*see* Leather for detail).
ESSENTIALS	Usually sliver-knit pile, loose fiber caught into a plain stitch weft knit.

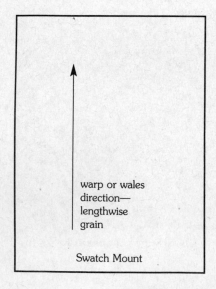

warp or wales
direction—
lengthwise
grain

Swatch Mount

Fabric Name

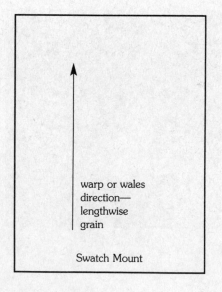

warp or wales
direction—
lengthwise
grain

Swatch Mount

Fabric Name

Gabardine (Gaberdine), Satin Gabardine, Venetian Cloth (*see also* Twill, Steep)

FIBER CONTENT

Family: Wool (venetian cloth possibly silk).

Present: Usually wool or blends of wool with MF fiber, sometimes cotton and blends, rarely silk.

YARN

Usually fine, combed (worsted if spun on wool system), warp 2-ply in high quality.

FABRIC CONSTRUCTION

Gabardine is warp-face twill weave, usually 2/1, right-hand for wool family fabric; sometimes cotton gabardine will be left-hand. The twill line may be regular or steep (see photos here). Diagonal wale line is clearly visible on the face only, but not so prominent as in Whipcord (see Twill, Steep). Venetian cloth may be the same or sometimes woven in a 4/1 satin weave, referred to also as satin gabardine (see Satin).

OTHER

Clear finish, twill line visible on face; venetian cloth has lustrous finish on face. Gabardine is usually piece dyed (solid color).

WEIGHTS, USES

Usually bottom weight for slacks, skirts, suits, uniforms, dresses, sportswear, coats, hats, especially rainwear (true to the derivation of its name!).

Gabardine—regular (45°) twill line Gabardine—steep (63°) twill line

NAMES

Medieval Spanish *gabardina,* meaning protection from the elements; a lustrous, polished finish was developed by the Venetians; thus the name *Venetian cloth.*

ESSENTIALS

Worsted type of yarn, warp-face twill weave, clear finish, wale distinct on face (not on back), but not so pronounced as in whipcord.

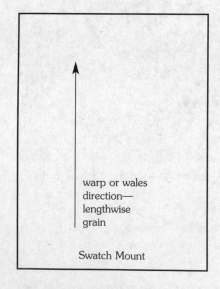

warp or wales
direction—
lengthwise
grain

Swatch Mount

warp or wales
direction—
lengthwise
grain

Swatch Mount

Fabric Name

Fabric Name

Gauze, *includes* Bolting Cloth, Bunting, Cheesecloth, Scrim, *plus, when stiffened,* Book Muslin, Buckram, Crinoline, Tarlatan (*see also* Madras Gauze, Voile [Filament]) (*see also* Leno for Gauze Weave)

FIBER CONTENT

Family: Silk for gauze, wool for bolting cloth, bunting, horsehair for crinoline.

Present: Cotton, often 100%, may be blends.

YARN, FABRIC CONSTRUCTION

Yarns carded only, plain weave, very loose and open (see Leno for gauze or leno *weave,* and for the fabric Madras gauze, which is leno woven).

OTHER

Heavily stiffened (sized) versions of gauze are: tarlatan—the most open, stiff and glazed, used for costumes, display, packaging; crinoline—used as an underslip to hold out full skirts; book muslin or buckram—used as a stiffening in bookbinding, millinery, lampshades, and (less today) as interfacing in heavy apparel like coats. Book muslin may be stiffened with starch, china clay, or pyroxylin.

WEIGHTS, USES

Sheer top weight, the most open weave used for gauze bandages; cheesecloth is circular woven, made for setting cheese curds, similar fabric sold for duster cloths; scrim is used as a cover or base cloth under upholstered furniture to cover springs and other structure, and in theatrical scenery; bolting cloth was originally made of wool, used for sifting flour (as was étamine, see Challis); bunting was also originally wool, used for flags and banners. More substantial versions of gauze are used for hot-weather, sports, and leisure wear.

Gauze

Buckram

NAMES

The city of Gaza, in the Middle East, was a center for sheer silk weaving thence the name *gauze,* French *gaze.* French *crin de cheval,* meaning hair of horse, the stiffness of crinoline achieved using horsehair. Old English *bontin,*

meaning to sift (flour), hence *bunting,* also associated with German *bunt,* meaning brightly colored. The derivation of *tarlatan* is uncertain.

ESSENTIALS Cotton type today, carded yarns, very open plain weave.

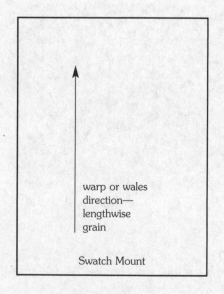

Fabric Name

Fabric Name

Gimp (Guimpe) "Braid"

FIBER CONTENT

Family: Silk overwrapping a core, probably cotton or wire.

Present: Wrapping is usually MF filament, often nylon or viscose around a thick core of the same fiber or cotton (occasionally wire).

YARN, FABRIC CONSTRUCTION

Not braided (hence listing as "braid"), this is a warp knit narrow fabric, from a raschel type of machine. On the back may be seen the vertical rows (pillars) of loops, made of yarn that may be spun or filament. The decorative yarn on the face, laid into and held by this knit, is a spiral or corkscrew novelty yarn, with a core of one thick yarn or group of yarns, or for some uses a wire. Gimp yarn has also been used in lace and embroidery.

USES

Gimp "braid" is used for trim on clothing, accessories, and upholstered furniture. The type with a wire core is used in display.

Spiral yarn on face

NAMES

Dutch *gimp,* French *guiper,* meaning to whip or wrap with silk. "Braid" here is a general term for narrow trims—the fabric is not *braided;* for true braiding, see Braid.

ESSENTIALS

Warp knit with narrow, spiral or corkscrew decorative yarns on the face.

warp or wales
direction—
lengthwise
grain

Swatch Mount

warp or wales
direction—
lengthwise
grain

Swatch Mount

Fabric Name

Fabric Name

Gingham, Tissue Gingham, Zephyr (*see also* Plaid)

FIBER CONTENT

Family: Cotton.

Present: Cotton and blends.

YARN

Best quality is fine, combed; gingham usually has checks woven with one color and white yarns, although by definition it can have stripes or even plaids; in tissue gingham, occasional heavier yarns outline the checks.

FABRIC CONSTRUCTION

Balanced plain weave, usually woven in checks, evenly alternating groups of (usually one) color with white, in both warp and weft (see photos). In tissue gingham, the ground is sheer, and a heavier yarn is used to mark off the blocks of color (see Rib Woven, Occasional). Zephyr, a fine grade of gingham, can have dobby or jacquard designs in the checks.

WEIGHTS, USES

Usually top weight, used for blouses, shirts, dresses, curtains; sometimes bottom weight, e.g., for tablecloths.

Checked gingham

Tissue gingham

Zephyr gingham

NAMES

Gingham is from the Malay *ging-gang,* meaning striped. *Tissue* indicates very light weight, as does *zephyr,* meaning a gentle breeze that hardly touches the skin, hence a light material.

ESSENTIALS

Cotton family, balanced plain weave, yarn-dyed, usually woven in checks—blocks of color alternating with white.

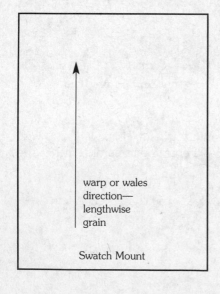

warp or wales
direction—
lengthwise
grain

Swatch Mount

Fabric Name

warp or wales
direction—
lengthwise
grain

Swatch Mount

Fabric Name

Herringbone, Chevron

FIBER CONTENT **Family:** Probably wool, affinity to twill pattern checks.

Present: Any, often wool and blends, used in classic fabrics.

YARN Any, usually spun.

FABRIC CONSTRUCTION 2/2 twill weave, line of wales reversing at regular intervals (see photo). There are various ways the reversal can be accomplished in this broken or irregular twill, and there may be differently colored yarns where the twill lines reverse, to make a striped herringbone.

WEIGHTS, USES Any, often bottom weight to heavy, used especially for suits, coats.

Herringbone tweed

NAMES, ESSENTIALS Broken twill weave, with wales alternating direction, balanced along vertical lines; resembles the backbone of a fish (herring) thus *herringbone*. French *chevron,* meaning rafter, an allusion to the shape of rafters meeting at the roof.

Fabric Name _____

Fabric Name _____

124

Interlock (*also called* "Double Jersey")

FIBER CONTENT	**Family:** Possibly cotton.
	Present: Cotton and blends; can be all MF fiber, usually polyester or nylon if filament fiber is used or acrylic when it is staple.
YARN, FABRIC CONSTRUCTION, NAMES	Fine yarn, spun (cotton) for interlock; when filament yarn is used, the fabric is often called "double jersey"—a misnomer—double it is, jersey it is not! It is doubleknit on a circular rib machine that forms wales on one side, directly behind the wales on the other. The resulting very fine 1 × 1 rib fabric does look like the face of a single plain stitch knit (see Jersey), but it has this look on both sides.
WEIGHT, USES	Top weight; interlock is the more stable T-shirt fabric, also used for polo shirts, pajamas, sportswear, leisurewear, and all kinds of casual wear: skirts, dresses, light slacks, coats. The silky filament form called "double jersey" is used for dressier but relaxed garments, and also for more formal women's wear, bridal and evening wear. Either version, though fine, has good stability and does not curl at the edges, as jersey does.

Interlock **"Double jersey"**

ESSENTIALS	Fine yarn, two feeds, knit on circular rib machine that forms the wales of the double 1 × 1 rib directly behind each other.

125

warp or wales direction—lengthwise grain

Swatch Mount

warp or wales direction—lengthwise grain

Swatch Mount

Fabric Name

Fabric Name

Jacquard Knit (*see also* Jacquard Woven)

**FIBER CONTENT,
YARN, WEIGHTS,
USES**

Any.

**FABRIC
CONSTRUCTION**

Usually weft knit machines, but can be warp knit; the jacquard control allows yarn feeds to be brought to any needle as desired, so intricate, usually multi-colored patterns can be knitted in. Designs from hand knitting are machine produced with jacquard control, such as Scandanavian "snowflake" or Fair Isle designs.

The photo shows plain stitch, single weft knit with jacquard design, while a doubleknit with this control may be seen in the Doubleknit File. In all cases, when a yarn is not looping on the face, it is carried in the back, so all colors are present at all points across the fabric. With a single knit, yarns not looping often form floats on the back (see photo); with a doubleknit, the yarns are held more closely, and the back has the birdseye look (see Doubleknit).

Electronic jacquard control of weft knit machines is ideally suited to rapid (economical) production of fad designs or those of possible fleeting interest, where it is always too time-consuming to make these by weaving. In days gone by, the same purpose was achieved using wood block printing, as in the famous toile de Jouy print that commemorated the first balloon ascent in France in 1783.

Single, plain stitch

NAME

See Jacquard Woven.

ESSENTIALS

Intricate, usually multicolor knitted-in pattern.

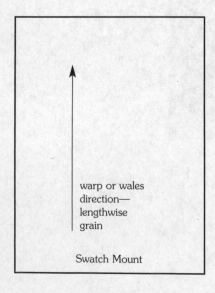

warp or wales
direction—
lengthwise
grain

Swatch Mount

Fabric Name

warp or wales
direction—
lengthwise
grain

Swatch Mount

Fabric Name

128

Jacquard Woven, Broché, Figured (*see also* Brocade [incl. Épingle Brocade, Lampas, Liseré Brocade]; Damask; Tapestry; *under* Ticking, Broché Coutil)

FIBER CONTENT

Family: Silk.

Present: Any.

YARN

May be filament or spun.

FABRIC CONSTRUCTION

Woven on a loom with a jacquard attachment, which traditionally uses cards—punched or not—to allow each warp to be controlled separately for each insertion of the weft; this makes it possible to weave any design, however intricate or large (by contrast, harness-controlled designs [see Dobby Design] are relatively small and hard-edged, not curving); it takes many rows to weave a smooth curve—as in creating computer graphics. Jacquard was actually the first to apply the binary system of control that governs telephone and computer systems, and the system adapts well to electronic control.

WEIGHTS, USES

Any, but it is the most expensive way to achieve an intricate and/or sweeping design in or on a fabric. These are therefore usually high-end materials, whether used in furnishings (drapes, upholstery, etc.), or in apparel (often evening wear). The three big-name fabrics that are jacquard woven are brocade, damask, and tapestry, each with separate Files in this *Glossary*; matelassé is often jacquard woven (see Matelassé).

Moiré pattern, woven

Snakeskin look

NAMES

The method of controlling warps was perfected by Joseph-Marie Jacquard in Lyons, France, during the period 1801–1810, to make raising of warp yarns in complex patterns automatic. Until he succeeded, a "draw boy" raised the warps at the weaver's command for each insertion of the weft. This was the method invented in China for the "high loom" used in weaving elaborate patterns or

figures in silks. In Europe, the draw boy sat at the side, not at the top of the loom, but it was still an onorous job. Jacquard built on previous significant French loom improvements but was the first to use punched cards.

Figures are often jacquard woven in fabrics less distinctive than brocade, damask, or tapestry, often smaller but still intricate and usually curving. Such fabrics may be named "figured Xyz" where "Xyz" refers to a name that could be applied to the background weave, such as figured crepe de chine. French *broché*, meaning stitched or embroidered, is also applied to a jacquard design in a fabric, for example, broché coutil (see Ticking). See also épingle and liseré brocade (Brocade), and palace satin.

ESSENTIALS Intricate woven design, can be curving and/or large.

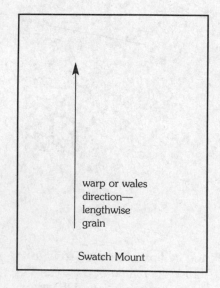

warp or wales
direction—
lengthwise
grain

Swatch Mount

warp or wales
direction—
lengthwise
grain

Swatch Mount

Fabric Name

Fabric Name

Jersey, *includes* Balbriggan, Lisle, Plain Stitch Single Weft Knit (*also includes* Purl Stitch) (*see* Interlock *for* "Double Jersey"; Tricot *for* "Tricot Jersey")

FIBER CONTENT

Family: Jersey: Wool.

Present: Jersey: Any natural or MF fiber. **Balbriggan:** Wool, cotton, and blends. **Lisle:** Long staple cotton.

YARN

Jersey: Spun or filament, fine or heavy. **Balbriggan:** Fine spun. **Lisle:** Fine, 2-ply, combed cotton yarn.

FABRIC CONSTRUCTION

Single weft knit, plain stitch. The face shows vertical lines (wales), while the back shows rows (courses) of crosswise lines (the round of the stitches) (see photo). Jersey is now often used with the (technical) back as the right side. The plain stitch that gives jersey is the simplest knit stitch, can be made flat or circular, and gives a lighter fabric than other weft knits. It has more stretch crosswise than lengthwise, so it fits the body closely. However, it curls at the edges, sags, shrinks, and runs or ravels the most readily of the knits. The **purl stitch,** done on another type of knitting machine, looks like the back of jersey on both sides.

OTHER

Balbriggan is usually given a light nap on the back, as it is used mostly for underwear ("long johns"). Lisle is mercerized and gassed (passed over a gas flame to burn off any fiber ends).

WEIGHTS, USES

Jersey is made from top weight to heavy. It is used for many kinds of apparel, from underwear to evening dresses, because of its body-fitting character. It is also used in bedding, giving smooth, soft sheets and pillowcases. Balbriggan is used mainly for underwear. Lisle is the smoothest, most lustrous cotton knit possible (closest to fine linen knit); it is used for high-grade sportswear and for stockings for those (few) who do not desire nylon and want something sturdier than silk!

Plain stitch

Lisle

NAMES Jersey got its name from Channel Isle of Jersey fishermen's knit sweaters. Balbriggan is a town just north of Dublin, Ireland. Lisle is perhaps named from the linen center of Lille in northern France.

ESSENTIALS Plain stitch single weft knit.

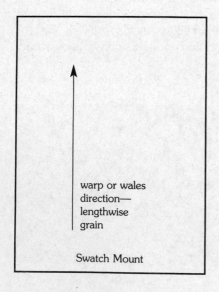

warp or wales
direction—
lengthwise
grain

Swatch Mount

Fabric Name

warp or wales
direction—
lengthwise
grain

Swatch Mount

Fabric Name

Lace, All Types

NAME Latin *laqueus,* meaning a noose, from which is derived *lace.*

TYPES Lace is an openwork fabric with a pattern or design in it. It evolved from (1) an elaboration of cutwork (like eyelet) or drawn threadwork, embroidered with buttonhole stitch, which developed, in sixteenth century Italy, into **needlepoint lace,** and (2) twisting and knotting cut warp yarns after weaving, which developed into **bobbin or pillow lace.** These are the two main classes of **handmade** lace. Some well-known names are described here; these, as well as the origins of lace, and **minor types** such as appliqué, Battenburg, Carrickmacross, crochet, filet (darned), Honiton, Paraguay, renaissance, tatted, and Tenerife are described in *Fabric Reference.*

 Forms of lace and **parts of lace** are also discussed in the *Fabric Reference; see* photos there and in this *glossary* below and pages following.

Needlepoint Laces: These are worked in buttonhole stitch over a parchment base, with an embroidery needle and (usually) fine linen thread; silk thread was also used for some. (Use caution in bleaching if you ever find antique lace or thread in case it is silk!). They include:

> *Alençon.* French, *fond simple* net ground, wrapped around with thread but still fragile, pattern usually flowers, outlined with raised *cordonnet* (outlining thread), which may have picots on it. A simpler construction with many of the same features is point de gaze, also called point de rose (but note that point de rose, rose point, or rosaline are names also given to the raised Venetian type described next).

Handmade Burano needlepoint lace, design/outlined with cordonnet
(Courtesy of Consorzio Merletti di Burano)

point de rose, rosaline, rosepoint. Venetian lace with small flowers, layered petals, involving raised cordonnets, joined by much-decorated brides. (What we call "Venetian point" today is like rosepoint—also what we call guipure—*see guipure* and Lace, Embroidered.) Gros point was of larger-scale design, more padded cordonnet with picots, giving a sculptured look. Point de neige had smaller designs, cordonnet the most built up with picots, and very elaborately decorated brides. Some Venetian laces had no cordonnet, e.g., point plat and coralline. Other types were Brussels rosepoint, point de gaze.

"Generic" point de gaze

**Point de rose, showing crown
with picots**
(Needle lace closeups courtesy of
Elizabeth M. Kurella)

warp or wales
direction—
lengthwise
grain

Swatch Mount

Fabric Name

warp or wales
direction—
lengthwise
grain

Swatch Mount

Fabric Name

Handmade bobbin lace

"Generic" Cluny edging

"Generic" Duchesse lace

guipure. Originally a braid; later a lace where the pattern was of bobbin-made or woven tape, which might be filled with stitching, joined together with brides (no net); still later, any bobbin or needlepoint lace of bold design with joining brides or open ground (no mesh ground); see Bruges under Bobbin Laces.

This application of *guipure* is made most often to embroidered (Schiffli) lace (see photos of Lace, Embroidered).

Bobbin Laces: These are made with threads twisted around each other, braided, plaited, or knotted, held in place with pins over a pattern on a curved bolster or pillow, the threads carried on (often weighted) bobbins. The interlacings have a woven or "clothy" look. In the following list, FL stands for Flanders (sixteenth to eighteenth century); FR for France.

Binche. FL; fine, smooth (no cordonnet), straight edges, spotted designs with *eye of partridge* fillings, separated from a *snowflake* ground by rows of holes.

Bruges. Nineteenth century Belgian guipure lace, with bobbin-made designs and fillings, held together with simple brides.

Chantilly. FR; often black; fine, hexagonal net ground; delicate designs (flowers, ribbons, vines); soft, silky, flat cordonnet; see photo Lace, Twisted.

Cluny. Nineteenth century English, based on old FR designs; firm and fairly heavy; simple, geometric patterns, often radiating wheel of *wheatears*; plaited border; narrow strips like railroad tracks go off in different directions ("divided trail").

duchesse. Nineteenth century Belgian; rather thick thread, simple floral and leaf designs; dense, "clothy" pattern, little cordonnet outline but leaf veins raised with heavier thread.

Mechlin or Malines. FL; similar to Val, but with silky cordonnet, no holes around the pattern.

torchon, beggar's. FR; sturdy, firm, usually narrow; simple, geometric patterns, central diamond may have "spider" inside, edges often scalloped like a shell or fan; special torchon type of diamond-shaped mesh ground, may have small spots (*tallies*).

Valenciennes or Val. FR; very fine thread used throughout design and ground (*fil continu*); same style of fillings and ground as binche, but later developed typical diamond mesh ground. Designs in Val (flowers or sprigs, later baskets) were more flowing than in binche, and had a row of tiny holes around each part of the pattern. Val-type (machine made) lace, soft and light, is often used for lingerie edging; see photo Lace, Twisted.

WEIGHT, USES Lace is usually a light fabric, as well as being open (sheer); a cotton Schiffli lace will, of course, be weightier than a fine nylon Valenciennes. Laces are used for lingerie, sleepwear, dresses (especially bridal), trim, curtains, table covers.

Today, virtually all the lace we use is **machine made,** by one of three methods: knitted, twisted, or embroidered.

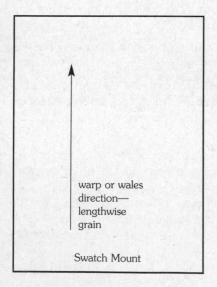

warp or wales
direction—
lengthwise
grain

Swatch Mount

warp or wales
direction—
lengthwise
grain

Swatch Mount

Fabric Name

Fabric Name

Lace, Embroidered (*mainly* Schiffli, aetz, burnt, or chemical type); Guipure, "Point" Laces

This File describes the Schiffli machine method that embroiders a design on net or fabric with 700–1,000 needles. If the design is allover and the ground fabric is subsequently either cut or dissolved away, the result is Schiffli lace. This method is particularly good to reproduce the look of handmade needlepoint laces made with a heavy, buttonhole stitch, textured pattern, and no mesh ground; motifs were connected with tie bars called *brides*. Lace we call guipure today is of this type (see photo), also rosepoint and some others of the "point" laces.

NAMES Swiss German *schiffli*, a little boat (German *schiff*, meaning ship), an allusion to the shape of the shuttle or bobbin carrying the embroidery thread in the machine developed in St. Gall, Switzerland, famous for embroidery. French *point*, meaning stitch (Italian *punto*). German *aetzen*, meaning to corrode or dissolve.

ESSENTIALS Lace formed by machine embroidery stitches, ground later removed.

Guipure lace medallion

Guipure lace allover

137

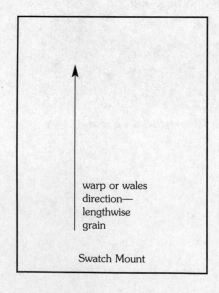

warp or wales
direction—
lengthwise
grain

Swatch Mount

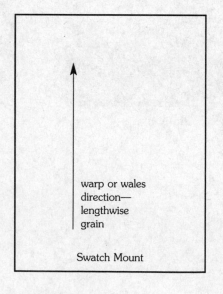

warp or wales
direction—
lengthwise
grain

Swatch Mount

Fabric Name

Fabric Name

This File describes the machine method used for most of the moderate-priced lace we use today: the raschel knitting machine (see NAME below, and also Raschel). Lace of any complexity of design can be produced by this method of warp knitting; however, since the yarns are looping in one plane, no great depth of texture is possible, compared to Schiffli embroidered lace or Leavers twisted lace. Few knit laces will have enough character to merit one of the needlepoint or bobbin lace names, but naturally this method can reproduce crochet lace well. It must be noted that the most modern raschel lace machines produce a very high quality product, e.g., luxury lace for lingerie.

In a knit lace, one can always see the vertical pillars of loops like crochet chains, with the pattern yarns laid in.

NAME

The principal machine type used to make most of the lace used today, *raschel*, can produce the widest variety of knit fabrics of all weights and textures, from sheerest lace to carpet (see Raschel), but its name has a romantic history especially connected with lace.*

Galloon form

"No name" Allover form

*Courtesy of Groz-Beckert KG, Albstadt, Germany.

Swiss-born Elisabeth Rachel Félix became a celebrated dramatic actress with the Comédie Française in Paris during the 1840s. Her fans admired the laces she wore as trim on her spencer jackets, and as wide stoles for evening. This created a demand for less expensive mass-produced laces. Improvements in Germany on warp knitting machines using two rows of latch needles resulted in successful products, marketed under her name. Eventually the machine bore it also, but with the German spelling "raschel."

ESSENTIALS Warp knit wales hold yarns that are laid in to make designs.

Fabric Name

Fabric Name

Lace, Twisted *or* Knotted (mainly Leavers *or* Levers *or* Nottingham *types*)

This File describes machine methods that imitate handmaking of lace by **twisting** yarns carried on thin bobbins around vertical threads moved by guide bars. The pattern is usually controlled by a jacquard mechanism, and can be extremely complex (more detailed information in *Fabric Reference*). The method, called *twisted* here, is termed *knotted* in many texts. The principal machine is the Leavers (Levers), although there are others of this type: barmen, bar warp.

NAMES

John Leavers (or Levers) of Nottingham, England, in 1813 made changes and improvements to the bobbin net machine (see Net). His developments allowed lace patterns to be produced with or without net background (see photos). Products of this machine are often called simply Leavers or Nottingham lace, as in lace tablecloths.

Leavers lace can closely imitate the handmade bobbin or pillow laces, and so can be given their names; when we do this, we should call one of these machine-made laces "Val type" or "Chantilly look," but it is usually described simply as Val or Chantilly lace. Leavers lace can also have great depth of pattern, to reproduce a needlepoint lace such as Alençon, with its mesh ground and heavy cordonnet; this cannot be imitated in embroidered lace and not at all well in knit lace.

ESSENTIAL

Yarns twisted completely around each other.

Val type edging

Bobbin-type edging with picots

Chantilly type

Nottingham bobbin type

warp or wales
direction—
lengthwise
grain

Swatch Mount

warp or wales
direction—
lengthwise
grain

Swatch Mount

Fabric Name

Fabric Name

Lamé, *also* Tissue/Cloth *of* Gold/Silver

FIBER CONTENT

Family: Metals (gold, silver, copper), as fine wire or beaten out into very thin sheets (*leaf*).

Present: Can be any fiber content, with the metal used usually aluminum (see Yarn).

YARN, FABRIC CONSTRUCTION

Lamé is a metallic effect, which can be any construction. It is most frequently achieved using metallic yarn (see photos of woven, knit below).

OTHER

Lamé effect may be achieved by applying metallic particles (often dispersed in a resin) to the fabric surface (see Coated).

WEIGHT, USES

Not usually heavy, may be top or bottom weight. Usually glitters or shines, giving a fairly glamorous or showy effect for evening or theater wear. Lamé is also used in more casual apparel such as knits, sportswear, or rainwear, and in interiors fabrics like drapes and upholstery.

Lamé knit

"Silver tissue" lamé woven

NAMES

French *lamé*, meaning trimmed with gold or silver leaf. French *tissu*, meaning a finely woven, usually sheer, cloth or fabric, hence gold tissue or cloth of silver.

ESSENTIALS

A fabric could be called lamé if it has a metallic effect and does not conform to any other classic fabric name—it is a general name. A brocade or a matelassé, for instance, may or may not contain metallic yarns; if a metallic fabric has a raised, jacquard-woven design (looking embroidered), then it should be called *brocade*. Similarly, if a metallic fabric has a puffed surface, it would merit the name *matelassé*.

143

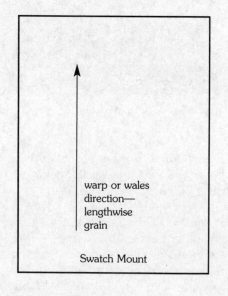

Fabric Name

Fabric Name

Leather, *includes* Chamois, Fur, Shearling, Suede (*see also* Flannelette, Sueded *for* Chamois; Flocked, Nonwoven *for* Suede-Like)

CONSTRUCTION, NAMES

Leather might be looked on as a "natural fabric," a material that is not manufactured, but is formed in nature as the skin of an animal (mammal, bird, reptile, amphibian, fish, etc.) that can be used as a textile. We preserve, stabilize, and soften skins and remove hair or feathers, by *tanning*. (With hair left on, and skin stabilized by *dressing*, it is generally called fur—exception noted below.)

Skin is made up of protein fibrils, set closer together on the outside; this is called the grain, and has the characteristic look of the animal skin, such as where the bristles grow in pigskin or the scales of snakeskin; it will also stand up better to wear than the less dense middle area (corium) or the flesh side, called suede (French *Suède*, meaning Sweden, known for fine kidskin suede gloves). The skin from large animals is termed *hide* (e.g., cowhide); that from smaller animals, *skin* (e.g., sheepskin).

Thick hides can be split into layers, with only the outside split having grain; this is called top grain leather, while the inside split layers have no grain (suede both sides). Inside split leather scraps, sewn into sheets (plates), are used for windproof interlinings in coats; this is called *chamois* (sometimes spelled *shammy*), from the fine, soft skin of a European mountain antelope-like animal. Better-quality soft suede from various animals may also be called *chamois* today, as is a napped cloth, both used for polishing.

Leather is embossed, dyed, or coated for many finishing effects. With the outer covering of hair left on, we call most skins *fur* (there are exceptions, such as *sheepskin*, also called *mouflon*, French for wild sheep; short-wooled skins are known as *shearling*—photo of shearling or sheepskin-look in Fur-Like. The style used by the Sherpa people of Nepal is called *sherpa*). Furs are preserved by dressing the skin, the equivalent of tanning.

Top grain
(Courtesy of SATRA Footwear Technology Centre)

Suede

ESSENTIALS Not manufactured but formed as skin by an animal; fibrous structure, preserved chemically, then used as fabric. When the outside layer is present, it is called top grain leather.

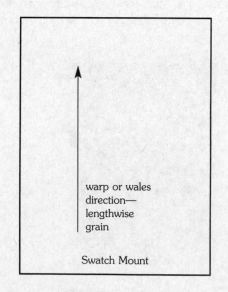

Fabric Name **Fabric Name**

Leno, Doup, *or* Gauze Weave, *also* Curtain Grenadine, Curtain Madras Grenadine, Madras Gauze, Madras Muslin, Marquisette, Mosquito Net, Thermal Cloth (Woven) (*see also* Dobby Weave—Openwork Effects *for* Mock Leno)

FIBER, YARN

Any. Originally silk filament (this unusual weave was fully developed in China by second to first century B.C.).

WEAVE

Leno weave is one in which one warp yarn of a pair is moved from side to side between interlacings of the weft (see photo); this is done with a doup attachment on the loom and is also known as gauze weave (developed originally using fine, strong silk filaments). This weave allows weft yarns to be held well apart without slipping, as they can in a very open plain weave; this openwork, ladder-like effect is called *latticed*. Compare a sample of leno (gauze) weave open fabric with the very open plain weave of the same name, gauze, as in bandages or cheesecloth (see Gauze). In thermal cloth, leno weave allows widely-spaced yarns for air entrapment, to give considerable insulation in a light-weight article. Leno weave is also used to hold selvages (see Selvage). Madras gauze or muslin is leno weave, with an extra, coarse weft cut away in some parts to leave figures woven in. Curtain grenadine and curtain madras are similar leno fabrics with extra-yarn figures or dots.

WEIGHTS, USES

Bottom-weight fabrics for drapes, coverlets, or thermal blankets; light-weight for curtains (see photo), mosquito netting. Light, fine marquisette is used for sheer curtains and evening or bridal wear and trim, as well as for millinery. Grenadine is an allover leno weave in hard-twist yarns for hot-weather blouses and dresses. Some leno may be incorporated, perhaps with clipped-figure eyelash effect, to create a cool, latticed, hot-weather clothing fabric with textural interest; the ground is usually batiste.

Curtaining

Grenadine

147

NAMES	Latin *duo*, meaning two (doup); French *marquée*, meaning a tent or its canopy entrance (marquisette); *grenadine* possibly from Grenada, Spain. For origins of other names see Gauze; Madras; muslin (under Sheeting).
ESSENTIAL	Leno weave.

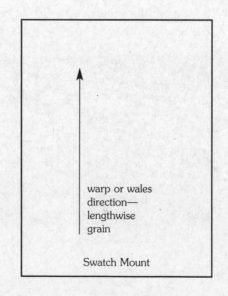

Fabric Name **Fabric Name**

(1) Linen, Linen-Like, Linen-Look, *also* Handkerchief *or* Tissue Linen (Linen-Like, Linen-Look), Butcher Cloth

FIBER CONTENT

Family: Flax; as well as being a fabric name, *linen* is a generic term for flax fiber, and to be called linen, fabric should be of 100% flax or at least 50% if a blend. Older names "linene" and "butcher linen" for linen-like rayon fabric are considered fraudulent now.

Present: Fabrics of many types of fibers with some or no flax may be called linen-like or linen-look, if they have slubs in both warp and weft and a linen-like hand. Rayon linen-like fabrics may be called butcher cloth from the older "butcher linen."

YARN, FABRIC CONSTRUCTION

Slubs in yarn both warp and weft, balanced plain weave usually quite close; character and texture come from yarns. Linen is less coarse than crash, while in turn is less coarse and open than burlap.

WEIGHT, USES

Linen is traditionally bottom weight, used for slacks, skirts, suits, dresses, and informal table linens. In much lighter weights, used for blouses, dresses, and unconstructed suits, it is often termed *handkerchief linen;* it will have more texture (slubs) than a truly fine handkerchief fabric like cambric. The very lightest may be called *tissue linen.*

OTHER

Often crease-resistant finish, especially with rayon linen-like.

Linen (bottom weight)

Handkerchief (tissue) linen
(top weight)

NAMES Latin *linum usitatissimum* ("most useful linum") is the species name for flax.
French *lin,* meaning flax. *Line* is the best-quality, longest flax fiber. Tissue
from French *tissu,* meaning a finely woven, usually sheer fabric. Butcher cloth
resembles the firm linen used for butchers' aprons.

ESSENTIALS Slub yarns both warp and weft, firm fabric in balanced plain weave.

Fabric Name

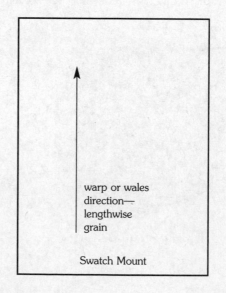

Fabric Name

(2) Crash, *also* Embroidery Crash (*also called* Art Linen, Embroidery Linen)

FIBER CONTENT **Family:** Flax, hemp, or jute.

Present: Flax, cotton, blends, may be wool, MF fiber.

YARN, FABRIC CONSTRUCTION, OTHER Thick, uneven yarns, balanced plain weave, coarse and somewhat open. Embroidery crash, also called art linen or embroidery linen, is made of smoother, round yarns (not flattened by pressing), which with the open weave allows yarn to be pulled out more easily for drawn-thread embroidery.

WEIGHT, USES Bottom weight to heavy, rarely top weight, comes between burlap and linen in degree of roughness or coarseness. Used for suits, dresses, table linens, drapes, slipcovers, towels, art needlework.

Linen crash

NAME Russian krashenina = colored linen toweling.

ESSENTIALS Coarse, fairly open plain weave, intermediate between linen and burlap in texture. Usually linen character, may be wool.

warp or wales direction— lengthwise grain	warp or wales direction— lengthwise grain
Swatch Mount	Swatch Mount

Fabric Name

Fabric Name

Lining Fabric—"No Name"

In Section One of *Fabric Glossary* the many materials used as linings are listed in one of the Fabrics According to End Use Categories. However, common lining fabric does not conform to any of those names, hence this entry.

FIBER CONTENT

Family: Silk.

Present: Viscose, cuprammonium (Bemberg®), acetate, triacetate, nylon, polyester; if silk, it could be called China silk (*see* Silk, Cultivated).

YARN

Filament, low twist.

FABRIC CONSTRUCTION, OTHER

Plain weave, fairly well balanced; usually solid color (piece-dyed).

WEIGHT, USES

Top weight, used (of course) for lining, sometimes for interlining, occasionally as an inexpensive fabric for apparel or costume use. A lining fabric gives some support, but it is there mainly to finish off the article (cover the construction lines) and (in a garment) to ease putting it on and wearing it. To accomplish this, linings are usually smooth, slippery, and soft to the touch. It is an advantage if they are absorbent, not harmed by perspiration, do not collect static, are strong with good abrasion resistance. Lining fabric of a filament lyocell could fulfill all these criteria.

Lining

NAME

The combination of fiber, yarn, fabric construction, and "other" described in this File yields nothing for this much-used and often-referred-to cloth other than *lining fabric*, so it has a file to itself, although there are also many "name" fabrics used in this way.

ESSENTIALS

Low-twist filament yarn, balanced plain weave, light weight, usually solid color.

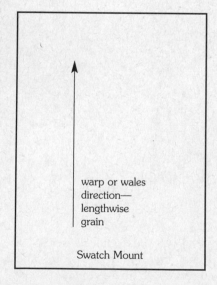

warp or wales
direction—
lengthwise
grain

Swatch Mount

Fabric Name

warp or wales
direction—
lengthwise
grain

Swatch Mount

Fabric Name

154

Loop Yarn (Bouclé, Bouclette, Curl, Gimp, Snarl, Spike), *includes the fabrics*
Astrakhan, Éponge, Poodle Cloth, Poodle Knit, Ratiné (*see also* Overcoats [3] Chinchilla, Ratiné Zibeline)

FIBER CONTENT

Family: Wool, other hair fibers, especially mohair.

Present: Any, often still mohair or wool; ratiné is often made of cotton or rayon.

YARN

Novelty yarn with effect component thrown out in loops at intervals; loops may be closed or open. Closed loops include: bouclé, which adds textural interest and warmth from air trapping—wiry mohair fiber makes an outstanding yarn of this type; bouclette, with a smaller loop; ratiné (gimp yarn), which not only has a tiny loop, almost a nub, but a rough surface; éponge, with a soft, spongy feel; and poodle cloth, which has a curly surface, as does astrakhan. Open loops include: snarl and spike yarns.

A loop yarn can also be created by air texturing MF filaments. A loop yarn may be a means of getting textural interest in glass or cellulose fiber yarns for drapery, which cannot be textured by heat setting.

FABRIC CONSTRUCTION, WEIGHTS, USES

Any construction. Loop yarn is knitted into sweaters, sportswear, accessories; woven wool family fabrics are used for suits, coats in bottom to heavy weight. Ratiné is top-weight woven, used for dresses and suits (*see also* Ratiné under Overcoats [3]).

Tweed

Ratiné

NAMES

French *bouclé*, meaning buckled, curled; *bouclette* (diminutive), meaning tiny loops. French *ratiné*, meaning frizzy; *éponge*, meaning sponge. Poodle cloth and astrakhan resemble the curly fleece of the poodle dog or the very young lamb from Astrakhan, which borders the Caspian Sea in Russia.

ESSENTIAL

Loops on fabric surface from yarn.

Swatch Mount

Fabric Name

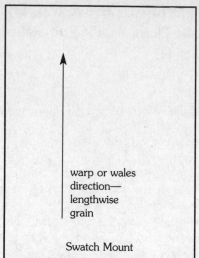

Swatch Mount

Fabric Name

Madras, Calcutta Cloth (*see* Leno *for* Curtain Madras; Dobby Design *for* Shirting Madras) (*see also* Plaid)

FIBER CONTENT **Family:** Cotton.

Present: Cotton, rayon, cotton blends, often with polyester.

YARN Usually carded only (not combed), yarn dyed.

FABRIC CONSTRUCTION Balanced plain weave, multicolor plaid, many specific patterns traditional when handwoven in India. Calcutta cloth is taken to be denser in weave and somewhat heavier.

COLOR Originally dyed with natural vegetable dyes which bleed (run) in washing; sometimes "bleeding madras" is sold, its attraction being the softness of the faded colors after washing. The Federal Trade Commission requires that the name madras be applied only to imported Indian fabric, colored with bleeding vegetable dyes. Others must be described to make clear they are different. Even when dyed with fast dyes (which will not run in washing), the colors will be subdued to look more like traditional madras.

WEIGHTS, USES Madras is top weight, used for shirts, dresses, sportswear, kerchiefs; Calcutta cloth is closer to bottom weight, for shorts, skirts.

Madras

NAMES Madras, now Chennai, is the capital of Tamil Nadu State in southern India; Calcutta is a city in the State of Bengal, northeastern India (possible confusion with Calicut, in Tamil Nadu).

ESSENTIALS Cotton family, yarn dyed, balanced plain weave plaid, soft, muted colors as if natural (vegetable) dyes were used, which bleed or run in washing.

warp or wales
direction—
lengthwise
grain

Swatch Mount

Fabric Name

warp or wales
direction—
lengthwise
grain

Swatch Mount

Fabric Name

Matelassé, Cloqué

FIBER CONTENT **Family:** Silk.

Present: Silk or MF filament for apparel; upholstery may be wool, cotton, or MF fiber.

YARN, FABRIC CONSTRUCTION, SURFACE Puffed, quilted, or blistered effect, with pockets of fabric raised above the ground; weave achieved in finishing by a combination of high-twist yarn and compound weave. Woven usually with two sets of warp and two of weft, which interchange at intervals, so that two layers of fabric are created, joined in many places. Weave may be dobby but is usually jacquard (larger or more intricate pattern). One set each of warp and weft are high- (crepe-) twist yarns which are woven mostly in the back of the fabric. In wet finishing, these crepe yarns shrink, causing the layer woven of other yarns to form a puff or blister in that area (see photos). The fabric is called matelassé when the puffed surface has definite raised pockets in the weave; cloqué has smaller raised blisters.

WEIGHTS, USES Expensive, showy fabric. Matelassé or cloqué evening dresses will be top weight, coats might be bottom weight, and medium to heavy matelassé is used for upholstery, drapes, bedspreads.

Cloqué

Matelassé, fabric face

Matelassé, fabric back

OTHER A matelassé effect can be achieved by fusing, gluing, or stitching together in places a layer of fabric to a layer which can be shrunk or which is elastic. A doubleknit can also imitate the two-layer puffed look of matelassé, as can embossing.

NAMES French *matelassé,* meaning padded; French *cloqué,* meaning blistered.

ESSENTIALS Puffed, blistered, or quilted looking surface.

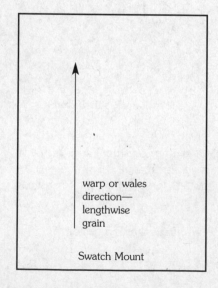

warp or wales
direction—
lengthwise
grain

Swatch Mount

<u>_____</u>
Fabric Name

warp or wales
direction—
lengthwise
grain

Swatch Mount

<u>_____</u>
Fabric Name

Moiré, Watered Silk

FIBER CONTENT **Family:** Silk; has been made with mohair (see Name below).

Present: Silk or MF filament (acetate, polyester, nylon, rayon), may have cotton in weft.

YARN, FABRIC CONSTRUCTION For traditional moiré, fine filament warp yarns are used, many more than weft, in a crosswise rib plain weave. Weft yarns may be nearly the same size as the warp or heavier. Moiré is usually a taffeta or faille, but there can be moiré grosgrain, etc. (see Rib Woven, Allover).

OTHER Wavy pattern in fabric like woodgrain or a watermark in paper (moiré is also called watered silk). Traditionally produced by pressing together two layers of cross-rib fabric; the ribs are not exactly aligned and so flatten each other at random, creating the pattern. The moiré will be durable if a thermoplastic fiber is used, pressed with heat. Moiré may also be woven in (see photo under Jacquard Woven) embossed, or printed on, or made visible (birefringence) by layering sheer, balanced plain weave fabrics like organdy or voile (see photo, Organza).

Moiré faille

WEIGHTS, USES Top or bottom weight; for uses see Taffeta and Rib Woven, Allover.

NAME French *mouaire,* meaning mohair, with which some moiré has been made.

ESSENTIALS Watermark or woodgrain pattern.

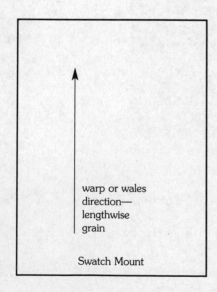

warp or wales
direction—
lengthwise
grain

Swatch Mount

Fabric Name

warp or wales
direction—
lengthwise
grain

Swatch Mount

Fabric Name

Net, as described in this file, is an openwork, mesh fabric, formed by twisting yarns around each other (see also Lace). The bobbinet machine produces a six-sided (hexagonal) mesh; other machines make mesh with four sides (see photos). Net fineness is expressed as hole count: the number of holes in a straight line, plus the number in a diagonal line. Net is also produced by knitting (see especially Raschel Knic).

FIBER, YARN, WEIGHTS, USES

Net is still made for fishing, and has been employed for hunting, but for consumer products it is mostly used for crinolines, bridal and evening wear, veiling, trim, and curtains. Cotton is used, but fine bridal net like illusion or tulle and millinery trim net like Malines are often made of fine filament nylon, as well as the traditional silk. Net with small dots all over is point d'esprit; the best has embroidered dots, some dots are flocked, and some today are made along with the net, and do not have much distinction. Cape net, used in millinery, is a fairly thick net, heavily sized with, for instance, starch. When dampened, it can be shaped and will hold that form when dry (see photo).

Point d'esprit

Bobbinet

Other net structure

Cape net

NAMES

Bobbinet is named for the bobbin net machine developed by John Heathcoat by 1808 which could twist yarns in the manner of hand bobbin lace making, and made wide net fabric very quickly. Illusion is so-named probably because it is "barely there"; *tulle* is from the French town of Tulle where net was made; *Malines* is from the Belgian town of Malines (Mechelen).

ESSENTIAL

Yarns twisted around each other to make an open mesh.

warp or wales
direction—
lengthwise
grain

Swatch Mount

warp or wales
direction—
lengthwise
grain

Swatch Mount

Fabric Name

Fabric Name

FABRIC CONSTRUCTION	*Nonwoven* is a term used in the United States for fabrics made directly from fibers, but not by the felting of wool or hair fibers. The fabric made from the inner bark of trees—tapa or bark cloth—could be considered "nonwoven," but is usually excluded. A quality brochure from an exhibition, "Cloth That Grows on Trees," has ten color photos and an article by the curator; *see* www.textilemuseum.ca. (A photo of tapa can be seen in *Fabric Reference*.)

In a sense, leather, too, comes roughly into this group of nonwoven fabrics, except that it is not manufactured, and so is not classified as a textile, although referred to in *Fabric Reference* as a "natural fabric." See also Leather.

USES

The scope of use of nonwovens has grown greatly, and a brief summary only is possible here; for a more complete coverage, consult the most recent edition you can find of a text, e.g., *Fabric Reference,* Fourth edition (2009). The uses open up as the methods of producing nonwovens become more sophisticated, as with inclusion of nanofibers. In general they encompass medical uses for absorbent disposable materials that can be antimicrobial; various uses in automobile manufacture; geotextiles; principal fabrics, linings and interlinings in apparel and in furnishings (the latter for bedding, upholstery, and carpets, etc.), plus many other applications.

TYPES

Bonded fiber web: Made with thin sheets or webs of fiber held together by chemical binders or heat fusing; examples are many interfacings and interlinings (using mostly nylon or polyester) such as Vilene® (by Freudenberg), as well as fabrics like J-Cloth® (rayon) for household use and others for table fabrics.

Spunbonded: Formed by bonding MF fibers after extrusion, or staple fibers in webs.

Spunlaced (hydroentangled): Made by tangling filaments after spinning, or by hydroentangling webs of staple fibers such as cotton, to give a fabric that works well in the water jet process, is absorbent for medical uses, and non-irritating.

Needled (needlewoven needlefelt, needle-punched): Made by punching fine barbed needles in and out of a fiber batt or web, tangling some of the fibers. Needling is also sometimes involved in processes to make nonwoven suede-like fabrics that leave microfibers on the surface; this gives the very soft hand of real suede as ordinary fabrics cannot. One of these, under the trademark name of Ultrasuede® (by Toray [America]) is well-known in apparel fabrics, while Alcantara® is used for luxury car upholstery.

Stitchbonded, no yarns: Made possible by forming the fibers of a web into stitches on machines of the Malimo type (see Stitchbonded).

ESSENTIAL Usually fibers but no yarns in the fabric structure.

**Spunlaced fusible
interfacing**

Ultrasuede® microfibric surface

warp or wales
direction—
lengthwise
grain

Swatch Mount

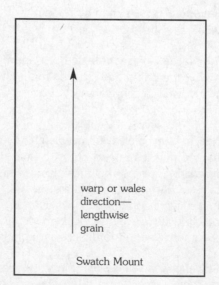

warp or wales
direction—
lengthwise
grain

Swatch Mount

Fabric Name

Fabric Name

(1) Organdy (Organdie)

FIBER CONTENT	**Family:** Cotton.
	Present: Best quality is 100% cotton, may be blends, e.g., with polyester.
YARN, FABRIC CONSTRUCTION	High-quality organdy is made of fine, combed yarns, which may be high twist; lower-quality yarns are carded only. Balanced plain weave, very thin fabric, which is definitely sheer after finishing.
OTHER	Crisp finish; in the best-quality organdy, crispness is given by an acid treatment; lower qualities may have starch, resin, or other stiffening added.
WEIGHTS, USES	Sheer, top weight, used for blouses, dresses (including girls' party dresses), evening and bridal wear (especially for hot weather), trim (collars and cuffs), curtains.

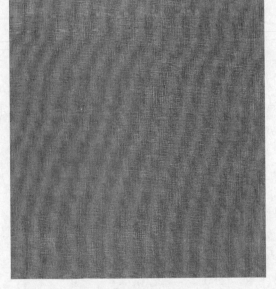

Organdy Organza

NAME	French *organdi,* meaning book muslin (very stiff muslin; see Gauze).
ESSENTIALS	Cotton family, sheer, crisp, balanced plain weave.

```
┌─────────────────────┐        ┌─────────────────────┐
│                     │        │                     │
│          ↑          │        │          ↑          │
│          │          │        │          │          │
│          │          │        │          │          │
│          │          │        │          │          │
│   warp or wales     │        │   warp or wales     │
│   direction—        │        │   direction—        │
│   lengthwise        │        │   lengthwise        │
│   grain             │        │   grain             │
│                     │        │                     │
│   Swatch Mount      │        │   Swatch Mount      │
│                     │        │                     │
└─────────────────────┘        └─────────────────────┘
```

_____ _____

Fabric Name **Fabric Name**

(2) Organza, Mousseline de Soie (*see also* Voile [filament] *for* Ninon)

FIBER CONTENT

Family: Silk.

Present: Silk, more often MF filament, usually polyester for apparel.

YARN, FABRIC CONSTRUCTION, WEIGHT

Fine filament yarn, balanced plain weave, sheer. Traditionally, high-twist plied silk yarn (organzine) was used for organza. Coarse, lobal monofilament MF fiber gives "sparkling organza."

OTHER

Organza and mousseline de soie are crisp. Other filament yarn fabrics which are also plain weave and sheer are soft, not crisp: Ninon or voile (filament) is soft; chiffon is very light and soft; georgette and chiffon are also dull and crepey.

USES

Lingerie, party and bridal wear (often the ground for burned-out patterns and embroidery), neckwear, trim, millinery, curtains.

NAMES

Organzine is warp yarn in the silk trade, 2-ply high twist for strength. French *mousseline de soie,* meaning silk muslin.

ESSENTIALS

Filament, sheer plain weave, crisp.

warp or wales
direction—
lengthwise
grain

Swatch Mount

Fabric Name

warp or wales
direction—
lengthwise
grain

Swatch Mount

Fabric Name

170

Overcoats or Interiors Fabrics, Warm, Woven (*see also* Boiled Wool *under* Fleece Knit, Two Face)

These textiles are medium to heavy in weight, and "woolly" in hand and appearance, even if not made with or entirely of wool. They have been used much more for overcoats and jacket/coats for cold weather than for interiors, and there, mostly as blankets.

The first three Files record coat materials, divided as to amount of nap on the surface. These have each been headed by one well-known name:

1. **Melton,** shows virtually no nap.

2. **Duvetyn,** nap is visible, soft and fairly short.

3. **Woven fleece,** shows a long, hairy nap on the face, brushed in one direction.

 Some fabrics are hard to fit into one of these sub-Files. Chinchilla and ratiné are unusual coat fabrics, and so are difficult to classify; they have been "filed" under (3). Blanket cloth was listed arbitrarily under (2), although some examples might qualify for another description, since blankets differ widely in softness of fiber and in surface finishing. (*See also* [4].)

 Given a separate File description here is:

4. **Mackinac,** distinct from the overcoat materials, widely used for heavy "lumberjack" sports shirts/jackets, but originating as a blanket.

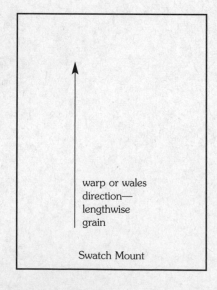

warp or wales
direction—
lengthwise
grain

Swatch Mount

Fabric Name

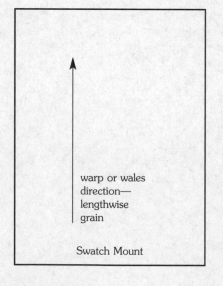

warp or wales
direction—
lengthwise
grain

Swatch Mount

Fabric Name

Overcoats

(1) Melton, *also* Blazer Cloth, Duffel, Frieze, Kersey, Molleton, Wadmala

FIBER CONTENT

Family: Wool.

Present: Wool or wool blends, often with nylon; warp may be cotton.

YARN, FABRIC CONSTRUCTION, OTHER

Carded (woolen spun) yarn, woven in plain (right-hand) twill or even compound weave; fabric dyed solid colors. Closely sheared nap, both surfaces heavily fulled (felted) in finishing, so fabric resembles felt. The result is a fabric without much luster, which resists soiling and wear, tailors well, and, for coats, is warm and virtually windproof. Kersey shows a little more nap (more lustrous), but is quite similar. Wadmala is a felted, coarse, twill-woven fabric made in Scandanavian countries.

WEIGHTS, USES

Some melton is bottom weight, used for slacks and jackets (see Names), and blazer cloth has similar characteristics. Melton is better known, however, as a winter coat fabric, with duffel and frieze very similar. These fabrics are also used for uniforms.

Melton

NAMES Jackets of this fabric were worn for fox hunting in Melton Mowbray, Leicestershire, England; *Molleton* is the French name. Kersey is a village in Suffolk noted for woolen cloth from the fourteenth century. Duffel is a Belgian town noted for this type of cloth, used in World War II to make "duffel coats" for seamen. Frieze was produced in Friesland, Netherlands. (See note on misspelling of the very different fabric frisé in the Velvet File.)

ESSENTIALS Woven wool fabric, napped, sheared, heavily fulled both sides, looks like felt.

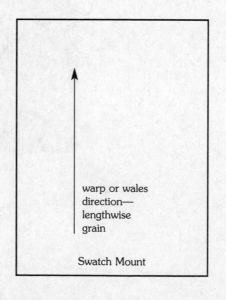

Fabric Name **Fabric Name**

(2) Duvetyn, *also* Blanket Cloth, Coachman Cloth, Doeskin, Loden, Peau de Pêche, Polo Cloth, Velour (Napped) (*See also* Sueded *for* Silk "Doeskin")

FIBER CONTENT

Family: Wool, fairly fine (soft).

Present: Wool or wool blends, often with polyester or nylon.

YARN, FABRIC CONSTRUCTION, OTHER

Carded (woolen spun) yarn, soft-twist weft; usually weft face (right-hand) twill weave; fabric usually dyed a solid color. Napped, sheared, and fulled in finishing, to leave a short, soft nap visible on the finished fabric, covering the weave. The surface is softer than fabrics in the Overcoat (1) File, and there is some luster. The hand is softer and the nap is not so long as on fleece or the other fabrics in the Overcoat (3) File. Blanket cloth might fall in either this or the Overcoat (3); see also Blanket Cloth in Overcoat (4) File, as it sometimes has more or less nap and is more or less soft.

WEIGHTS, USES

Bottom weight to heavy, used for suits, uniforms, jackets, coats. Blanket cloth, of course, was originally and still is used for blankets, but also for coats, notably the Hudson's Bay "point" blankets, that have been used to create classic coats and jackets, plus other apparel and accessories. See blanket cloth as sports shirt/jackets in Overcoat (4).

Duvetyn

NAMES

French *duvet,* meaning down; *peau de pêche,* meaning peach skin, often called simply "peached" (see Sueded); *velours,* meaning velvet, all from the short, soft nap on the surface of duvetyn, peau de peche or velour. This fabric was used for coachmen's caped coats and for polo coats; thus these names. *Doeskin* presumably comes from the hand, like the suede side of the soft skin of a female deer. The word *blanket* comes (maybe) from the French *blanquette* (diminutive of *blanc,* meaning white), an undyed woolen cloth used for coverings, or—a derivation with a lot more human interest—from the

name of Thomas Blanket, a Flemish weaver who produced cloth in Bristol in the reign of Edward III (fourteenth century). This was the king who was nicknamed "the royal wool merchant" and did encourage Flemish weavers to settle in England, among his many activities to support what would become the basis of the English economy for many years. Loden, originally made in the Tyrol mountainous area of western Austria from coarse mountain wool, gets its name from the Old German *loda*, meaning hair cloth. The most characteristic dyed color is an olive, known as *loden green*.

ESSENTIALS Woven wool fabric with a short, soft nap on the surface.

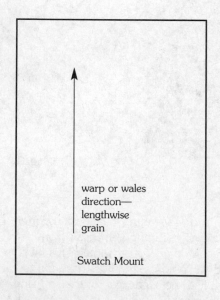

warp or wales direction— lengthwise grain

Swatch Mount

Fabric Name

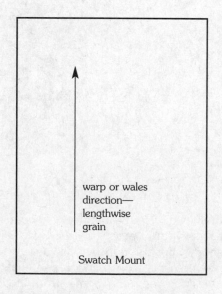

warp or wales direction— lengthwise grain

Swatch Mount

Fabric Name

(3) Fleece Woven, *also* Beaver, Broadcloth (Wool), Chinchilla, Elysian, Mouflon, Ratiné Zibeline (*see also* Fleece Knit, Single Face *for* Fleece *or* Lamb's Wool Interlining) (*see also* Ratiné *under* Loop Yarn)

FIBER CONTENT	**Family:** Wool, from fairly fine (soft) to coarser.
	Present: Wool, specialty hair (mohair, camel, alpaca); blends, especially with nylon; warp in some may be cotton.
YARN, FABRIC CONSTRUCTION	Carded (woolen spun) yarn, soft-twist weft; usually weft-face (right-hand) twill or satin weave (*see also* Ratiné under Loop Yarn).
OTHER	Noticeable, often lustrous, soft nap—longer than the fabrics in the Overcoat (2) File, nap brushed in one direction. Fleece and beaver have the longest, soft nap. Elysian has a deep nap or pile, made to form a ripple pattern. Wool broadcloth has the finest, softest, most subtle nap. Zibeline (zibelline) also has a soft, lustrous nap, and is usually black in color. Chinchilla cloth and ratiné, after many finishing procedures, including rubbing in a circular motion, develop surface nubs or curls. Mouflon is a name given to an equivalent of shearling (see Leather), but which has emerged as a name for a jacket fabric with a nap just slightly longer than that of fabrics in the Overcoat (2) File.
WEIGHTS, USES	Wool broadcloth is bottom weight but is the lightest of these fabrics, used for suits, uniforms, light coats, and more for women's wear than men's wear. Mouflon is used in jackets; the rest are usually medium heavy to heavy weight for winter overcoats or hats.

Woven fleece

Chinchilla

Elysian

NAMES

For fleece, the coat just shorn from a sheep, as in Fleece Knit, but in this fabric reflecting the shaggy look of the outside of the fleece. Real beaver hair is used for felt and napped fabric. Broadcloth, see Broadcloth (Cotton). *Elysian* is from *Elysium,* in Greek mythology the place of perfect happiness for the dead. French *mouflon* meaning wild (long-haired) sheep, found in the mountains of, for instance, Sardinia (see also Leather, for mouflon with the more usual meaning equivalent to *shearling*). Zibeline is a Siberian sable with soft, silky fur. The fabric chinchilla with a wavy curl does not at all resemble the very soft fur of the chinchilla, a small South American mammal. French *ratiné*, meaning frizzy.

ESSENTIALS

Woven wool family fabric; nap, usually long and lustrous.

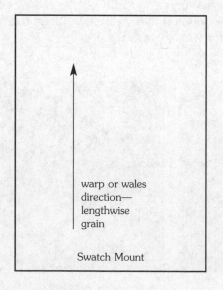

Fabric Name

(4) Mackinac *or* Mackinaw Cloth, Lumberjack *or* Jac Cloth, *also* Buffalo Cloth *or* Buffalo Check

FIBER CONTENT	**Family:** Wool, fairly coarse.
	Present: Usually coarse wool or wool blend (warp may be cotton). The name buffalo check is now given to a similar design on plain weave cotton shirt or dress fabric.
YARN	Carded only, yarn dyed.
FABRIC CONSTRUCTION, OTHER	Woven in large plaid or check, traditionally 2/2 right-hand twill weave (see Check, Twill Weave), heavily napped on one or both sides.
WEIGHTS, USES	Made originally for blankets, now used mainly for heavy sports shirts/jackets (lumberjackets) and coats.

Buffalo check Mackinac

NAMES	This type of blanket was used in North America by Europeans for trading with Indians and takes its name from a prominent trading post at the Straits of Michilimackinac (shortened to Mackinac, pronounced "mackinaw"), between Lakes Huron and Michigan; buffalo cloth nap probably suggested shaggy buffalo fur; this fabric was used by lumbermen (lumberjacks).
ESSENTIALS	Coarse wool, 2/2 twill weave plaid or check, heavy nap.

179

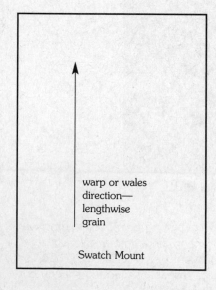

warp or wales
direction—
lengthwise
grain

Swatch Mount

Fabric Name _____

warp or wales
direction—
lengthwise
grain

Swatch Mount

Fabric Name _____

180

Oxford Cloth, *includes* Oxford Chambray

FIBER CONTENT

Family: Cotton.

Present: Often still 100% cotton, may be a blend, e.g., with polyester, or made of other MF fibers, e.g., rayon.

YARN, FABRIC CONSTRUCTION

Usually 2 × 1 basket plain weave, warp is two finer yarns carried as one, weft is a single yarn, thicker than the warp and softer twist (see Basket Weave). If warp yarns are dyed and weft undyed, the fabric is called oxford chambray (see photo).

WEIGHTS, USES

Top weight, important shirting fabric, also used for dresses, sportswear, and pajamas. Because of the porous basket weave and soft finish, 100% cotton can be used to give a very comfortable tailored shirt, for instance, that does not crush easily and needs very little ironing, even without a Durable Press finish.

Tattersall check—
2 × 1 basket weave

Oxford chambray—
2 × 1 basket weave

NAMES

Recorded as being either (1) one of a group of shirting fabrics made by a Scottish firm and given names of famous universities, or (2) simply popular with students at Oxford University. For origin of *chambray* see Chambray. For origin of *Tattersall* (above) see Check, Twill Weave.

ESSENTIALS

2 × 1 basket plain weave, weft softer twist, thicker than warp, top (shirting) weight.

warp or wales direction—lengthwise grain	warp or wales direction—lengthwise grain
Swatch Mount	Swatch Mount

Fabric Name

Fabric Name

Paisley (Design Motif)

FIBER CONTENT

Family: Fabric in this design was originally made of cashmere (goat) under-fleece.

Present: One of the most universally used design motifs. Can be any fiber content.

YARN, FABRIC CONSTRUCTION

Any.

WEIGHTS, USES

Any apparel, men's, women's, children's wear, underwear, nightwear to outerwear, or any household or interior decorating textile, from bedding to towels, napkins to oven mitts, curtains to carpet!

Paisley print

Drawing of stylized pine cone or paisley pattern based on Indian "Kalka" design.
(Courtesy of Arthur Sanderson & Sons)

183

NAME

The Scottish town of Paisley was most successful in producing a product in the style of the very expensive shawls from Kashmir, introduced into Europe by the East India Company from the mid-eighteenth century. These shawls were handwoven, with designs either tapestry woven or embroidered, using the fine undercoat or "down" (called *pashmina* from the Persian for wool) of the Himalayan cashmere goat. Many European companies worked to duplicate the fine, soft, light yet warm shawls with their exotic designs, eventually using cashmere spun around silk for warp and fine wool for weft. By the mid-nineteenth century Paisley had established itself as foremost in shawl production, using jacquard looms; the distinctive design, no matter how produced, has become known as a *paisley* pattern.

ESSENTIAL

Variously also called *pine, pine cone, tadpole*, and *mango fruit*, this design motif is thought to have come from Chaldea (Babylon) and derive from the growing shoot of the date palm. There is a drop-shaped area with a curled-over point, which, with the areas between motifs, can be filled with fine floral and foliage patterns (see drawing). From the first Kashmir shawls (late seventeenth century) through to the eighteenth century impact in Europe, the design developed into the *buta* shape of a closely packed "vase" of flowers, then became increasingly stylized and affected by European taste (see photo).

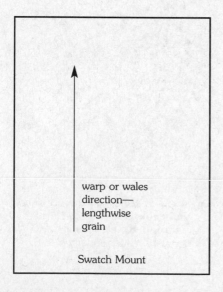

warp or wales direction—lengthwise grain

Swatch Mount

Fabric Name

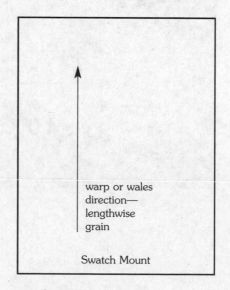

warp or wales direction—lengthwise grain

Swatch Mount

Fabric Name

Two major methods of producing a surface pattern on a fabric by application of a chemical are discussed in the following Files, each headed with a well-known name: Burned-Out or Plissé.

(1) Pattern Applied—Chemical, *includes* Burned-Out (Burn-Out, Burnt-Out), Etched (Coupe de Velours, Dévoré or Façonné Velvet, Satin or Voile Découpé)

FIBER CONTENT

Family: Based on elaborate silk family fabrics.

Present: Must contain two fiber types, one of which is removed by a treatment that does not affect the other fiber type.

YARN, FABRIC CONSTRUCTION, OTHER

Usually compound woven, ground is often sheer, plain woven of filament, with extra yarns forming floats or a pile on the face. The extra yarns are made of a fiber that will be dissolved ("burned out," "etched") by a chemical that leaves the others unaffected. The chemical is printed on, so that portions of the face yarns are dissolved, allowing the ground to show.

An example is a ground of silk organza, with pile or surface floats of acetate; acetone printed on will dissolve parts of the surface, leaving the sheer ground.

WEIGHTS, USES

Top or light bottom weight, used for elegant and elaborate dresses for "after five," evening, or bridal wear, and in sheer curtains.

Façonné velvet

Satin découpé

NAMES

Coupe de velours, satin découpé, or *voile découpé* (French *couper*, meaning to cut) suggest that part of the velvet (French *velours*) or other fabric was cut away. It probably was cut originally; today the etched or burned-out method is used. French *façonné*, meaning patterned, but in *façonné velvet* it means not simply patterned, but burned-out pile. *Dévoré velvet* (French *dévoré* means eaten away, devoured) may not sound elegant in literal translation, but the fabric is!

ESSENTIALS

Usually a compound weave, ground fabric composed of a fiber type unaffected by the chemical that dissolves the fiber used in surface yarns, or same effect achieved with complex yarn wrapping and core.

Fabric Name

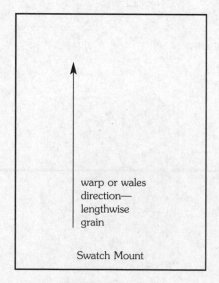

Fabric Name

(2) Pattern Applied—Chemical, *includes* Plissé, Crinkle Crepe, Seersucker Look

FIBER CONTENT **Family:** Cotton.

Present: Still 100% cotton.

YARN, FABRIC Yarns usually carded only in a fairly balanced plain weave.
CONSTRUCTION

OTHER Caustic soda (sodium hydroxide) is applied to parts of the fabric; these areas shrink, so that the rest of the material puckers. The chemical treatment may be in lengthwise strips, giving a seersucker look, or all over in any design, when the fabric is called crinkle crepe or plissé.

WEIGHTS, USES Top or bottom weight, used for summer nightwear in particular, but also for lingerie, children's wear, shirts, sportswear—any casual, hot-weather clothing; also used for curtains and bedspreads. Plissé offers the comfort of a 100% cotton fabric, yet because it is *intended* to have a crinkled look, requires little or no ironing without any Durable Press finish. The crinkle is permanent, but flattens in wear more easily than true seersucker, especially if the fabric is not firmly woven.

Plissé—seersucker look

NAME French *plissé*, meaning pleated, wrinkled, or crinkled.

ESSENTIALS Cotton plain weave fabric with crinkled, puckered areas; may look like seersucker.

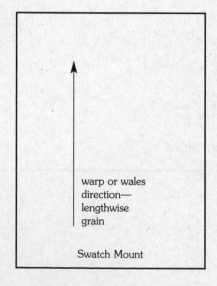

warp or wales
direction—
lengthwise
grain

Swatch Mount

warp or wales
direction—
lengthwise
grain

Swatch Mount

Fabric Name

Fabric Name

A surface pattern can be achieved on a fabric by application of pressure. With heat and/or binding chemicals used, such an effect can be durable or permanent. Some possibilities are discussed here.

Pattern Applied—Pressure, *includes* Crushed, Embossed, Fluted, Gauffered (Goffered), Pleated

FIBER, YARN, FABRIC CONSTRUCTION

Embossing is a finishing procedure which may be applied to fabric of any fiber, yarn, or fabric construction, including the "natural fabric" leather. The material is stamped or passed through engraved rollers, to impress a design which will stand up in relief on the surface. The rollers are usually heated, and with thermoplastic materials the design will then be permanent (e.g., the vinyl-coated material shown in the photo); if a resin coating is used with cotton fabrics, the design can be durable (e.g., embossed muslin). Pile fabrics, such as velvet or corduroy, can be embossed so that part of the pile is pressed flat.

Fabric can be *crushed* in finishing (random unevenness). Pressing into rounded folds gives *fluting*, into sharp folds, *pleating* (older terms *gauffering* or *goffering*). Pressure and heat are involved in all of these as a rule.

WEIGHT, USES

Any weight, any use. In light fabrics the embossed design may imitate jacquard woven patterns; most leather-like fabrics have a grain effect embossed on them (see photo of snakeskin look under Coated)—used for clothing, accessories (shoes, handbags, gloves), and upholstery.

Vinyl-coated knit

189

NAMES *Emboss* is from the Old French *embocer*, meaning to cause to bulge, hence, to carve or mold in relief; a *boss* is a protuberance. French *gaufre*, meaning honeycomb gives *gaufrer*, to pleat, crimp, or flute—in English, gauffer or goffer (Crimped book edges are also called gauffered.)

ESSENTIALS Fabric surface with raised pattern, impressed by engraved rollers.

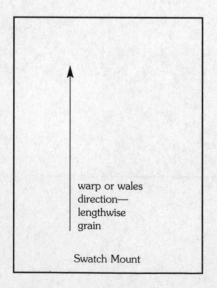

warp or wales
direction—
lengthwise
grain

Swatch Mount

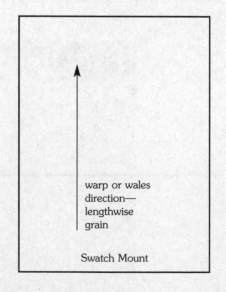

warp or wales
direction—
lengthwise
grain

Swatch Mount

Fabric Name

Fabric Name

Pattern in Yarns or on Dyed Ground

Ancient methods of producing patterns in cloth are through dyeing yarns before the fabric is made, or (parts of) the fabric after construction. These have been listed under one heading, but the detailed discussions are separated into (1) Pattern in Yarns and (2) Pattern on Dyed Ground.

(1) Pattern in Yarns, *includes* Chiné, Ikat, Jaspé, Kasuri, Matmee, Mudmee, Patola, Space Dye, Strié, Yarn Tie-Dye, Warp Print

FIBER CONTENT

Family: Silk, cotton.

Present: Any.

YARN

Any. For chiné effect, yarn is dyed in a pattern, then woven to give a design with a blurred, bleeding-edge look; when yarn is tie-dyed and then woven, the result is termed ikat (Indonesia), mudmee or matmee (Thailand), kasuri (Japan), or patola (India). The best-known term is *ikat*; warp yarns only dyed in pattern, warp ikat; weft yarns dyed, weft ikat; both warp and weft dyed, double ikat. Commercially, warp yarns can be printed before weaving and then woven with weft undyed or one color; the edges of a warp print design are disturbed in weaving, giving the chiné look (see photos).

Space-dyed yarn can be produced by several methods, to give either a mottled or striated color (e.g., by injecting dye into a cone of yarn) or multicolors along a yarn (e.g., by passing the yarn under jets of dye). Such yarn produces a random pattern in fabrics made of it. Strié or jaspé are other names for this effect running lengthwise in the cloth.

FABRIC CONSTRUCTION, WEIGHTS, USES

Any; chiné fabrics are usually plain weave; space-dyed yarn is often used in weft knit fabric.

Ikat madra chiné effect

Warp print look georgette

NAMES French *chiné*, meaning variegated; Indonesian *ikat*, string bundles; Indian *patola*, a silk double ikat fabric made in Patan, a village in northern Gujurat, northwestern India, long ago used in trade with Indonesia, French *strié*, meaning streaked; French *jaspé*, meaning a striated, often green quartz stone, jasper.

ESSENTIAL Yarn dyed or printed creates pattern when woven or knitted into fabric.

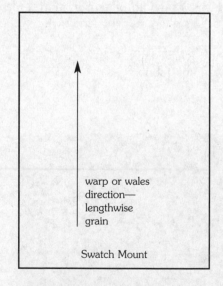

Fabric Name **Fabric Name**

(2) Pattern on Dyed Ground (Discharge, Resist), *includes* Bandanna (Bandana), Batik, Gunma Silk, Plangi, Shibori, Tie-Dye

FIBER CONTENT

Family: Cotton for batik and most early tie-dye.

Present: Batik or tie-dye still usually on cotton, but also silk; discharge today is rare, done on cotton or wool.

YARN, FABRIC CONSTRUCTION, WEIGHT,

Fine yarns as a rule, filament (silk or MF) or spun; usually plain weave, light weight.

OTHER

Fabric is dyed a solid color, usually a deep shade, so that the pattern stands out against it (see photos).

With **resist** methods, the fabric is first treated so that the dye cannot penetrate the pattern areas. These methods include the following:

Batik: Pattern parts are covered with wax; fine hair-lines dyed where the wax cracks on the fabric during dyeing are a characteristic of this kind of pattern.

Gunma Silk: in fabric made of high-twist silk yarns, the degumming is manipulated in specific areas, so that dyeing produces artistic patterns.

Tie-dye: Pattern areas are tied tightly, so dye cannot penetrate; with larger tie-dye patterns, there may be a certain amount of bleeding of the color at the edges of the tied part, again, typical of tie-dye. When the effect of batik or tie-dye is produced perhaps by screen or roller printing, hair-lines will be carefully included for a batik look and some softened or bleeding edges for a tie-dye effect; unless it is bandanna cloth, when there will be white dots recalling the tied areas, usually with a blue or red ground.

With **discharge** methods, the fabric is first dyed, then pattern areas are printed with chemicals to remove the color; these may be left white or be printed with other colors. The back of a discharged pattern shows traces of the ground color.

Bandanna

Tie-dyed muslin

193

Discharge print Top: face; bottom: back

Batik

USES

Any apparel, often sportswear, various household textiles. Squares called bandannas are used for handkerchiefs, head or neck scarves.

NAMES

Bandanna (sometime spelled *bandana, bandhana*) derived through Hindi from the Sanskrit *bandh,* meaning to tie ready for dyeing; *batik* may come from the Javanese root *tik,* meaning a dot. *Shibori* is Japanese tie-dyeing. *Gunma* is a prefecture in India.

warp or wales direction—lengthwise grain

Swatch Mount

Fabric Name

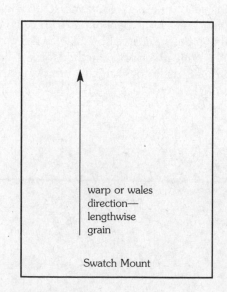

warp or wales direction—lengthwise grain

Swatch Mount

Fabric Name

Plaid

FIBER, WEIGHTS, USES

Any.

YARN, FABRIC CONSTRUCTION

Unless printed, plaid will involve dyed yarn of different colors. If woven, they will cross at right angles, usually in a plain or twill weave, but sometimes more complex, such as dobby. Plaids are also rendered by knitting, a classic example being *argyle*: diamonds of solid color with an over-diamond pattern of contrast color lines (photo of argyle in *Fabric Reference* as an example of *intarsia* knitting). Arresting plaids can also be knitted on the raschel machine.

NAME

Aside from the textile pattern described here (generally pronounced "plad," there is another meaning of plaid: the *plaid* (pronounced "played"), an item of Highland dress. This is the length of tartan worn on the outside, over the left shoulder. Originally it was in one piece with the kilt as the *belted plaid*. From a long piece of fabric the kilt was first pleated around the wearer and held by a belt; the loose end was then gathered over the shoulder (to leave the sword arm free), and held with a pin, button, or clasp. Gaelic *plaide*, meaning a blanket or cloth woven in a crossed pattern as described in this File. *Plaide* itself is a contraction of *peallaid*, meaning a sheepskin, from Gaelic *paelle*, meaning skin or hide.

An Etruscan war report from c350 B.C.E. seems to make reference to plaid, tartan, or check in describing a checked or crosshatched loose garment worn by "northern invaders" who rode four wheeled battle wagons.*

ESSENTIALS

Lines of various colors crossing each other at right angles, making rectangles or squares. For a distinction among *tartan, plaid*, and *check* see Tartan.

Plaid

Plaid—very like tartan, but sett uneven

*Gerhard Herm, *The Celts*, New York, St. Martin's Press, 1977 (translated from the German).

195

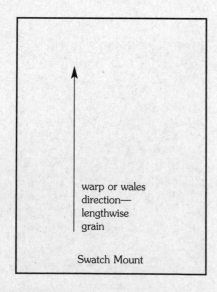

warp or wales
direction—
lengthwise
grain

Swatch Mount

Fabric Name

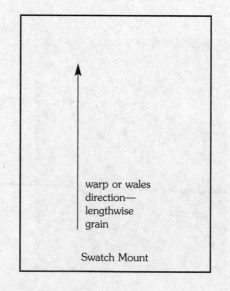

warp or wales
direction—
lengthwise
grain

Swatch Mount

Fabric Name

196

Poplin (*see also* Broadcloth)

FIBER CONTENT
 Family: Originally made of silk or silk and wool.

 Present: Usually made of cotton or blends, usually with polyester, may be made of other fibers.

YARN
 May be carded only or combed. There are more warp yarns than weft, and the weft is usually heavier.

FABRIC CONSTRUCTION
 Quite firm (close) plain weave, with crosswise ribs fine but easily visible when the weft yarns are thicker than the warp, as they usually are in North American poplin. British poplin is virtually as fine as cotton broadcloth, the "sister fabric."

WEIGHTS, USES
 A sturdy fabric, top or bottom weight, used for shirts, dresses, pajamas, also for raincoats, slacks, sportswear, and for furnishings.

Poplin

NAME
 French *papeline,* meaning papal, "of the Pope," since the fabric was originally made in Avignon, in southeast France. This town was papal property from the fourteenth century until the French Revolution, but was the residence of popes, instead of Rome, 1309–1377. The fabric then was all silk; in Ireland, a worsted wool weft was introduced.

ESSENTIALS
 Firm plain weave fabric, usually cotton family, fine but definite crosswise rib.

warp or wales
direction—
lengthwise
grain

Swatch Mount

Swatch Mount

Fabric Name

Fabric Name

198

Print, Large Scale (*includes* Digital, Screen, Transfer)

Large scale designs require printing methods other than roller. A design printed by roller (see Calico) can be no wider than the roller, and must not have a *repeat of pattern* (from bottom of design to top) longer than the circumference of the roller. Roller size is limited by practical and economic concerns. Rollers are heavy and if too large are cumbersome to handle. They are also very expensive to produce (engrave), and are reserved for classic patterns that promise long market demand life, and/or for inexpensive fabrics, such as calico.

For large scale and/or exclusive designs, other methods must be used. Frames holding fine screening with the areas not to be colored sealed off, one screen for each color, allow relatively inexpensive printing of exclusive designs or short runs; this is *flat screen printing*. The screens may be moved by hand or automatically. Much faster and wider printing is done by *circular* or *rotary screen printing*, by *transfer printing*, or by *digital printing*. For more information on all of these printing methods, see *Fabric Reference*.

One type described and illustrated here is

1. Screen Print, represented by the well-known "name" print, toile de Jouy. Large-scale results possible with a Digital or Transfer Print are covered under

2. Other (Digital, Transfer).

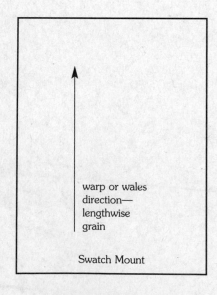

warp or wales direction— lengthwise grain

Swatch Mount

Fabric Name

warp or wales direction— lengthwise grain

Swatch Mount

Fabric Name

Print, Large Scale

(1) Screen Print, *represented by* Toile de Jouy

FIBER CONTENT	**Family:** Cotton; originally a print on very fine cotton.
	Present: Usually cotton or blends, rarely of silk or MF filament.
YARN, FABRIC CONSTRUCTION, WEIGHTS	Usually carded only yarn, in a plain weave, bottom weight. Occasionally a finer cotton satin or sateen is used, and much more rarely a top-weight filament material, such as surah.
OTHER, USES	This is the name applied today to a *type of print:* a line print in one color on a cream or white background; it is almost always a large design repeat, usually screen printed today. The design typically suggests a French rural scene from the latter half of the eighteenth century; the photo of one such design has been reduced from a drapery print on canvas, to show more of the picture. Toile de Jouy is used mainly in interior design decorating, for drapes, slip-covers, wall-covering, bedding, sometimes accessories, rarely apparel.
NAME	French *toile de Jouy,* meaning cloth of Jouy, a village near Versailles, outside Paris, where in 1759, a famous printworks was set up by Christophe Philippe Oberkampf. Here were printed not only the style of design that we term toile de Jouy today, but others such as floral chintz. Printing at Jouy-en-Josas was done on very fine cotton fabric, imitating the immensely popular materials from India. Printing at this plant was first done using wood blocks, then engraved copper plates, and by the end of the eighteenth century, with wood rollers. Fabric in this design is also sometimes called simply "toile."

Print detail

Toile de Jouy print

Print detail

ESSENTIALS	Fine line print, one color on light ground, usually of a late eighteenth century (French) rural scene.

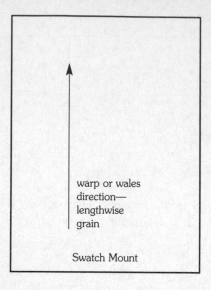

warp or wales
direction—
lengthwise
grain

Swatch Mount

Fabric Name

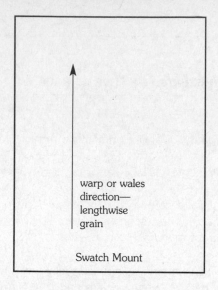

warp or wales
direction—
lengthwise
grain

Swatch Mount

Fabric Name

Toile de Jouy print

202

(2) Other (Digital, Transfer)

Digital (ink jet) print: This method uses print heads that spray very fine drops of special colored inks, electronically controlled so that the design is created digitally. With some machines, the color can "happen" on the spot as the droplets (which may be measured in picoliters) merge at any point. Color and design changes are made at a computer.

Digital ink jet printing would seem to meet many needs in today's textiles world, especially where fashion is involved. Samples can be quickly prepared, and there is no limit to size of pattern repeat (lengthwise). Wide fabrics can be printed, so this method is suitable for home furnishings materials. For details of various types of ink jet machines look in a recently revised text, such as *Fabric Reference* Fourth edition.

Transfer (heat transfer, or thermal) print: Heat is applied to a paper carrying dyes, which vaporize (or sublime, i.e., change from solid to vapor) and transfer to a fabric or other substance held in contact with the paper. Transfer prints as discussed in this File were originally applied to MF fiber materials, especially to polyester weft knits, since the material is not pulled or stretched; modified methods allowed other materials to be transfer printed, and this can be done on garments during or after assembly.

Transfer prints can be well defined, so a woven fabric design can be applied to a knit, for instance; the photo below shows a herringbone-look print paper. Preparing the paper costs much less than for a screen or roller, so exclusive designs are not expensive. However, transfer printing is not being widely used.

Transfer print on tricot

Paper, herringbone look

```
┌─────────────────────┐        ┌─────────────────────┐
│         ↑           │        │         ↑           │
│         │           │        │         │           │
│         │           │        │         │           │
│         │           │        │         │           │
│         │           │        │         │           │
│   warp or wales     │        │   warp or wales     │
│   direction—        │        │   direction—        │
│   lengthwise        │        │   lengthwise        │
│   grain             │        │   grain             │
│                     │        │                     │
│   Swatch Mount      │        │   Swatch Mount      │
│                     │        │                     │
└─────────────────────┘        └─────────────────────┘
```

_____ _____
Fabric Name **Fabric Name**

Raschel Knit (*see also* Chenille Yarn; Gimp "Braid"; Lace, Knit; Stretch, Power)

FABRIC CONSTRUCTION

Warp knit; needles can accept yarn of any type, from sheerest to heavy; guide bars allow complex patterns. Usually visible in raschel fabric is the pillar-and-inlay construction, with vertical wales of loops like crochet chains, and other yarns laid in to those loops, often to lie on the face. Similar machines (cidega) knit much trim. (See photos; there are also photos of raschel knits in these Files: Chenille Yarn; Gimp "Braid"; Lace Knit; Stretch, Power.)

USES

Raschel knits range from net or fine, sheer lace, through much curtain fabric and material for dresses, suits, and coats, to carpet. Powernet, the power stretch fabric used in foundation garments, is raschel knit, since this machine can incorporate elastic yarns easily. Chenille yarns knitted in on the raschel machine can give a very good Persian lamb look (see Chenille Yarn).

Crochet lace look

Raschel knit-light coating

Face Back

NAME

"Raschel" has a romantic origin—most unusual for a machine! See Lace, Knit for the story.

ESSENTIALS

Warp knit, wales of stitches visible, with yarn laid in to form a pattern of any complexity, weight, or texture.

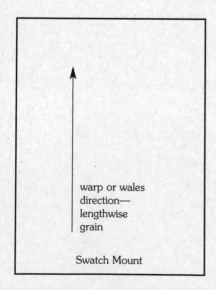

warp or wales
direction—
lengthwise
grain

Swatch Mount

Fabric Name _____

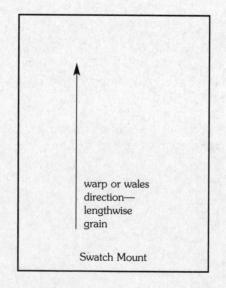

warp or wales
direction—
lengthwise
grain

Swatch Mount

Fabric Name _____

Rib Knit, *includes* Accordion, Cable, Poor Boy, Shaker (*see also* Interlock)

FABRIC CONSTRUCTION

Single weft knit, in which all the loops of some wales are drawn off to the back of the fabric, while all those of other wales are drawn off to the face across each course, giving raised wales on both sides. Rib knits are described by the number of wales drawn off to the face by the number drawn to the back, the finest being a 1×1 rib; the photo shows a 2×2 rib. Like any weft knit, a rib knit may be circular, giving tubular fabric, or flat, allowing fashioning to shape; see Uses. *Accordian* rib is 1×1 rib alternating with 2×2.

FIBER, YARN, WEIGHTS

A rib knit can, of course, be made of any fiber or yarn type, and can be any weight from top weight to heavy. A 1×1 rib in a fairly heavy yarn is called *shaker*, a 2×3 or 3×1 rib in medium or fine yarn is called *poor boy*. *Cable* results when groups of stitches are interchanged for a few courses and then changed back, as if braided.

USES

Because of its construction, rib knit has excellent crosswise stretch and recovery, and is used for bands which should fit closely to the body: sleeve or sock cuffs, waistbands, and such. Fashioned (flat) rib knits are also much used for shaped collars. Because of the raised ridges, a rib knit will be thicker than a plain stitch knit of the same yarn, and so gives better insulation, in sweaters, for instance.

2 × 2 rib

Shaker

Cable

NAMES

A narrow ridge like the *rib* of an animal; *cable* like a heavy cord; folds as in the bellows of an *accordion*.

ESSENTIALS

Weft knit, stitches drawn off to face or back across each course, to give vertical raised wales on both sides.

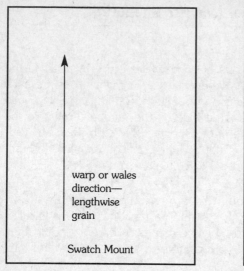

warp or wales
direction—
lengthwise
grain

Swatch Mount

Fabric Name

warp or wales
direction—
lengthwise
grain

Swatch Mount

Fabric Name

There is a large family of plain weave materials which are ribbed. These ribs usually run throughout the fabric (allover), but some appear only occasionally or are more prominent than others within the same fabric (occasional). In most of these fabrics, the ribs run crosswise, but a few are lengthwise.

(1) Rib Woven, Allover, *includes* Barathea, Bengaline, Faille, Givrene, Gros de Londres, Paris, etc., Grosgrain, Poult (*or* Poult de Soie), Radzimir (*or* Rasimir, Razimir, Rhadzimir), Repp (*see also* Barathea *under* Basket Weave; Broadcloth; Moiré; Poplin; Taffeta) (*see also another* Barathea *under* Worsted Suiting)

FIBER CONTENT	**Family:** Silk (often cotton in weft yarns).
	Present: Any fiber, most silk or MF filament in the warp, often cotton or blends in the weft, some made of all wool or flax.
YARN, FABRIC CONSTRUCTION	Most have filament warp, finer and more numerous than spun weft, which is often of cotton or blends. Except for barathea, all are close plain weave, resulting in an allover crosswise rib; the warp covers over the weft, giving the surface a silky character unless the warp is spun yarn. (In barathea, the ribs are broken with some twill interlacing, giving a pebbled look.) Weft yarns may be plied, or several yarns may be carried as one, to give a pronounced rib. These are firm fabrics, with a pleasing texture, but in cases where the warp is smooth filament and the weft a coarse spun, the fabric may be subject to yarn or seam slippage.
	Taffeta has the least noticeable rib, and similarly cotton broadcloth and some poplin, so these were put in their own files.
WEIGHTS, USES	Top weight to heavy, used for dresses, skirts, slacks, suits, coats, trim (especially grosgrain ribbon), neckwear (especially repp for neckties), accessories, upholstery.

Bengaline or faille

Repp

Givrene

Grosgrain ribbon

NAMES	*Bengaline* from Bengal, India; *grosgrain* from the French *gros*, meaning coarse or pronounced and *grain*, meaning texture; others are *gros de Londres* (London), *gros de Paris*, etc.; French *poult de soie*, meaning pelt of silk; French *faille*, silky, scarf-life turban; *givrene* from French *givre*, hoarfrost; *repp* from Old English out of German *die Rippe*, meaning rib. French *ras de Saint Maur*, a smooth fabric from Saint Maur in the Left Bank part of Paris, gives radzimir and variations.
ESSENTIALS	Crosswise ribs in plain weave fabric, from barely visible to prominent, warp much finer and more numerous than weft.
TYPES SUMMARY	**Types of plain weave allover rib fabrics:** From finest to coarser rib, are described below (also see photos in this and other Files mentioned).

Silky Face:

taffeta. Made entirely of filament yarn, warp and weft the same size, but many more warp than weft; this gives a fine crosswise rib. (See Taffeta.)

faille. Has a more pronounced rib than taffeta, and the name *faille* is applied to a variety of coarseness of texture, from just a little more visible rib than taffeta to a very definite rib such as *bengaline*. The rib will be more pronounced as the weft is thicker, and especially so when the weft is a bundle of yarns. These fabrics have a silky face, since the many fine warp yarns are filament and cover the weft entirely. Weft may be filament but is usually spun. Among the mid-range of this group of silky face, crosswise rib, plain weave fabrics are: *poult de soie* (also called *poult*), *grosgrain* (usually ribbon width), *gros de Londres, gros de Paris,* etc. *Givrene* has an irregular rib and *barathea* a broken rib (see also Worsted Barathea under Worsted Suiting).

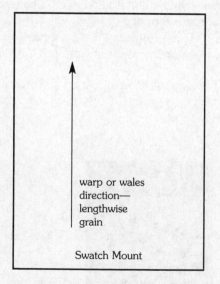

Fabric Name　　　　　　　　　　　**Fabric Name**

The base of *moiré* is usually one of these fabrics.

radzimir (also spelled rasimir, razimir, or rhadzimir). Has smooth crosswise ribs; obsolete for some years, it is again being used.

Face Silky or Not:

repp. The most pronounced of the allover ribs, and may be made of any fiber (ottoman has larger ribs, but they are occasional only—see Rib Woven, Occasional for Ottoman). Repp with filament warp (silky face) is the fabric of "old school ties," much used for neckties. When woven in cotton, rayon, wool, or linen, repp may also be used for upholstery.

Cotton Family Allover Woven Ribs.

broadcloth. The finest, composed of warp and weft about the same size, but at least twice as many warp as weft, creating a fine crosswise rib. [*See* Broadcloth (Cotton).]

poplin. Similar to broadcloth, but in North America is usually a less refined fabric with a somewhat coarser rib and is often used in bottom weight as well as top weight. (See Poplin.)

warp or wales
direction—
lengthwise
grain

Swatch Mount

Fabric Name

warp or wales
direction—
lengthwise
grain

Swatch Mount

Fabric Name

(2) Rib Woven, Occasional, *includes* Dimity, Épingle, Ottoman, *includes* Tissue Gingham (*see also* Ciré *for* Rip-stop) (*see also* Épingle Brocade)

FIBER CONTENT

Family: Cotton (dimity, tissue gingham), silk (ottoman, épingle).

Present: Cotton, blends (dimity, tissue gingham); ottoman or épingle may be of any fiber, including wool, but in dress fabrics, usually has silk or MF filament face (warp).

YARN

Spun for dimity and tissue gingham, filament or spun for ottoman, épingle.

FABRIC CONSTRUCTION

Plain weave, occasional heavier yarns. These are warp yarns for dimity, giving one of the rare plain weave lengthwise rib fabrics; sometimes there are occasional heavier yarns warp and weft, giving crossbar dimity; on a sheer gingham base, the fabric is called tissue gingham (see Gingham for photo).

For ottoman, many more and finer warp yarns cover the weft, which at intervals is *much* thicker than the warp, giving occasional, very heavy, rounded, crosswise ribs. Weft yarns are often spun (cotton or wool) and may be plied or contain several singles carried as one. In all but sheeting or bottom-weight apparel or upholstery fabrics, the warp yarns are usually filament and cover the ribs completely to give a silky face. As with the allover woven ribs, this is a firm fabric; more than with allover ribs, fine filament yarns may wear on the surface of these heavy ribs.

The ribs in épingle may be lengthwise or crosswise, often occasional, and may be of different color from ground.

WEIGHTS, USES

Top or bottom weight for dresses, shirts, skirts, slacks, suits, coats, accessories, curtains, bedding; medium-heavy to heavy for coats, upholstery.

Dimity

Crossbar dimity

Ottoman

NAMES

Greek *dimitos,* meaning of double thread; ottoman is a silk fabric connected with Turkey and the Ottoman Empire, thirteenth century; French *épingle,* meaning pin.

ESSENTIALS

Occasional ribs, plain weave.

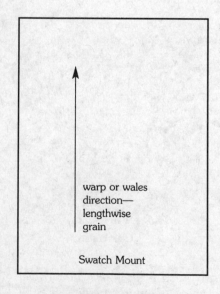

warp or wales
direction—
lengthwise
grain

Swatch Mount

Fabric Name

warp or wales
direction—
lengthwise
grain

Swatch Mount

Fabric Name

Sateen, *sometimes called* Weft Sateen, *includes* Swansdown

FIBER CONTENT

Family: Cotton.

Present: Cotton or blends.

YARN, FABRIC CONSTRUCTION, OTHER

Weft yarns are softer twist and thicker than the warp, and may be mercerized.
Weft-face satin weave, usually 1/4 (5 shaft). This indicates a weave where each weft floats over four warps, interlacing with only one (the fifth); see *Fabric Reference* for more information on the satin weave. A high thread count can be achieved more easily in a satin weave than a plain, hence many high count sateen sheets. However, a satin weave cannot be constructed as closely with weft floats as when warp floats are used, and so a heavy cotton fabric in satin weave, e.g., for upholstery, will probably be a warp-face cotton satin or "warp sateen"—see Satin for names. Sateen may be plain or printed. Swansdown is a heavy weft-face satin weave, napped to give a soft face.

WEIGHTS, USES

Top or bottom weight, used extensively for linings in apparel and drapes, also for slipcovers and drapes, sheets, mattress covers, and sportswear. Swansdown used for workclothes.

Sateen

NAME, ESSENTIALS

Sateen, meaning diminutive of satin, the original satin being made of (expensive) silk; similar to the relationship between the names *velveteen* and *velvet.* Less lustrous than satin because made of spun yarn with a weft float. There is some confusion in naming satin-weave fabrics made of cotton: This File calls the weft float fabric simply *sateen,* but some references term it a *weft sateen,* and call a warp float fabric made of cotton a *warp* or *warp-faced sateen*—this *Glossary* prefers *cotton satin.* See Satin. Swansdown from soft, napped face.

warp or wales direction— lengthwise grain

Swatch Mount

Fabric Name

warp or wales direction— lengthwise grain

Swatch Mount

Fabric Name

Satin

FIBER CONTENT

Family: Silk (cultivated), originated in China.

Present: Silk or MF filament if fabric is called simply satin; may also be made of cotton (cotton satin or warp sateen).

YARN

Filament (silk is the only natural filament); if spun yarn (cotton) is used, fabric should be differentiated by name, e.g., cotton satin.

FABRIC CONSTRUCTION, OTHER

Warp-face satin weave, usually 5 shaft (4/1; four warp yarns float over weft, interlace with one), less often 8 shaft (7/1; float of seven), but satin has been made in 12 shaft (see *Fabric Reference* for more on satin weave). Since most of the warp lies on the face and smooth filament yarns can be packed in closely (interlacing of only one each time with the weft), satin *can be* the smoothest, fullest, most lustrous woven fabric, very flexible for its weight.

Satin finish, satinized, or satinesque is a smooth, lustrous finish to give the appearance of satin, given by calendering with or without a glaze; not likely satin weave, more often applied to warp knit tricot.

TYPES

The following list includes the names of many types of satin included in other Files:

antique satin. See Satin/Shantung.

brocaded satin. Satin ground, raised design in velvet or other weave; if in velvet, it is equivalent to voided velvet (see Velvet).

brushed-back or flannel-back satin. See Satin, Brushed-Back.

charmeuse. See Satin/Crepe.

cotton satin. Also called *warp sateen.* Warp-face satin weave, but made with cotton or cotton blend (spun) yarn; yarn is usually finer, with tighter twist than the yarn used in weft-face sateen.

crepe-back satin. See Satin/Crepe.

duchesse satin. Fine but full satin, long float (8- or 12-shaft weave), fine filament yarn in a close weave, to give a very luxurious fabric.

farmer's satin. See *cotton satin.*

hammered satin. Finishing process leaves small indentations on the surface, as if hammered.

panne satin. See *shoe satin.*

palace satin. Satin weave background with jacquard figures; could also be called *figured satin. See* Jacquard Woven.

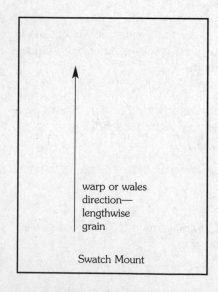

warp or wales
direction—
lengthwise
grain

Swatch Mount

Fabric Name

warp or wales
direction—
lengthwise
grain

Swatch Mount

Fabric Name

218

peau de soie. French, meaning skin of silk; firm satin, dull luster, usually has a fine, cross-ribbed back. Traditionally made in 8-shaft weave, but most peau de soie today is 5-shaft weave.

satin découpé. See Burned Out, under Pattern Applied—Chemical

satin gabardine. Very like gabardine but in a 4/1 satin weave (see Gabardine).

satin stripes. Lustrous warp floats may alternate in stripes with dull weft, to give a striped variation of satin/crepe; vertical stripes in satin weave may also be alternated with sheer (plain weave) stripes, e.g., in chiffon or cotton voile.

shantung/satin. See Satin/Shantung.

shoe or slipper satin. Heavy, stiff, very lustrous fabric. Filament warp, many ends; weft may be fine, plied, combed cotton.

upholstery satin. Heavy, filament warp, usually cotton weft.

venetian cloth. Lustrous face may be accentuated by satin weave (see Gabardine).

WEIGHTS, USES Top or bottom weight; if not closely woven, will have a cheap, sleazy look and hand. Used for linings, lingerie, sleepwear, loungewear, blouses, dresses, especially evening and bridal, suits, coats, binding, trim, bedding, drapes, upholstery.

4/1 satin

7/1 cotton satin

Hammered

NAME From Zaytoun (Tzu-t'ing, Zaitun), a port in southeastern China, later called Guangzhou (Chuanchow).

ESSENTIALS Warp-face satin weave; if fabric name is simply *satin,* one can expect that the yarn is filament, low or zero twist.

219

warp or wales
direction—
lengthwise
grain

Swatch Mount

Fabric Name _____

warp or wales
direction—
lengthwise
grain

Swatch Mount

Fabric Name _____

Satin, Brushed-Back, Flannel-Back, *or* Kasha

FIBER CONTENT **Family:** Silk (see Satin).

Present: Usually MF fiber warp, cotton or blend weft.

YARN Warp yarns filament; weft yarns spun, thicker than the warp, and soft twist.

FABRIC CONSTRUCTION Warp float satin weave, usually 4/1, which puts most of the smooth warp yarns on the face and most of the weft yarns on the back.

OTHER Back of the fabric (weft yarns) is napped or brushed in finishing: Fibers are torn out of the yarns to lie on the surface as a soft nap; see Kasha Flannel in Flannelette File.

WEIGHTS, USES Top weight used for nightwear and loungewear to give an elegant satin face with soft, warmer back next to the skin; bottom weight used mainly as lining for cold-weather coats.

Flannel-back satin

NAME Kasha probably suggests the softness of cashmere.

ESSENTIALS Warp-face weave; warp is filament yarn, weft is spun yarn; brushing or napping of the back in finishing.

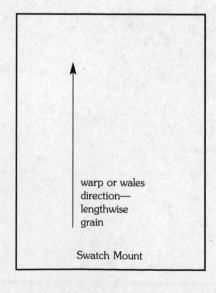

warp or wales
direction—
lengthwise
grain

Swatch Mount

Fabric Name

warp or wales
direction—
lengthwise
grain

Swatch Mount

Fabric Name

Satin/Crepe, *also* Charmeuse

FIBER CONTENT

Family: Silk (*see* Satin).

Present: Silk or MF fiber.

YARN

Warp is filament, low twist (lustrous) in satin/crepe, slightly more twist and less luster in charmeuse. Weft yarn for both is crepe twist (very high), which gives a dull or matte look; it is filament for satin/crepe, may be spun for charmeuse.

FABRIC CONSTRUCTION, OTHER

Warp-face satin weave, which puts most of either set of yarns on one side; may alternate in stripes of matte and luster. Satin/crepe is a reversible fabric; when used with the lustrous side as the face, it is called crepe-back satin; with the matte side as the face, it is called satin-back crepe. Charmeuse is not reversible; it is used with the more lustrous (satin) side as the face. Both fabrics are very drapable, from the combination of satin weave and high twist crepe yarns.

WEIGHTS, USES

Satin/crepe is top or bottom weight, reversible, for lingerie, sleepwear, loungewear, blouses, dresses, dressy suits, eveningwear, trim. Charmeuse is light top weight, soft, drapes very well, with a semi-lustrous face and duller back; uses are the same as satin/crepe, except not used for suits.

Reversible satin/crepe **Charmeuse**

NAME

French *charmeuse,* meaning charming.

ESSENTIALS

Warp-face satin weave, lower-twist warp more lustrous than crepe-twist weft. Satin/crepe reversible, one side smooth, lustrous, the other dull. Charmeuse lighter weight, not reversible, face less lustrous, weft may be spun yarn.

warp or wales direction— lengthwise grain	warp or wales direction— lengthwise grain
Swatch Mount	Swatch Mount

Fabric Name _____ **Fabric Name** _____

Satin/Shantung, *also* Antique Satin

FIBER CONTENT

Family: Silk, both cultivated and wild.

Present: Silk or MF fiber.

YARN, OTHER

Warp is low-twist filament (in antique satin, a dark color); weft is slub yarn, as in shantung—typical of wild silk.

FABRIC CONSTRUCTION, NAMES

Warp-face satin weave, which puts most of the smooth filament yarns on the face; most of the slub yarns are therefore on the back, to give the *look* of shantung (except that this is not plain weave, as shantung is). When both sets of yarns are the same color, the fabric is reversible. Antique satin has a dark warp, and the side showing the slub yarns (technical back of the fabric) is the *right side;* the dark warp yarns, showing through only occasionally, throw the texture into relief, as antiquing does in wood, leather, or silver.

WEIGHTS, USES

Satin/shantung is top or bottom weight, reversible, for dresses, dressy suits, loungewear, eveningwear; antique satin is bottom weight, mainly used for drapes.

Reversible satin/shantung

Antique satin

ESSENTIALS

Warp-face satin weave, smooth filament warp yarns, slub weft yarns. If all one color, it is reversible fabric satin/shantung; if warp yarns dark, it is antique satin, where slub side is the right side.

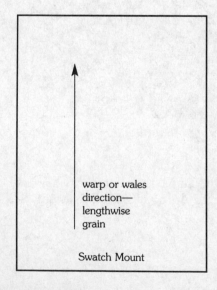

warp or wales
direction—
lengthwise
grain

Swatch Mount

Fabric Name

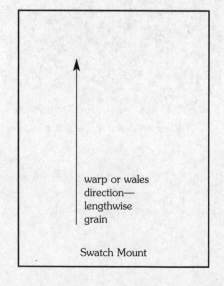

warp or wales
direction—
lengthwise
grain

Swatch Mount

Fabric Name

Seersucker (*see* Plissé under Pattern Applied—Chemical *for* Seersucker Look)

FIBER CONTENT **Family:** Probably cotton.

Present: Usually cotton and blends; rarely other, except for a version made with a thermoplastic fiber, using latent shrinkage to make the puckers.

YARN, FABRIC CONSTRUCTION Traditional: yarn carded or combed; plain weave, fairly balanced, with lengthwise strips of puckered or crinkled yarns alternating with relatively flat strips. Puckers are achieved in weaving by slackening the tension of groups of warp yarns, so the pucker is created as the weft yarns are beaten up. Warp yarns that shrink differently can also give the effect.

OTHER Seersucker may be solid color, check, or plaid, but is often woven with yarn-dyed stripes lengthwise, between the rows of puckers. If stripes of latent-shrinkage warp yarn are woven, alternating with strips of stabilized (relaxed) yarn, seersucker will result in wet finishing that fabric. A seersucker look can be embossed or given with a chemical printing—see Plissé, under Pattern Applied—Chemical.

WEIGHTS, USES Because seersucker is puckered, it usually requires little or no ironing, even if made of 100% cotton with no Durable Press finish; it is therefore very satisfactory for summer wear. Made in top or bottom weight, for dresses, sportswear, summer nightwear, summer suits, bedspreads, curtains.

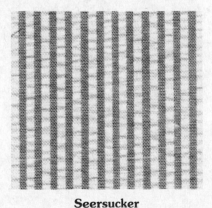

Seersucker

NAME Persian *shir o shakar,* meaning milk and sugar, indicating the alternating stripes of smooth and crinkled yarns.

ESSENTIALS Lengthwise stripes of puckered or crinkled yarns, alternating with those that lie relatively flat.

| warp or wales direction—lengthwise grain | warp or wales direction—lengthwise grain |
| Swatch Mount | Swatch Mount |

Fabric Name **Fabric Name**

Selvage (Selvedge, Selvege)

FIBER, YARN

Any.

FABRIC CONSTRUCTION, OTHER, NAME

Woven; the selvage (variously spelled) is the "self edge" of the fabric, running lengthwise in the direction of the warp. It is formed as the weft is interlaced at right angles to the warp during weaving. Traditionally, the weft is wound on a bobbin and carried back and forth across the loom in a shuttle; the selvage is formed as the weft folds around with the passage back, making a finished edge. The selvage may be made with heavier or plied yarns for strength, and/or in a basket weave; this is sometimes called a **tape selvage,** often used on sheets. Some items, like terry towels, are woven several side by side, cut apart and hemmed to make a stitched **split selvage.**

More and more looms used today are shuttleless: The bobbin and shuttle are done away with, for much more efficient systems which all feed weft from one side of the loom only, pre-measuring and cutting the lengths, so each weft has cut ends. This makes for a different kind of selvage on these fabrics, and for most of them, it looks quite different (see photos).

Tucked-in weft gives a selvage that looks like that on a shuttle-woven fabric. The difference is seen only if a weft yarn is raveled off; the cut length of weft has been tucked in, to be woven into the fabric for a short distance. The other methods leave a fringe of weft yarns protruding from the selvage, held in place by heat **fusing** (where the yarns are thermoplastic) or by **leno** weave.

Fabric is carried through various processes on a tenter (or stenter) frame, held along the selvage by pins or clips; these form **tenter holes.** Since fabric is usually carried face up, the tenter holes are nearly always smaller on the face; they rise in a miniature volcano shape. This can be a useful guide when laying out to cut material with little difference between face and back (see General Guides to Fabric Right Side and Face, Section Four, *Fabric Reference*).

Shuttle loom selvage with tenter holes

Tucked-in selvage, shuttleless loom

Leno selvage, shuttleless loom

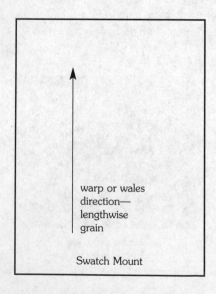

warp or wales
direction—
lengthwise
grain

Swatch Mount

Fabric Name

warp or wales
direction—
lengthwise
grain

Swatch Mount

Fabric Name

Serge

FIBER CONTENT

Family: Wool, or possibly silk—*see* Name.

Present: Usually wool or blends of wool and MF fiber.

YARN

Usually combed (worsted).

FABRIC CONSTRUCTION

Even 2/2 right-hand twill weave, flat wale.

OTHER, WEIGHTS, USES

Clear finish, twill line visible on the back as well as the face; usually bottom weight for suiting, and solid color (piece dyed). The traditional navy blue serge in a suit tends to develop a shine with wear and pressing. In serge made of wool, this can be counteracted by sponging with diluted vinegar and then steaming, but this should not be used on other types of fibers.

Serge

NAME

Latin *serica,* meaning silk, so possibly made originally of silk. An alternative derivation offered is from the Spanish *xerga,* meaning blanket. Denim is thought to derive from *serges de Nîmes,* a twill fabric made in Nîmes, France.

ESSENTIALS

Worsted type of yarn, 2/2 right-hand twill weave, flat wales, clear finish.

warp or wales direction— lengthwise grain	warp or wales direction— lengthwise grain
Swatch Mount	Swatch Mount

Fabric Name **Fabric Name**

Sheeting, *especially* Plain Weave (*includes also reference to* Damask, Dobby, Jacquard, Rib, Sateen) (*see also* Jersey)

Sheeting today is not only used for many items of bedding, accessories, other furnishings, and apparel, but comes in a number of weaves (as well as some knitted). This File concentrates on **plain weave sheeting** and sheeting-type fabrics, discussed under two main names, *muslin* and *percale*. Other more complex weaves used for high-end sheeting are cited.

Muslin, *includes* Factory Cotton, Greige Goods, Osnaburg; Percale, *includes* Holland (for Cambric Muslin *see* Cambric; for Dotted Muslin *see* Dotted Swiss; for Book Muslin *see* Gauze) (for Madras Muslin, see Leno Weave)

FIBER CONTENT

Family: Muslin, percale: cotton. Historically, the name *muslin* has been applied to a very wide range of cotton fabrics, from coarse to very fine (names such as *cambric muslin* or *dotted muslin* signifying the fine end). Muslin is even made of other fibers, e.g., *mousseline de laine* (wool muslin) and *mousseline de soie* (silk muslin). **Holland:** Flax.

Present: Bedding: Cotton, cotton blends, usually with polyester. Best quality percale made 100% of long staple cotton (Egyptian, Pima, Sea Island), or 100% of flax (linen). **In apparel:** also rayon. **Holland:** flax.

Muslin

Crinkle sheeting

Percale

YARN

Muslin and osnaburg usually woven with carded only (not combed) yarns, some may be high twist for *crinkled* sheeting. Yarn for percale sheeting and holland is almost always combed; and 2-ply yarns, very fine and strong, are used in only the highest quality.

Generally close, balanced plain weave (see *Fabric Reference* for more on balanced versus unblanced weaves). In household sheeting, the heavier and coarser type is called *muslin*, and *percale* is the finer plain weave sheeting.

Closeness of weave in household sheeting is well-known to buyers as *thread count*, or yarns per square inch (never converted to metric) : around 115 = fairly sleazy and open fabric; 128 = medium; 140 = family or institutional weight—sturdy, not very light. Percale sheets, with finer, lighter yarns yet close weave, begin at thread count 180; many are 200, and can be found through 300s to super luxury around 440 (approximately 220 warp, 220 weft per inch). The combination of using 100% long staple cotton fiber (Pima or Egyptian), fine combed yarns (best are 2-ply), high thread count, and a balanced plain weave make for a light but strong, silky-smooth, and soft fabric—the best percale.

However, it should be understood that much sheeting of the highest thread counts is not plain weave but a weft face satin weave, giving a *sateen*, not percale (see Sateen, and *Fabric Reference* for discussion of how yarns can be packed more closely in a satin weave). This gives a very soft hand to sheeting, but will not wear as well as a comparable quality percale. Such sateen sheets have been described in terms like "ultimate," and promoted as having thread counts in the order of 1200!

That promotional figure of 1200 is not what it seems. In these cases, 2-ply yarns have been used and the thread count given as if they were singles, so the "1200" above is undoubtedly a 600 thread count using 2-ply yarns, a closeness of weave possible with sateen. With a percale in plain weave, you may similarly see 600, for a thread count of 300 woven with 2-ply yarns.

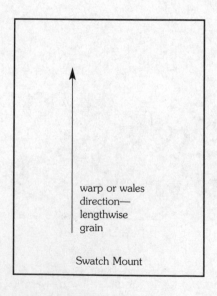

warp or wales
direction—
lengthwise
grain

Swatch Mount

Fabric Name

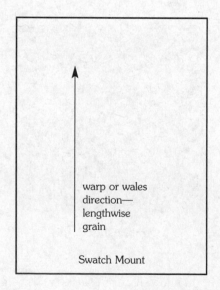

warp or wales
direction—
lengthwise
grain

Swatch Mount

Fabric Name

Finally, superb and fashionable sheeting may be of dobby weave (smaller, geometric patterns including waffle), jacquard weave (damask), and even ottoman (occasional prominent crosswise ribs). See files on Dobby Design, Damask, and ottoman (under Rib Woven, Occasional).

OTHER

Osnaburg is an unbleached muslin sheeting with some cotton "trash" still in it (waste bits of the cotton plant), Osnaburg is close to **greige goods**—fabric as it comes off the loom (known also as "factory cotton"). Unbleached muslin is still referred to by some as "unbleached calico." Sheeting of the muslin type is used for casual wear, and may be crinkled. This may be done by shrinking high-twist yarns and/or mechanically in finishing (see photo). Most sheets today, especially cotton/polyester blends, will have a Durable Press finish, to give smoothness without ironing after laundering. Holland, originally made of linen, is today a fabric similar to sheeting percale, made very stiff and sometimes glazed.

A final summary regarding sheeting: thread count is not everything. A sheet made with the highest quality, long staple cotton fiber, woven of well-spun yarns (the term "ring-span" has been used to suggest this) in a 200 thread count percale can be very soft and wear well. Of course, the best and most expensive sheets will have the most fashionable and pleasing colors, print designs, construction details, fit, and trim. Such top of the market bedding can cost well over $1,000 for a Queen size set.

WEIGHTS, USES

Most top weight, can be bottom weight; used not only for many items of bedding, plus accessories, drapes, slipcovers and other furnishings and interiors uses, but for apparel as well: sleepwear, shirts, dresses, sportswear. Holland used for window roller blinds.

NAMES

Muslin from Mosul, a city on the Tigris River, in what is now the northern tip of Iraq; by the twelfth century, it was a textile center in what was then Mesopotamia (the land between the two rivers Tigris and Euphrates). A number of Hindi words relate to muslin, e.g., *mullmull* (see Batiste). *Osnaburg* was woven in the city of Osnabrück, in northwestern Germany, as the basis for prints. (See Challis for mousseline de laine; Organza for mousseline de soie.) *Percale* from the Persian *pargalah*, meaning a cotton fabric made in Iran. *Holland* from firm, crisp linen fabric made in Holland.

ESSENTIALS

Muslin: cotton or blends, close, balanced plain weave, but not particularly refined yarn or finishing.

Percale: good quality cotton or blends, fine combed yarn plus close, balanced plain weave, thread count of 180 up.

| warp or wales direction—lengthwise grain | warp or wales direction—lengthwise grain |
| Swatch Mount | Swatch Mount |

Fabric Name

Fabric Name

236

Shirting, Basic Dress

The best-known fabric for dress shirts is cotton broadcloth, and there is also the more relaxed oxford cloth shirting. In Section One of *Fabric Glossary*, under Fabrics According to End Use Categories, these are listed along with the many other fabrics used as shirting, and all are discussed in the Files. There is shirting, however, that does not conform to any of these names, hence this entry.

Shirting Fabric—"No Name"

FIBER CONTENT

Family: Flax.

Present: Cotton and blends, often with polyester; lyocell.

YARN, FABRIC CONSTRUCTION, OTHER

Lower quality use carded only yarn; better to best quality will be woven with combed yarn, with top quality and durability using very fine 2-ply. Many classic dress shirt patterns are formed with dyed warp yarns in groups (yarn-dyed stripes). Such designs are printed on the least expensive shirting. Printed is less costly but lower quality than yarn-dyed, as the stripes are not as sharp in the fabric, and the color will fade more readily. There is a considerable expense involved in keeping yarn-dyed fabric in stock, rather than printing it up after an order has been given from a sample. (For more on this aspect of costs in production, see Dyeing Stages in *Fabric Reference*.)

Shirting is a plain weave, with more warp than weft, but not the ratio found in broadcloth of 2 to 1, so there is not the fine cross rib found in broadcloth; an example would be 130×80. The best may be mercerized, but this is not as likely as with broadcloth.

WEIGHT, USES

Top weight, used for dress shirts, but also for other apparel for men, women, and children (such as tailored pajamas), and extensively in decorating.

Basic dress shirting—130 × 80

NAME

As with "lining fabric," the combination of fiber, yarn, fabric construction, and "other" for some materials we call "shirting" does not fit the description of any other fabric used in this way—hence, "no name" or just "shirting." *Shirt* comes from the Old English *scyrte*, from the Germanic, and has a connection to "short." An undershirt was worn from Medieval times, but was usually loose. The article of clothing we know as a *dress shirt* developed as a standard in men's wear as the vests, jacket, and breeches or trousers worn with it gradually became of better and closer cut and fit, i.e., tailored, at the end of the eighteenth, and in the early years of the nineteenth centuries. Shirts were for centuries made of linen, but cotton fabrics gained ground throughout the nineteenth century, with the mechanization of spinning and weaving. However, it was not until early in the twentieth century that the "coat shirt," buttoning up the front, was developed. The collar-attached shirt, now the norm for business or daywear, was introduced around World War I.

ESSENTIALS

Cotton; lyocell or blends; warp and weft yarns about the same size; often lengthwise yarn-dyed stripes; plain weave, more warp than weft.

Fabric Name

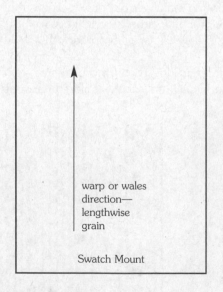

Fabric Name

Silk, Cultivated (Reeled), *includes* China Silk, Habutae (Habutai, Habutaye), *plus* Airplane Cloth, Measuring Tape Fabric, Parachute Cloth

FIBER CONTENT

Family: Cultivated or reeled silk (fine twine filaments).

Present: China silk or habutae is still usually silk, sometimes MF fiber, especially polyester; parachute cloth is usually nylon; airplane cloth may be fine cotton.

YARN, FABRIC CONSTRUCTION

China silk or habutae has fine, even filament yarns, low twist for softness, close balanced plain weave. Parachute cloth and airplane cloth are somewhat firmer fabrics. Airplane cloth of cotton will have fine, combed yarns.

OTHER

Degumming is a vital step to produce "silky" silk. As *raw silk,* it is dull and stiff; after scouring to remove the silk gum, it is lustrous and drapable (see *Fabric Reference* for illustrations, and details of silk production).

Airplane cloth or parachute cloth made of cotton is sometimes treated or coated to give a glazed or polished finish; in this form it may be referred to as measuring tape fabric.

WEIGHT, USES

Very light weight but compact and strong. Used for lingerie, linings, blouses, shirts, dresses, with the firmer fabrics for sportswear, luggage, and parachutes.

China silk

NAMES

China silk is made from cultivated or reeled silk which, for centuries in the ancient world, was available only from China. This provides the fine, strong, unbroken filaments which give this fabric its character. *Habutae (habutai, habutaye)* is the Japanese name for a very similar fabric. The other names are derived from the uses where lightness and strength are needed.

ESSENTIALS

Very light but compact, balanced plain weave fabric, typical of smooth and fine, yet strong cultivated silk material.

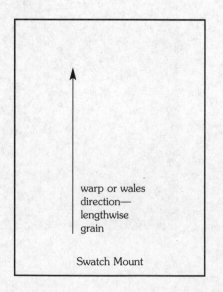

Fabric Name Fabric Name

240

Silk, Uneven (*not* Reeled), *includes* (1) Wild Silk, (2) Uneven Silk, Other Sources (*see also* Silk, Cultivated; Spun Silk)

There are many silk fibers and yarns that are not smooth, lustrous, and white as cultivated or reeled silk is; these have been divided here into two main categories.

(1) Wild Silk

Wild silk is spun by different types of mostly undomesticated "silkworms"—caterpillars that eat oak, castor, and other leaves; cultivated silkworms will spin silk only if fed leaves of the white mulberry. The wild silk moths are from various varieties, mostly the family *Saturniidae*, the "giant silk moths"—different types from *Bombyx mori* which produces reeled silk. Since these moths complete their life cycle (moth fi egg fi caterpillar fi chrysalis fi moth), they emerge from the cocoon, breaking the filaments. This means there is no long, unbroken filament.

Wild silk is coarser, stiffer, and more uneven than cultivated silk. Not all the gum can be removed, giving a fiber that is ecru or eggshell brown in color, rougher, and less drapable than cultivated silk. The yarn is usually spun from relatively short fiber lengths (silk as staple), producing uneven, slubby, or nubby yarns. However, these characteristics are valued and enjoyed for the color and textural interest they give; supply is small, and they have the advantages of a protein fiber: unique hand, insulating property, and dyeability. All this makes wild silk fabrics expensive. (See *Fabric Reference* for much more detail on wild silk.)

Wild silk is often erroneously called *raw silk*, which is cultivated silk in the gum—with the gum still on—stiff and dull, but which will become white, lustrous, soft, and drapable.

Continued

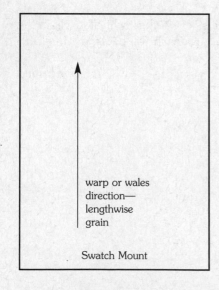

warp or wales
direction—
lengthwise
grain

Swatch Mount

Fabric Name

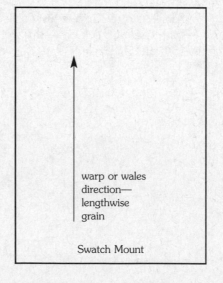

warp or wales
direction—
lengthwise
grain

Swatch Mount

Fabric Name

Shantung, Honan, Pongee, *also* Tussah, Muggah, "Silk Burlap," *plus reference to* Yamamayu Silk

FIBER CONTENT	**Family:** Wild silk (see above for comparison with cultivated silk).
	Present: Wild silk, or this character imitated in MF fibers (some spun purposely thick and thin), or cotton, Tussah, muggah, and silk burlap are associated with the roughest wild silk fabrics, which may be as coarse as burlap (see photo); today *tussah* is also a general term for wild silk, as well as a fabric.
YARN	Uneven, slubby; if undyed, will have an ecru (eggshell brown) color; much is spun from waste silk. In shantung, slubs are much more noticeable in the weft direction, with a finer, smoother warp. Honan or pongee may have slubs in both warp and weft yarns, and the tussah group usually does.
FABRIC CONSTRUCTION	Usually plain weave. Although tussah (wild) silk can be made into fabric in various ways, e.g., knitted, the fabric called *tussah* is usually plain weave.
WEIGHTS, USES	Top or bottom weight, except tussah, which is almost always bottom weight. They are used for blouses, dresses, slacks, suits, neckwear, drapes, furniture, wall coverings.
NAMES	Shantung is a province in northern China; Honan, an area of northern China. Chinese *pen chi*, meaning woven at home, from which came *pongee*. *Tussah* (also spelled tasar, tussore, and variations) from Sanskrit *tasara*, meaning a shuttle. *Muggah* (also with variant spellings) from ancient Sanskrit *muga*, meaning amber brown, for the color of the silk cocoon of the *muga* moth, raised in the Assam region of northeastern India. Wild silk types living in Japan give *yamamayu* silk.
ESSENTIALS	Wild silk character: uneven spun yarn, natural color ecru to brown, fabric plain weave, with texture from slubby to quite rough.

Shantung

Tussah
"Silk burlap"

243

```
┌─────────────────────────┐        ┌─────────────────────────┐
│                         │        │                         │
│         ▲               │        │         ▲               │
│         │               │        │         │               │
│         │               │        │         │               │
│         │               │        │         │               │
│         │               │        │         │               │
│    warp or wales        │        │    warp or wales        │
│    direction—           │        │    direction—           │
│    lengthwise           │        │    lengthwise           │
│    grain                │        │    grain                │
│                         │        │                         │
│      Swatch Mount       │        │      Swatch Mount       │
│                         │        │                         │
└─────────────────────────┘        └─────────────────────────┘
```

Fabric Name _____ **Fabric Name** _____

244

(2) Silk, Uneven, Other Sources, *includes* Douppioni (Dupion), Silk Linen, Thai Silk (*see also* Noile under Spun)

FIBER CONTENT **Family:** Uneven silk produced during sericulture, although some may be wild.

Present: Slubby silk fibers, or this character imitated in MF fibers (some made purposely thick and thin), or cotton.

YARN Uneven, slubby; much is spun from waste silk (see noile under Spun File). In most Thai silk, slubs are much more noticeable in the weft direction, with a finer, smoother warp. Douppioni and "silk linen" may have slubs in both warp and weft yarns.

FABRIC CONSTRUCTION Usually plain weave. Thai silk fabric is narrow because it is hand woven.

WEIGHTS, USES Top or bottom weight. They are used for blouses, dresses, slacks, suits, neckwear, drapes, furniture, wall coverings.

NAMES Latin *duo*, meaning two, thus *douppioni*, from a double cocoon, which cannot be unreeled evenly. Thai silk comes, naturally, from Thailand.

ESSENTIALS Fabric plain weave, quite rough with slubs in weft direction at least. Thai silk has slubs, mainly in the weft. "Silk linen" has slubs in both warp and weft yarns, like linen. Douppioni may have slubs weft only or both ways.

Douppioni

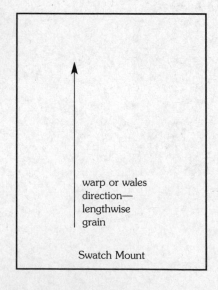

warp or wales
direction—
lengthwise
grain

Swatch Mount

Fabric Name

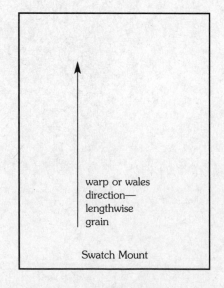

warp or wales
direction—
lengthwise
grain

Swatch Mount

Fabric Name

Split-Film Yarn (Fibrillated, Slit-Split, Stretched-Tape)

FIBER CONTENT **Present:** Usually polypropylene (olefin).

YARN Filaments are formed, not by "chemical spinning" of a liquid through spinneret holes, but by splitting a film or tape; this gives a flat fiber. A sheet of film (or a tape) is first "started" with slits made into it, then as the film is stretched it splits into fine filaments.

A few synthetic fiber types will form split-film filaments in this way, but polypropylene is most used. This is the least expensive way to produce a yarn, and polypropylene, the least costly of the strong MF fibers, is appropriate for the uses to which the yarn is put.

USES Considerable use as twine; it is strong and cheap, although rather slippery and difficult to knot securely. A major use is in a plain woven fabric, used as primary backing for tufted carpet (see photo). The backing material is not very attractive but is hidden in use; polypropylene is inert to conditions that can weaken carpet backing—altogether a satisfactory use. This application has cut deeply into the market for burlap (made of the cheapest natural fiber, jute), which was the traditional primary backing for tufted carpet. Split-film fabric is also used for secondary carpet backing. Fine split-film or fibrillated yarn is also used to knit the backing for some sliver-knit pile fabrics, e.g., for bed covers. Again, the backing yarn is hidden and gives strength at least expense. Split film material is light, stable, and rot resistant, useful for geotextiles and other industrial fabrics.

Primary backing, tufted carpet

NAMES, ESSENTIALS The names are from the less expensive method of filament yarn production, which gives a flat filament—no romance here, as with raschel, although *fibrillated* has a certain exotic sound.

warp or wales
direction—
lengthwise
grain

Swatch Mount

Fabric Name _____

warp or wales
direction—
lengthwise
grain

Swatch Mount

Fabric Name _____

Spun *as in* Spun Rayon *or* Spun Silk, Fuji, Noile,
Tsumugi (*see also* Silk, Uneven)

FIBER CONTENT **Family:** Waste silk, wild silk.

Present: Staple fiber of silk or any MF fiber which is also used as filament.

YARN Spun yarn is mechanically spun from staple (relatively short) fibers, drawn out and twisted to make yarn.

FABRIC CONSTRUCTION May be any; fuji, noile are usually plain weave.

WEIGHTS, USES Top or bottom weight, used for nightwear, loungewear, blouses, dresses, slacks, suits, neckwear, drapes, furniture coverings.

Silk noile

NAMES Spun yarn is made from staple (short) fibers (in contrast to silky filaments—very long fibers), so *spun rayon, spun silk,* etc., indicate this staple fiber form. This gives a character more like cotton, wool, or linen. Noile is named for *noils,* the shortest waste silk fibers, and noile fabric has little bumps of fiber on its surface. Japanese *tsumugi,* meaning handspun broken silk.

ESSENTIALS Staple fiber (relatively short) in spun yarn; spun silk may be waste (broken filaments from cultivated silk) or wild silk broken filaments. The surface of noile has little bumps from tiny lumps of the shortest waste silk (noils) in the yarn.

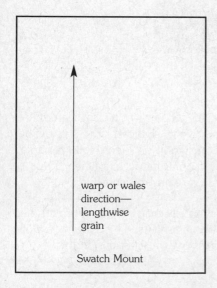

warp or wales
direction—
lengthwise
grain

Swatch Mount

Fabric Name

warp or wales
direction—
lengthwise
grain

Swatch Mount

Fabric Name

Stitchbonded (*or* Knit-Sew, Loop-Bond, Stitch-Knit), *also called* Mali (*or* Arachne)

FIBER CONTENT

Family: Not a historical fabric.

Present: Any, often acrylic or modacrylic; in industrial fabrics, also use glass fiber.

FABRIC CONSTRUCTION

Post-World War II fabric construction method, developed in then-East Germany (Mali) and Czechoslovakia (Arachne). Mali holds layers of yarns, fibers, foam, etc., together with (in most cases) yarn looped through, using a warp knit stitch. The machines produce fabric very quickly, compared to interlacing yarns on conventional weaving looms (see photos).

- **Malimo** fabrics have a set of vertical yarns, with crosswise yarns laid at a slight angle to each other, all stitched together with rows (wales or pillars) of warp knit loops.

- **Maliwatt** fabrics are composed of a fiber batting held with yarn looping, giving a corded effect.

- Other processes use no yarn at all; a web of fibers is held together by forming the fibers into stitches as in **Kunit** plush. These are discussed in *Fabric Reference*.

| Malimo | Maliwatt | Kunit | Kunit teddy bear |

(Illustrations courtesy of Malimo Maschinenbau GmbH)

WEIGHTS, USES

Stitchbonded fabrics range from top weight (can be semi-sheer) to heavy. The machines are now made by Karl Mayer Textilmaschinenfabrik GmbH, but the largest manufacturer of this type of fabric is Tietex International, Ltd., of Spartanburg, SC. Applications have been in many home and contract uses, including bedding and drapery, as well as industrial use.

NAMES *Mali* and *Malimo* from the inventor, Heinrich **Ma**uersberger, his home town of **Li**mbach, and **O**berfrohna, a part of Limbach in what was East Germany in 1958. An alternative version of the origin of the end of the name is from **mo**lleton, a woven fabric like melton, which was imitated in an early product. Origin of *plush*, see Velour Knit.

ESSENTIALS Components are held together by vertical wales of warp knit loops, like stitching, either using yarn for the looping, or forming stitches or half stitches by stitchbonding the fibers of a web.

warp or wales
direction—
lengthwise
grain

Swatch Mount

warp or wales
direction—
lengthwise
grain

Swatch Mount

Fabric Name

Fabric Name

Stretch for comfort or fit gives freedom of body movement, with stretch of 25–30 percent and recovery loss of usually no more than 2 to 5 percent. This stretch can be given in many ways; the main ones are: (1) bias cut in wovens,(2) knits, (3) stretch textured filament yarns, and (4) a (low) percentage of elastomer (a higher percentage of an elastomer such as gives power stretch—see Stretch, Power). Other methods are biconstituent fibers, and slack mercerization. All of these are discussed briefly here. See *Fabric Reference* for more detail on any.

FIBER, YARN, FABRIC CONSTRUCTION, USES

1. Woven fabric cut on the bias will give stretch or body-hugging fit, made use of in classic cuts of clothing and household articles, as in fitted upholstery, and bias-cut binding tape.

2. Knit fabric, especially weft knits, inherently possess comfort stretch and ability to fit closely to the body, which is the reason we use them for underwear, socks, gloves, and headgear. Tricot warp knit, unless it contains elastic yarns, has stretch only lengthwise (the direction of the wales).

3. Stretch can be introduced by using textured MF filament yarns, set by heat into a coil-spring shape or a curl; these are used in sportswear, stretch hosiery, gloves, etc., for fewer sizes.

4. There has been a major trend in apparel to include relatively small percentages (2–5%) of elastic fibers for comfort, fit, or just fashion. Some years ago this was aimed at giving shape recovery to cotton sweaters, which tend to bag compared to wool, or to ensure that hosiery would keep a body-hugging fit. It soon went on to give garments of classic woven fabrics this fit as an element of the fashion outline, or just to look unrumpled in all day wear. One big market is in jeans, to provide comfort for many older adults.

 The first elastic fiber so used was spandex (elastane), with the best-known brand name being Lycra® (by Invista, formerly DuPont Textiles and Interiors or DTI). However, this famous name no longer indicates specifically spandex, but comfort stretch by various means. Now other elastic fibers are also serving these purposes. One is elasterell-p, a sub-category of polyester, with the first one produced by DuPont, a bicomponent containing DuPont™ Sorona®. This fiber suits many comfort stretch purposes, e.g., in denim, as it is more durable to harsher washing processes than spandex. It has many of the good qualities of polyester as well. Also competing in this category is the first lastol fiber, the olefin-based XLA™ (by Dow Chemical), offering a soft stretch and giving excellent performance blended with fibers such as cotton, wool, or linen. See *Fabric Reference* fourth edition for more detail on elasterell-p and lastol.

Stretch knit

Popcorn knit

Bias cut woven

Much less commonly used to give comfort stretch:

5. Fibers combining an *elastomer* and another polymer in a *bicomponent* filament, as has been used in women's hosiery.

6. Cotton woven fabric mercerized without tension, leaving some "give" after this *slack mercerization*.

ESSENTIALS Stretch up to 35 percent; enough for comfort give in body movement or (smaller percentages) for fashion fit close to the body.

warp or wales
direction—
lengthwise
grain

Swatch Mount

warp or wales
direction—
lengthwise
grain

Swatch Mount

Fabric Name

Fabric Name

Power stretch (Sometimes called "active stretch") is the term applied to a fabric with sufficient stretch to supply body support or control (athletic compression garments, contour fashion): 35–50 percent, with recovery loss of no more than about 5 percent. For this, an *elastomer* is needed—a truly elastic fiber, in a significant percentage of fiber content, 10 percent up to a maximum of about 50 percent.

FIBER CONTENT (YARN)

Family: Rubber, the only natural elastomer, not found as a fiber; liquid latex is made into a fiber or yarn. Rubber is now also synthesized.

Present: Rubber is still used as an elastomer, but it must always be overwrapped or covered; more often, especially in more fashionable fabrics, spandex (elastane) is used, either uncovered, wrapped, or core spun. Spandex is used in amounts up to 50 percent (most often less), along with other fibers, usually nylon or polyester. The best-known trademark name, Lycra® (by DuPont), no longer signifies their spandex only. Before that, it was used almost as a generic and as if spandex were 100% of the fabric, which it never has been—so far! Special forms of Lycra® were developed to give better comfort (a softer fit), along with good control in waistbands or body-shaping apparel. Lycra® in athletic compression garment tests gave performance improvement with less fatigue

FABRIC CONSTRUCTION, USES

Some elastic waistbands, for instance, are woven, but the raschel type of warp knit has been the main construction for power stretch fabrics incorporating elastomeric yarn. Powernet (see photo) is such a knit fabric used for foundation garments (brassieres, girdles). Tricot warp knit has successfully incorporated spandex yarn and is used extensively for swimwear and actionwear.

**Powernet
(raschel warp knit)**

**Swimwear fabric
(tricot warp knit)**

ESSENTIALS Contains elastomer for power stretch: 35–50 percent stretch (enough for body support or control—athletic compression garments, contour fashion); recovery loss no more than 5 percent.

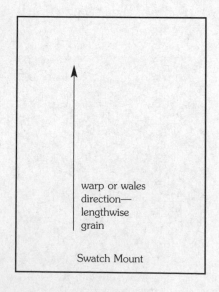

warp or wales
direction—
lengthwise
grain

Swatch Mount

warp or wales
direction—
lengthwise
grain

Swatch Mount

Fabric Name

Fabric Name

Sueded, Suede Cloth, Suede-Like, Brushed, "Doeskin," Emerized, Peached, Peau de Pêche, Sanded, Silk "Chamois" (*see also* Flocked; Nonwoven)

FIBER CONTENT

Family: Protein fibrils on surface of flesh side of tanned skin as in suede.

Present: Any, often cotton or blends, may be MF fiber, e.g., nylon, polyester (especially microfibers), some silk.

YARN

Spun or filament; if filament yarns are used, especially as in tricot or simplex, filaments will be broken to give the look and feel of suede. With microfibers or silk, such breaking of filaments gives the very soft feel of chamois or doeskin.

OTHER

If spun yarns are used, the fabric is brushed or napped so that the fibers are torn out of the yarn; if filament yarns are used, the fabric is sanded or emerized—rubbed with a sandpaper-like surface provided by emery-covered or carborundum rollers, so that filaments are broken to give a short, soft, close nap very much like the surface of real suede especially if microfilaments have been used. Some "sand-washed" silk has had similar treatment. Both brushing and sanding are dry finishing procedures.

WEIGHTS, USES

Top or bottom weight, used for nightwear, loungewear, blouses, dresses, sportswear, jackets, suits, gloves, accessories, upholstery duvet covers.

Sueded woven

Sueded tricot knit

NAMES

See Overcoat (2) for doeskin, peau de pêche; "peached," like peach skin; see Leather for chamois, suede.

ESSENTIALS

Fabric with short fiber ends on the surface to give a hand like real suede, an effect produced by brushing or sanding in dry finishing.

warp or wales direction— lengthwise grain		warp or wales direction— lengthwise grain
Swatch Mount		Swatch Mount

Fabric Name _____ **Fabric Name** _____

258

Surah, Foulard

FIBER CONTENT **Family:** Silk.

Present: Silk or MF filament.

YARN, FABRIC CONSTRUCTION Filament yarn, 2/2 right-hand twill weave.

OTHER Soft, smooth, closely woven fabric. Surah may be plain or printed; *foulard* is the name given when the fabric is printed in small geometric or other designs typical of classic scarf and necktie materials.

WEIGHTS, USES Top weight, used for neckwear, lingerie, robes, blouses, dresses, linings.

Surah—silky twill

Foulard ascot

NAMES French *surah*, meaning a silk fabric connected with the port city of Surat in northwestern India, where fine silks and cottons were dealt in; French *foulard*, meaning neckerchief or scarf.

ESSENTIALS Filament, top weight, smooth (lustrous), soft, 2/2 right-hand twill weave; surah may be printed or plain, foulard will be printed in small "necktie" motifs.

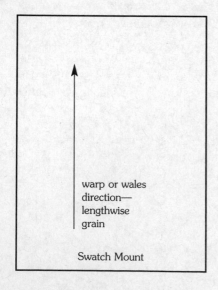

warp or wales
direction—
lengthwise
grain

Swatch Mount

Fabric Name

warp or wales
direction—
lengthwise
grain

Swatch Mount

Fabric Name

Taffeta, *includes* **Antique, Chameleon, Paper, Shot,** *and* **Tissue Taffeta** (*see also* **Color Variable** *regarding* **Chameleon, Shot Taffeta**)

FIBER CONTENT

Family: Silk.

Present: Silk or MF filament, except for slub weft in antique taffeta.

YARN, FABRIC CONSTRUCTION

Except for antique taffeta, only filament yarn is used, in a close, plain weave. Warp and weft are almost the same size, but there are many more warp than weft; this results in a firm, smooth fabric with a crosswise rib that is usually very fine. The changeable or iridescent fabric that results from using different colored yarns in warp and weft is called shot silk or shot taffeta; with two colors in the weft and a third in the warp, the result is chameleon taffeta. Antique taffeta has dark warp and slub weft yarns, similar to the arrangement in antique satin, except for the weave.

OTHER

Firm, crisp fabric, that rustles when moved. When made of silk, this rustle is called *scroop* and results from an acid treatment. A heavily heat-calendered taffeta gives ciré, with a shiny surface and yarns flattened to close up most of the spaces between; see Ciré. Sometimes a fabric with a rib as visible as in faille may have taffeta crispness; it is then called faille taffeta (or taffeta faille) (see Rib Woven, Allover). The woodgrain-patterned moiré is often a taffeta; see Moiré.

WEIGHTS, USES

Top weight as a rule, may be bottom weight. Used for dresses, ribbon, trim, lining, active sportswear (squall, ski jackets), also for curtains, lampshades, luggage lining, umbrellas.

NAMES

Persian *tafta*, a lustrous silk; archaic names: *taffatie* or *taffety;* for chameleon, see Color Variable; for antique, see Satin/Shantung; very light, sheer taffeta is called tissue taffeta; an extremely stiff, thin fabric may be called paper taffeta.

ESSENTIALS

Silky (filament), crisp, closely woven, smooth plain weave, but with crosswise ribs, usually very fine.

Taffeta

261

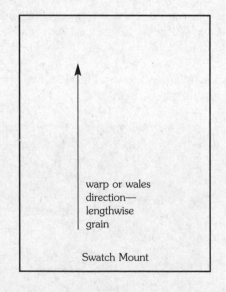

Fabric Name _____ **Fabric Name** _____

Tapestry, Gobelin (*see also* Tapestry Velvet *under* Velvet) (*see also* Jacquard Woven)

FIBER CONTENT

Family: Flax and wool.

Present: Cotton, wool, other staple fibers.

YARN, FABRIC CONSTRUCTION

Warp yarns are finer than the fairly heavy weft, giving a crosswise ribbed effect. Yarn dyed, woven closely in a complex pattern.

A small amount of tapestry is still *hand woven* (see Gobelin under Names). In this technique, weft yarn forming the design is woven in only where it appears on the face. However, almost all tapestry used today is jacquard woven, with the intricate pattern formed automatically (see *Fabric Reference* for more on jacquard weaving). In this method, each color of weft in a row of the design is carried across in the back when it does not appear on the face. This makes for a firm fabric that is neat on the back, but not generally reversible, since the design is usually much clearer on the face. Occasionally, a cheaper tapestry-like fabric will have a printed pattern.

WEIGHTS, USES

Bottom weight to heavy, used for upholstery, drapes, wall hangings, handbags, luggage, sometimes for jackets, coats.

Tapestry

NAMES

French *tapis*, meaning carpet, cloth, or cover. A name *Gobelin* given to tapestry comes from the Gobelins family, who set up a factory for hand weaving tapestry, late in the eighteenth century, on the Left Bank in Paris. The factory still exists, run by the government.

ESSENTIALS

Complex pattern, multicolor; crosswise ribbed effect with heavier weft yarns; firm, close jacquard weave; not reversible.

**Jacquard-woven tapestry scene.
Original size 30 cm × 30 cm (12" × 12").**

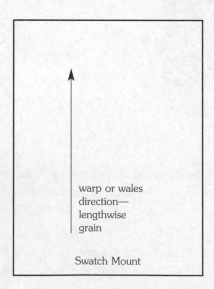

warp or wales
direction—
lengthwise
grain

Swatch Mount

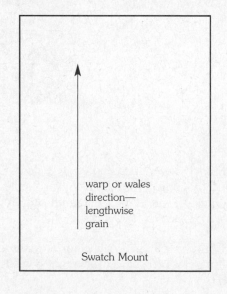

warp or wales
direction—
lengthwise
grain

Swatch Mount

Fabric Name

Fabric Name

264

FIBER CONTENT

Family: Wool, perhaps wool and flax from name derivation.

Present: Wool, blends of wool with cotton or MF fibers, or may have no wool; rarely of silk or other filament.

YARN, FABRIC CONSCTRUCTION

Carded or combed, warp and weft yarns the same size and closeness, with both sets dyed several colors. The arrangement of colors (*sett*) in an authentic tartan is almost always in the same order in the warp as it is in the weft; the fabric can be turned 90 degrees and the colors will line up exactly. Tartan is woven in an even, 2/2, right-hand twill.

OTHER

An authentic tartan has been approved and registered at Lyon Court, Edinburgh, Scotland, with the Lord Lyon, King of Arms. For one clan name there may be a clan, chief's, dress, and/or hunting tartan, plus patterns for family branches. There are also district and regimental tartans. Ancient tartans are of softer colors, as when natural dyes were used. Many other tartans are now registered, for instance, for a number of Canadian provinces.

WEIGHTS, USES

Original: Bottom weight, used for the long piece of wide fabric wrapped around the body to give the "belted plaid," latterly separated for Scottish Highland dress into the pleated and wrapped kilt, plus the long, straight piece of "plaid." Since early in the nineteenth century, some Scottish soldiers have worn tartan trousers ("trews") instead of the kilt.

Present: Today tartan is made from top weight to heavy, and is used for almost any apparel, accessory, or interiors and furnishing article, from scarves, dressing gowns, dresses, shirts, suits, and coats to drapes, blankets, and carpet.

Dress Stewart

NAMES Old French *tertaine,* meaning cloth half wool, half flax. (The Gaelic is *breacan,* derived from *breac,* meaning checkered—*see* Shepherd's Check under Check, Twill Weave.)

ESSENTIALS Colors in the warp and weft match (even sett); 2/2 right-hand twill weave; registered in Edinburgh.

Tartan vs. Plaid, Check A multicolor, yarn-dyed woven check that does not conform to the Essentials outlined in this File should be called a plaid— that is, all tartans are plaids, but not all plaids are tartans. A fabric woven using yarns in limited colors, in blocks with light-colored, is called a check; an exception is the shepherd's check, also called shepherd's plaid—*see* Check, Twill Weave.

For twill weave plaid/check, see also Overcoat (4); for twill weave check, see also Check, Twill Weave.

For plain weave plaid, see also Gingham, Madras; for plain weave check see Gingham, Oxford Cloth (Tattersall in shirting).

warp or wales direction— lengthwise grain

Swatch Mount

warp or wales direction— lengthwise grain

Swatch Mount

Fabric Name

Fabric Name

Terry Cloth, Terry/Velour, Turkish Toweling (*see* Velour Knit *for* Terry Knit)

FIBER CONTENT

Family: Probably cotton, perhaps flax.

Present: Cotton, blends, usually with polyester, rayon also sometimes used.

YARN, FABRIC CONSTRUCTION, OTHER

Carded yarn; warp pile weave, usually slack-tension warp method. An interval is created between the cloth already woven and the next weft insertions. Tension is let off the pile warp yarns when these weft yarns are beaten up, causing loops to be formed, which can be on either or both sides. The loops can later be sheared, to form velour. Terry can be woven with jacquard patterns or with a simpler, narrow dobby pattern in a hem border. Some terry looms can weave several towel widths side by side in different color combinations. Terry can also be woven by the over-wire method, but this is rarely done.

WEIGHTS, USES

Bottom weight to heavy, used for towels, also for loungewear and sportswear—anywhere absorbency and washability plus warmth are advantages. Uncut loops give best absorbency, cut loops (velour) give a luxurious, velvety hand.

Terry/velour

NAMES

Terry from French *tirer,* meaning to pull out; pile loops were pulled out by hand in Turkey to make the absorbent Turkish toweling. Latin *vellus,* meaning hair, the derivation of *velour.*

ESSENTIALS

Cotton family warp pile woven; uncut loops both sides in terry cloth, for best absorbency; when loops are cut, the fabric is called velour.

warp or wales direction— lengthwise grain	warp or wales direction— lengthwise grain
Swatch Mount	Swatch Mount

Fabric Name **Fabric Name**

Ticking (Includes distinction between traditional Ticking and most modern mattress coverings)

Ticking is the name still used for mattress covering, but what is seen today on any fashionable box spring or mattress is almost never traditional ticking. That material, written up below, has many uses, but fashionable bed sets will have a tricot or jacquard-woven covering, probably printed. A photo of one of these is included below for this reason—a "satinized" nylon tricot with a luxurious-looking transfer- or rotary-screen-printed design. Other ticking mattress coverings are jacquard woven, which may be overprinted (see next page), or chintz (see appropriate Files for these fabric names) (see Print, Large Scale, plus *Fabric Reference* for information on these printing processes). Circular knit tickings have been made, to fit better on foam mattresses. A different type has been produced by Tietex, using a BodyClimate® Polartec® fabric, originally developed by Malden Mills for apparel. It has stretch and recovery, but also wicks and has temperature-regulating properties that make it more comfortable for the person lying on a visco ("memory foam") or latex foam mattress.

Because traditional ticking is still used, its full description follows:

Ticking (Traditional), *includes* Broché Coutil, Coutil (*see also* Drill)

FIBER CONTENT	**Family:** Probably flax or hemp, since ticking was originally used for closely woven and durable covers (ticks) for down/feathers in mattresses and pillows.
	Present: Cotton, blends, usually with polyester.
YARN, FABRIC CONSTRUCTION, OTHER	Yarn carded only, weft may be lower twist than warp, and during use, this softer-twist yarn spreads to close up the fabric. Ticking traditionally has warpwise yarn-dyed stripes. It is often made in 2/1 warp-face twill weave (see photo), but may be plain or satin weave; it is always closely woven. Coutil is also firm and closely woven, but in a fine herringbone 2/1 twill.

Traditional

Ticking
(Courtesy of Culp Home
Fashions, Culp Ticking Division)

Coutil

Jacquard woven fashion ticking
(Courtesy of Culp Home Fashions, Culp Ticking Division)

WEIGHTS, USES	Traditional woven ticking is a durable bottom-weight fabric, still used for pillow and mattress coverings, furnishings, also for sportswear or workwear. Striped ticking is the material we associate with a railroad engineer's overalls and hat. Coutil is the typical nonstretch fabric used in corsets or surgical belts. Broché coutil, with a jacquard design woven in (see Jacquard Woven), is preferred for corsets in much period costuming.
NAMES	Latin *teca,* meaning case, i.e., pillow or mattress "tick," case, or cover; French *coutil,* meaning drill, twill, ticking (Drill is a separate File).
ESSENTIALS	Cotton family; close weave; ticking is usually warp-face twill, often with warp-wise stripes; coutil is a fine herringbone weave.

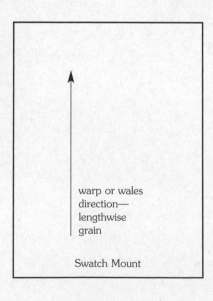

warp or wales
direction—
lengthwise
grain

Swatch Mount

warp or wales
direction—
lengthwise
grain

Swatch Mount

Fabric Name

Fabric Name

Tricot, Souffle (*includes* Simplex)

FIBER CONTENT

Family: Silk.

Present: Rarely silk, usually MF fiber, often nylon or polyester, may include some spandex; cotton only on specially adapted machines.

YARN, FABRIC CONSTRUCTION

Almost always filament yarn, dictated by the type of needle used on the tricot machine. This is warp knitting, where a yarn end is fed to each needle from the lengthwise direction. Guide bars move the yarns from side to side, to loop now on one needle, now on another, forming crosswise lines of a zig-zag pattern on the technical back of tricot, while the technical face shows lengthwise wales that *look like* plain stitch (see Jersey). Tricot is a very stable fabric, even in a sheer; loops do not unravel or run; there is some stretch crosswise but little give lengthwise. With multicolored tricot, the technical back is often the right side, since the lengthwise stripes of color join neatly on the back; printing may be on the technical back or face, making that the right side (see photo).

Simplex is like a double tricot, and has the plain stitch or jersey look on both sides (see photo).

Souffle is a sheer (often flesh-colored) tricot (see photo).

OTHER

Tricot may be calendered to give a smooth finish called satinized. Cotton simplex for gloves is shrunk in caustic soda and sueded.

WEIGHT, USES

Tricot is made in weights from sheer to heavy; used for lingerie, nightwear, bridal and evening wear, loungewear, linings, dresses, upholstery. Simplex is usually bottom weight, used for its greater firmness in loungewear or more tailored wear, such as nurse's uniforms, and also for gloves. Souffle is used in ballet and theater costuming and in museum and other costume exhibitions to provide nearly invisible support to other parts of a garment.

Souffle

Tricot

Simplex glove edge

271

NAME

French *tricoter,* meaning to knit, but in English *tricot* means the product of this specific warp knitting machine. French *souffle*, meaning a breath, hence a very light fabric.

ESSENTIALS

Warp knit; look of plain stitch wales on the face of tricot and on both sides of simplex; tricot has a zig-zag pattern across the back; usually filament yarn.

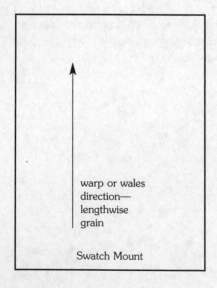

warp or wales
direction—
lengthwise
grain

Swatch Mount

warp or wales
direction—
lengthwise
grain

Swatch Mount

Fabric Name

Fabric Name

Tropical Worsted, Panama (*see also* Worsted Suiting)

FIBER CONTENT **Family:** Wool.

Present: Wool or blends, often with polyester, viscose.

YARN Combed (worsted) yarn—any shorter fibers removed in spinning, the rest laid almost parallel to each other, yarn smooth, well twisted.

FABRIC CONSTRUCTION, OTHER Usually plain but not close weave, to allow air circulation for hot weather. Clear finish for crisp suiting.

WEIGHT, USES Light end of bottom weight for hot-weather suiting, slacks, skirts.

Tropical worsted

NAME *Worsted* takes its name from the village of Worstead, near Norwich, England, where a high-quality wool cloth was being made by the twelfth century; tropical worsted is a plain weave suiting developed for wear in tropical heat.

ESSENTIALS Combed (worsted) yarn, smooth, crisp; tropical worsted usually plain but not close weave, made in lightest bottom weight for hot-weather suiting.

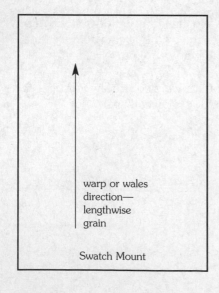

warp or wales
direction—
lengthwise
grain

Swatch Mount

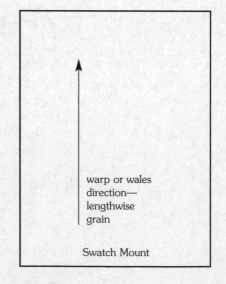

warp or wales
direction—
lengthwise
grain

Swatch Mount

Fabric Name _____ **Fabric Name** _____

Tufted (Carpet), *also* Candlewick (*or* Chenille)

FIBER, YARN, FABRIC CONSTRUCTION, OTHER	Pile fabric made by punching yarns into a basic fabric, usually plain woven. May be any fiber content or yarn type; pile may be cut or uncut (except candlewick). Most tufted fabrics are coated on the back to hold the pile in place (except candlewick). See *Fabric Reference* for more detail on tufting of carpets.
WEIGHTS, USES	Over 95 percent of carpeting today is tufted, thus heavy weight is most common, although tufted mats, for instance, are not so heavy. Tufted carpets are made with spun or textured filament synthetic fiber yarn, or wool yarn, pushed into a primary backing, usually woven, of jute (see Burlap) or polypropylene (see Split-film Yarn).
	One distinctive lighter tufted fabric is Candlewick or Chenille, used especially for bedspreads. It is described more fully below.

Candlewick, Chenille

FIBER CONTENT	**Family:** Cotton.
	Present: Cotton, blends.
YARN, OTHER	Yarns are carded only; base fabric is woven in finer, firmer yarns than the low-twist, plied yarns used for tufting the pile. Tufts have cut ends. Unlike most tufted fabrics that need a coating on the back to secure the tufts, candlewick has no coating. The tufts are held in place by the opening out (*blooming*) of the thick, soft-twist cotton pile yarns during wet finishing, plus shrinkage of the base fabric.
WEIGHT, USES	Bottom weight, used for housecoats, sportswear, mats, bedspreads, upholstery.

Candlewick

275

NAMES French *chenille,* meaning caterpillar. Ends of candlewicks are said to have been hand-hooked into cotton fabric in the southern United States from about 1700 to create the pile fabric candlewick. This Colonial craft skill was revived around 1900 by Catherine Evans (later Whitener) of Dalton, in the hilly country of North Georgia. She hooked in a thick, soft, plied yarn, cut to give the tufts. Machine tufting developed, especially after WWII, and has engulfed carpet manufacture.

ESSENTIAL Soft, low-twist cotton yarn punched into a fabric substrate, usually woven cotton, may be stitch-knit or nonwoven.

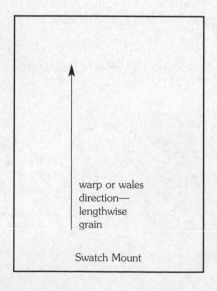

warp or wales
direction—
lengthwise
grain

Swatch Mount

Fabric Name

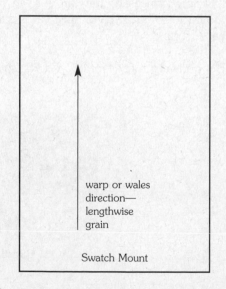

warp or wales
direction—
lengthwise
grain

Swatch Mount

Fabric Name

276

Tweed, Homespun, *also* Saxony, *includes* Cheviot, Donegal, Harris, Irish, Knickerbocker, Scottish, Shetland, Thornproof (*see also* Covert *under* Twill, Steep)

FIBER CONTENT

Family: Wool, fairly coarse.

Present: Fairly coarse wool, or cotton, MF fibers and blends; may include *effect fibers:* coarse, white kempy wool or reindeer hair (see photo). Saxony is a similar fabric, made from softer (finer) wool.

COLORATION, YARN

Fibers usually stock-dyed, with the colored fibers blended in spinning to give a misty *heather* effect. Heather effects are also achieved when naturally colored wool is blended. Wool from the four-horned Jacob sheep, for example, ranges in color from very dark brown to almost white. When dyed later in spinning at the roving stage, the effect is a mottled *marl* coloring—two tones of the same color, often a 2-ply yarn, with one darker than the other or the "mixey" look called *salt and pepper* or *ragg*. A heather or marl effect is also achieved by printing of top or sliver, called *mélange*, or *vigoreaux*. *Nubs*—small lumps of fiber of contrasting color—are also characteristic of yarns in tweed (see photo Donegal tweed); these yarns may be called nub or knop, also knot, bourette, knickerbocker, nep, or spot. Yarn is carded only (woolen spun), and so is rough and hairy.

WEAVE

Scottish tweeds are right-hand twill weave; some well-known Irish tweeds such as Donegal are plain weave, while others are twill; homespun is a simple, tweed-like fabric made in plain weave. Some tweeds are basket plain; a few may be dobby, but none is really complex. See Herringbone for photo of reversing twill weave tweed.

OTHER

Tweed, like most fabrics of wool, undergoes fulling in finishing—felting on purpose, to close up the yarns and make the fabric warmer. Traditionally, this was done by working the damp fabric with the feet or hands; machines imitate this action, the fulling mill with giant wooden blocks pounding the wet fabric or the more common machines squeezing the wet fabric, to promote gradual felting.

TYPES

Cheviot. Made from the wool of sheep raised in the Cheviot Hills in the Scottish borders, or from similar fairly rough wool (56s or coarser). Other tweed names derive from the same area, e.g., Galashiels (Gala), a borders wool textile center, and Bannockburn, which uses single yarns alternating with 2-ply, with marl color effects.

Donegal. Plain weave, nubs of various colors in the yarn, usually heather effect. Genuine Donegal tweed is handwoven in County Donegal, Ulster Province, northwestern Ireland, but there is much "Donegal-type" tweed. This tweed may have white warp, dark weft. (See photo.) Also see *Irish tweed.*

warp or wales direction— lengthwise grain	warp or wales direction— lengthwise grain
Swatch Mount	Swatch Mount

Fabric Name **Fabric Name**

Harris. Law prohibits use of the name *Harris* unless the fabric carries the "orb" certification mark (see photo), so there is no "Harris-type" tweed. The name means that it is made of 100 percent Scottish wool, spun, dyed and finished (by machine and the most modern methods), but *handwoven* at crofts on the Isle of Lewis in the Outer Hebrides, Scotland. Made not only in the standard bottom weight, but now 90 percent is in lighter weights (light, bantam, super bantam) down to "featherweight." Rapier-type looms that weave 2 m (80 inches) wide cloth have been adapted to pedal operation.

Irish. General term for tweeds originating in Ireland, made in plain or twill weave, often with white warp, dark weft yarns.

knickerbocker. Tweed made with colored nubs, perhaps associated with the knee-length "knickerbockers" or "plus fours."

Scottish. All tweeds woven in Scotland are 2/2 right-hand twill weave; they may be herringbone, and almost always show heather effect or marl.

Shetland. Made from the fairly coarse, sturdy wool of sheep raised on the Shetland Islands, northeast of Scotland.

Saxony. Similar to tweeds, but made of finer, softer wool.

thornproof. A tough tweed, woven with well-twisted yarns packed close together.

Other tweed names: Bute, Connemara, Craiganputtach, Glengarry, Linton, Lovat, Manx.

WEIGHTS, USES Usually bottom weight and heavier, used for slacks, skirts, suits, coats, upholstery, with increasingly important lighter weights for dresses, skirts, slacks. Harris tweed, for example, has sold more and more of its output in light, bantam, super bantam, and featherweight.

Effect fiber in tweed

Donegal tweed

Harris tweed tag

NAMES *Tweed* possibly a mistake (Scottish *tweel,* meaning twill), and/or a connection with the many wool cloth-making centers in the Scottish borders, along or near the River Tweed. French *bourre,* meaning flock or floss, *bourette* being a diminutive. *Ragg* from reclaimed ragg wool.

ESSENTIALS Fairly coarse wool, hairy yarns, stock dyed, simple weave (usually plain or twill).

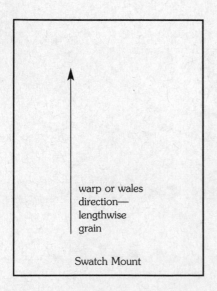

warp or wales
direction—
lengthwise
grain

Swatch Mount

Fabric Name

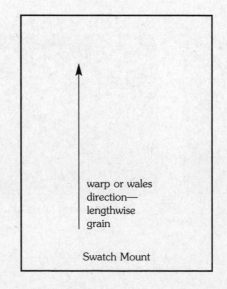

warp or wales
direction—
lengthwise
grain

Swatch Mount

Fabric Name

Twill, Steep (Strong), *includes* Artillery Cord, Cavalry Twill, Covert (Cloth), Élastique, Tricotine, Whipcord (*see also* Barathea, Chino, Denim, Drill, Gaberdine, Ticking *in which twill is or can be steep*)

Fabrics woven with a steep twill line represent materials which can take hard wear. Several from the wool family established themselves as durable for riding pants: cavalry twill, also known as tricotine and élastique; and whipcord or artillery cord, plus some that may have a regular or steep twill line, such as barathea.

Of course there is a well-known group from the cotton family, some with regular twill angle and some either regular or steep; for these, consult the Files on: chino, denim, drill, gaberdine, and ticking.

A *regular* twill has a wale line angle of 45° to the selvage; a *steep* twill has a 63° angle. The steep twill line is formed when more warp is packed in. Since warp yarns are stronger than weft, the steep twill fabric will be more durable (other things such as fiber content and yarn quality being equivalent); see photos of regular and steep twill gabardine, under Gabardine.

Artillery Cord, Cavalry Twill, Covert, Élastique, Tricotine; Whipcord

FIBER CONTENT	**Family:** Wool.
	Present: Best quality still wool or blends; active sportswear often polyester; general sportswear may even use cotton, rayon.
YARN	Worsted combed, if made of wool; better quality of any fiber will be combed. Covert is usually marl yarn, with mottled coloring (see Tweed for marl).

Cavalry twill Covert Whipcord

FABRIC CONSTRUCTION, OTHER	Steep right-hand irregular or broken twill weave. Cavalry twill (élastique, tricotine) has a clear *double twill line*; whipcord (artillery cord) has a *prominent, raised twill wale line*. Clear finish, giving tight face, smooth except for the twill lines.
WEIGHT, USES	Usually bottom weight or heavier for hard wear: uniforms, coats, suits, riding pants, sportswear, upholstery.
NAMES	*Artillery cord* connects to use as uniforms. *Cavalry twill* from use as tough material for riding pants (cavalry uniforms). French *élastique*, meaning springy, resilient. *Tricotine* from French *tricoter*, meaning to knit—the double twill line gives the appearance of a plain knit face (except for the line running diagonally). *Covert cloth* was also developed for riding pants, the smooth finish and mottled color preventing or masking the picking up of twigs and such while crashing through *coverts*—thickets where game finds cover; French *couvrir*, to cover. *Whipcord* has a twill wale line that stands out like the cord of a whip.
ESSENTIALS	Steep, right-hand twill weave; cavalry twill with pronounced double line, covert with mottled coloring, whipcord with raised, cord-like line.

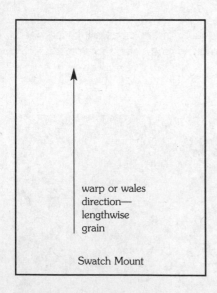

warp or wales
direction—
lengthwise
grain

Swatch Mount

Fabric Name

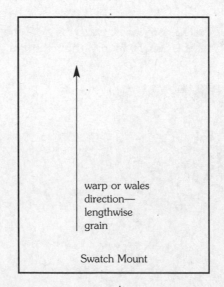

warp or wales
direction—
lengthwise
grain

Swatch Mount

Fabric Name

Velour Knit, *also* Plush Knit, Terry Knit, Velvet Knit (*see also* Fleece Knit, Two Face) (*see also* Velvet Woven Pile *for* Panne Velvet)

FIBER CONTENT

Family: Probably silk (French *velours*, meaning velvet; see Velvet).

Present: Cotton and blends, also MF fibers, often acrylic or polyester.

YARN, FABRIC CONSTRUCTION, OTHER

Carded yarn, weft knit on special circular plain stitch machines, with extra yarn knitted into the back of the plain stitch (inlay) and pulled out to form loops for terry knit. These loops are later sheared to make the cut pile surface of knit velour or plush knit. (Some plush knit is sliver-knit; some is stitch-knit; see Fur-like; Stitch-knit.) Where the pile is not as deep, the fabric may be called knit velvet; some is weft knit as described for knit velour, but much is warp knit—a tricot ground with extra yarns laid in and later sheared.

WEIGHTS, USES

Top to bottom weight and heavier, used for nightwear, loungewear, infants' and children's wear, leisurewear, sportswear, coats, toys, upholstery.

Velour knit

Terry knit

NAMES

Velour from Latin *vellus*, meaning hair, or French *velours*, meaning velvet; *plush* from French *peluche,* meaning shaggy; *terry* from French *tirer,* meaning to pull out, as pile loops originally were in terry.

ESSENTIALS

Spun yarn knit pile, extra yarn inlaid at the back of the plain stitch weft knit (jersey stitch), pulled out into loops (terry knit); may be sheared to form cut pile surface (knit velour, plush knit). Allover cut pile not as deep as velour is called knit velvet; pile laid all one way is called knit panne velvet. These effects can also be achieved with filament yarn and a warp knit (tricot) ground.

warp or wales direction— lengthwise grain	warp or wales direction— lengthwise grain
Swatch Mount	Swatch Mount

Fabric Name **Fabric Name**

Velour Woven Pile, *also* Plush

FIBER CONTENT

Family: Probably silk (French *velours*, meaning velvet; see Velvet).

Present: Velour pile woven in cotton, blends also MF fibers; plush woven of cotton, wool, MF fibers, and, for paint rollers and very high-grade upholstery, of mohair.

YARN, FABRIC CONSTRUCTION

Carded yarn, warp pile weave, usually double cloth method. The pile in velour is longer, more dense than in cotton velvet; pile in plush stands erect, is longer but less dense than velvet, made of cotton or wool. There is now also knit velour or plush—see Velour Knit. See also Stitch-Knit (Kunit) for plush.

WEIGHTS, USES

Bottom weight to heavy, velour used for sportswear, loungewear, evening wear, upholstery, drapes; plush used for toys, upholstery, and, in mohair especially, paint roller covers. The original teddy bear fabric was a wool woven plush; today it is usually knit or Stitch-Knit, except the highest price range (see photo Stitch-Knit.)

| Woven velour | Plush |

NAMES

See Velour Knit.

ESSENTIALS

Cotton family (also wool, hair for plush); warp pile woven; longer pile than velvet, and velour is more dense; plush pile stands erect, is longer but less dense than velvet pile.

warp or wales direction— lengthwise grain

Swatch Mount

Fabric Name _____

warp or wales direction— lengthwise grain

Swatch Mount

Fabric Name _____

Velvet, *includes* **Bagheera, Brocaded, Chiffon; Ciselé; Cotton; Genoa; Lyons; Nacre; Panne; Sculptured; Soprarizzo; Tapestry; Voided,** *also* **Frisé (***sometimes misspelled Freizé, Friezé***), Moquette (***see* **Pattern Applied—Chemical, Burned-Out** *for* **Coupe de Velours** *and* **Dévoré** *or* **Façonné Velvet); (***see also* **Velour [***including* **Plush]; Velveteen; Flocked** *for* **Velvet-Like)**

FIBER CONTENT	**Family:** Silk.
	Present: The fabric called simply velvet is understood to have pile of filament—silk or MF fiber; if made of cotton, should be called cotton velvet.
YARN, FABRIC CONSTRUCTION, OTHER	One set each of warp and weft yarns weave the back (plain or twill); an extra set of warp forms the pile. A ground of twill weave can hold the pile tufts better; it is called *twill-*, *jean-*, or *Genoa-back*. Most velvet today has an allover cut-pile surface, given by cutting apart a double cloth. For surface variations, the over-wire method is used, in which the pile warp is held up; with this method, pile may be cut or uncut and of varying heights in different rows. Frisé is also over-wire, as it always contains uncut loops. (See photo.) Moquette is usually made this way, but it may have cut loops, made by the double cloth method. Velvet may be crushed, embossed, sculptured, or be given a crush-resistant finish.
TYPES	*bagheera velvet.* Uncut pile, but very fine, firm ground, for apparel.
	brocaded velvet. Some pile raised above the rest of the fabric, to give an embroidered effect; see Brocade.
	chiffon velvet. Very light, soft, drapable velvet. Fine filament yarns, pile short, slightly more dense than *transparent velvet* (reference Chiffon). (See photo.)
	ciselé velvet. Figured velvet, cut and uncut pile, may have some satin ground. (See photo.)

Chiffon velvet

Ciselé velvet

287

warp or wales
direction—
lengthwise
grain

Swatch Mount

Fabric Name

warp or wales
direction—
lengthwise
grain

Swatch Mount

Fabric Name

cotton velvet. Ground and pile of cotton or blends, more dense than velveteen and so is used in jackets, suits, furnishings, for better wear. Pile is not so long, dense, or plush as velour.

Genoa velvet. Similar to ciselé, satin ground, multicolored pile.

Lyons velvet. Heavier, stiff velvet, with firm, short pile; may have spun yarn ground.

nacre velvet. The ground warp and weft are a different color from the pile. Some pile is flattened by embossing, so that a changeable, *mother-of-pearl* effect is created; French *nacre,* meaning mother-of-pearl.

panne velvet. Light-weight velvet; pile is shorter than plush and pressed sharply down in finishing to give a high luster. French *panne,* meaning plush. There is also knit panne velvet, either a weft or warp knit (see Velour, Knit).

sculptured velvet. High/low pile can be produced by embossing *(gauffering—see* Pattern Applied—Pressure). In true sculpturing, some pile is cut away: part is first flattened, the rest is sheared off, and what was pressed down is brushed up.

soprarizzo velvet. Cut and uncut pile, as ciselé.

tapestry velvet. Jacquard woven velvet, with tapestry-like pattern in pile, raised above the ground. (See photo.) (*See also* Tapestry.)

voided velvet. Velvet pattern with satin ground. (See photo.)

Frisé

Tapestry velvet

Voided Velvet

WEIGHTS, USES Much velvet is bottom weight, some lighter or heavier, used for dresses, suits, coats, shoes, hats, trim (especially for formal and evening wear), drapes, upholstery; frisé, moquette, and tapestry velvet are used principally for upholstery.

NAMES Latin *vellus,* meaning hair (note French *velours,* meaning velvet, but velour is a separate fabric in English); French *frisé,* meaning curled; French *moquette,* tufted fabric; see derivations of other names under Types.

ESSENTIALS Warp pile weave; velvet is taken to be an even, allover, cut pile of silk or MF filament, unless a specific name is attached, as cotton velvet, ciselé velvet, etc.

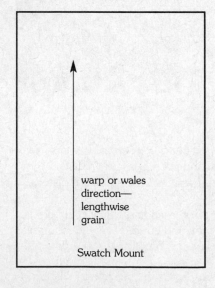

warp or wales
direction—
lengthwise
grain

Swatch Mount

Fabric Name

warp or wales
direction—
lengthwise
grain

Swatch Mount

Fabric Name

Velveteen (*see also* Flocked *for* Velveteen-Like)

FIBER CONTENT, YARN, FABRIC CONSTRUCTION, OTHER

Much of the basic information in the Corduroy File regarding uncut corduroy applies to velveteen as well, since it is a cotton family, weft pile weave fabric. The main difference is that the floats of extra weft yarns are arranged all over the fabric for velveteen, not in vertical rows; the result is that when cut, there is no visible wale, only a short, close pile. Cutting these pile floats still takes a very long time, for it cannot be mechanized even to the degree corduroy cutting can. The best-quality velveteen will have long staple cotton fiber, combed mercerized yarns, and a twill weave ground (which holds the pile tufts better), called *twill-, jean-,* or *Genoa-back*.

WEIGHTS, USES

Bottom weight; if a heavier cotton pile fabric is wanted, e.g., for upholstery, it will usually be made by a warp pile method, to give a closer fabric with more dense pile—in other words, a cotton velvet. Velveteen is used for children's and women's wear more than for men's wear, to give a less expensive dressy fabric, where durability is not a chief requirement. Also used for drapes and other interior furnishings.

Velveteen

NAME

Root stem same as for velvet, from the Latin *vellus,* meaning hair; the suffix "een" indicates a diminutive, as it does in sateen for instance, a silk family fabric made of cotton. Like corduroy, velveteen historically was less luxurious than velvet, which could be made only of silk until the advent of MF filament fibers.

ESSENTIALS

One set each of warp and weft yarns to weave the back, extra weft interlaced in small, scattered floats, which are later cut, to give a short, dense pile.

warp or wales
direction—
lengthwise
grain

Swatch Mount

warp or wales
direction—
lengthwise
grain

Swatch Mount

Fabric Name

Fabric Name

Voile (Cotton Type), *plus reference to* Wool Voile, Nun's Veiling

FIBER CONTENT

Family: Originally flax, possibly silk.

Present: Cotton and blends; the best quality is long staple; there is also a wool voile, which is very similar to nun's veiling; for the silk or MF filament type, see Voile (filament).

YARN

Cotton type uses fine, high-twist, combed yarn for smoothness in good-quality voile; the high-twist yarn gives firmness, and the very best quality (see photo) will be 2-ply twist-on-twist yarn, plied in the same direction as the singles. The fabrics using wool are also made of high-twist yarns.

FABRIC CONSTRUCTION, OTHER

Balanced, open plain weave for sheer fabric. Lower-quality cotton voile may have a stiffening (sizing) added in finishing. The best-quality cotton voile is gassed, so that the gas flame burns off any protruding fiber ends.

WEIGHT, USES

Light, sheer fabric, used for lingerie, nightwear, blouses, shirts, dresses, curtains.

Cotton voile

NAME

French *voile*, meaning a veil; nun's veiling is used for religious clothing.

ESSENTIALS

Firm from high-twist yarns; sheer, open plain weave.

warp or wales
direction—
lengthwise
grain

Swatch Mount

Fabric Name _____

warp or wales
direction—
lengthwise
grain

Swatch Mount

Fabric Name _____

294

Voile (Filament), Ninon, *also* Gaze *or* Gazar (*see also* Gauze)

FIBER CONTENT

Family: Silk.

Present: Rarely silk, usually MF filament, often polyester or nylon for apparel, polyester for sheer curtains ("sheers").

YARN, FABRIC CONSTRUCTION, OTHER

Fine filament yarn of sufficient twist to make it firm; balanced plain weave, sheer. Silk ninon was traditionally made with two or three warp yarns taken as one, and two or three weft lightly twisted together (called double or triple ninon), giving almost a mesh effect. Now usually single yarns, and called voile when used for sheer curtains. Silk gaze or gazar may be plain weave or leno (see Leno). Polyester voile for curtains may be constructed to be burnt-out, leaving some areas more "see through" than others (see Pattern Applied—Chemical).

OTHER

Filament voile (ninon) is drapable, not crisp as is organza or mousseline de soie; it is less drapable than georgette or chiffon, not as soft as chiffon, and not dull and crepy as are both georgette and chiffon.

USES

Lingerie, party and bridal wear, neckwear, trim, millinery, but especially sheer curtains ("sheers").

Filament voile

NAMES

French *voile,* meaning a veil. If the fabric today is called simply voile, it is assumed to be cotton voile; if made of filament fiber, that would be named, for instance in sheers, "polyester voile." French *ninon,* a diminutive of Anne—no clue how this came to be attached to this fabric. French *gaze,* meaning gauze (see Gauze).

ESSENTIALS

Filament, sheer plain weave, less soft than chiffon and not crepe yarns as in chiffon and georgette, less crisp than organza or mousseline de soie.

warp or wales direction— lengthwise grain	warp or wales direction— lengthwise grain
Swatch Mount	Swatch Mount

Fabric Name **Fabric Name**

A fabric, to be truly waterproof, not simply water repellent or resistant, must not allow water to penetrate, even when it falls on the material with great force, as in a cloudburst, heavy seas, or firefighting; garment seams must also be sealed.

Oilskin, developed to give light but waterproof wear for slickers and sou'westers (for deep sea fishing), is a fine fabric like lawn, percale, or taffeta, treated with a drying oil such as linseed, oxidized to a stiff, yellow, translucent finish. Light-weight **slicker** fabric today is usually coated with urethane (polyurethane or PU). Waxes and metallic soaps have provided other waterproof treatments. Heavier fabrics for "swamp coats" or firefighters' protective clothing may be given a latex (liquid rubber) **coating,** or vinyl coating may be used (polyvinyl chloride or PVC). Neither rubber nor vinyl can be dry-cleaned, and they may become brittle at low temperatures.

Another route to a waterproof fabric is to use **film,** as we do for shower curtains and inexpensive rainwear. The biggest problem in using a film or the coatings listed above (as usually produced for clothing) is that they are impervious not only to (liquid) water, but to water vapor as well; this means that perspiration vapor cannot pass through the material (it does not "breathe"), and so a person wearing a raincoat, for example, could be dry on the outside but wet on the *inside* from perspiration!

Microporous PU is a waterproof coating that allows water vapor (perspiration) to pass through; it is also dry-cleanable. A microporous film such as is used in Gore-Tex® fabrics does the same thing. Either allows clothing to be waterproof (and windproof) yet comfortable for "all weather" and extended use. Gore-Tex® film with raised abrasion-resistant dots (see photo) allows lighter fabric Paclite™ that does not require backing liner.

Poplin, microporous PU Coatingon back

Rip-stop ciré laminated to Paclite™ Gore-Tex® film, needs no protective backing.
(Courtesy of W.L. Gore & Associates, Inc.)

ESSENTIALS Fabric impervious to water, no matter with what force it falls; such fabric will also be windproof. There may be a surface coating, or a layer in a compound fabric, that prevents water drops from passing through.

warp or wales
direction—
lengthwise
grain

Swatch Mount

warp or wales
direction—
lengthwise
grain

Swatch Mount

Fabric Name

Fabric Name

Water Repellent/Resistant (Showerproof), Soil or Stain Repellent/Resistant
(*includes* Soil Release) (*see also* Waterproof)

Water-repellent or -resistant fabric will hold off liquid, for example rain, in a fairly light fall; in rainwear, it is often called *showerproof* (a more positive-sounding term). If water falls on the material with great force, however, such fabric will become wet. Such fabrics will also repel water-borne stains; some types of formulations resist both water- and oil-borne stains, giving *soil or stain resistance*.

Soil release is included in this File, although it serves another purpose from soil or stain *resistance*. Fabrics that are difficult to clean, or are seldom cleaned, benefit greatly from a good soil resistant finish; examples are carpets and upholstered furniture. Items that will be washed frequently, especially when made of polyester, perform better with a good soil release finish; examples are polyester tablecloths, or cotton/polyester workwear. However, some prominent finishes are described as giving both water and oil repellency *and* stain release.

Water repellency: Can be contributed by choice of fiber and yarn, fabric construction, or finish.

Fabric constructions, including fiber and yarn type: Give water resistance:

Closely woven cotton: For instance, canvas will hold out water by virtue of the swelling of the cotton fibers when wet, *if* the material is hanging free, as in a tent; the effectiveness can be increased with finishes such as wax-containing products or application of tar, which gave the name *tarpaulin* (see Canvas).

Closely woven fabric of MF microfibers: Can be highly water repellent while being vapor permeable.

Calendering: Can use a thermoplastic fiber in a closely woven fabric while pressing the fabric flat, closing up the interstices between yarns and making it water repellent (see Ciré). Materials such as wax can also be pressed into a fabric in hot calendering.

Finishes: Two main types have been used to give water repellent materials: silicone compounds and fluoro-textile types, the latter of which also give soil or stain resistance. However, fluoro compounds are being phased out of use, presumably for ecological reasons.

The best-known trademark names of these finishes are therefore changing definition, and do not specify the type of chemical used: Teflon® (by DuPont), and Scotchgard™ (by 3M) are trademark names best-known for fabric protection against spills and stains. These will be used in rainwear and workwear, for example, but also extensively in interior furnishings. With such finishes, liquid "beads up" in drops on the surface of the material (see photo).

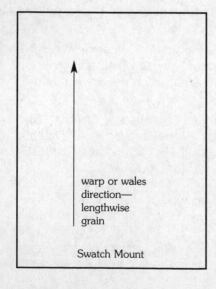

warp or wales
direction—
lengthwise
grain

Swatch Mount

warp or wales
direction—
lengthwise
grain

Swatch Mount

Fabric Name **Fabric Name**

Cretonnes with water and soil repellent **No special finish** **Soil release**

SOIL RELEASE FINISH

As noted, soil release differs from water or soil resistance; soil release is aimed at fabrics that tend to hold on to *oily* stains, in particular, those of polyester fibers and polyester/cotton with resin durable press finishes. Soil release finishes assist water and detergents to lift oily soil from fibers and fabrics, whether in laundering or in spot treatment. Along with this ability goes the desirable feature of increased absorbency (see photo), making fabrics of polyester, for example, more comfortable to wear. There will also be less tendency for such materials to collect static electricity; any moisture in a fabric will conduct static charges away.

ESSENTIALS

Water repellent treated fabric resists water but will become wet if impact is heavy or prolonged. Some finishes resist both water and oil-borne stains to give soil and stain resistance.

Soil release finishes allow water and detergent to loosen soil, especially oily soil, more easily; they also give increased absorbency.

warp or wales
direction—
lengthwise
grain

Swatch Mount

Fabric Name _____

warp or wales
direction—
lengthwise
grain

Swatch Mount

Fabric Name _____

Worsted Suiting, *includes* Barathea; Birdseye; Nailhead; Pincheck, Pinhead, or Pinpoint; Sharkskin (*see also* Basket Weave for Hopsack Suiting; Gabardine; Serge; Tropical Worsted; Twill, Steep for Cavalry Twill, Whipcord) (*see also other names under* Check; Herringbone)

FIBER CONTENT

Family: Wool.

Present: Wool and blends, specialty hair fibers, MF, rayon, lyocell. (See comment under Yarn regarding importance of wool.)

YARN

To be designated as *worsted*, yarn must be combed on the wool system, which does not necessarily mean that it is made of wool! However, wool or hair fiber is needed if the article is to be shaped by steam and pressure, as in suit tailoring. (See also Canvas, Tailor's.)

FABRIC CONSTRUCTION, OTHER

A great many suitings are twill weave or a variation of it, such as herringbone, to give a fabric that is durable and wrinkle resistant (see *Fabric Reference* for detail on combed yarns and twill weave).

A few suitings made for hot weather wear, such as tropical worsted, are plain weave to allow more air circulation, or have a basket (plain) weave component, such as barathea. For barathea, two weft yarns are carried as one, in a steep right-hand twill weave. Barathea is also called *twilled hopsack* or a *basket twill*. (A different barathea is described in Rib Woven, Allover.)

Birdseye suiting

Sharkskin

Worsted Suitings

Classic stripe

Fine dobby

Nailhead, pinhead, or pin check has a tiny check effect, almost like dots in rows. Alternating a color with white yarn in weaving gives what is called a *pick-and-pick* effect.

Sharkskin suiting has a close weave pick-and-pick, with black and white yarns alternating (see photo). This may be in a plain weave or in a 2/2 right-hand twill. (There was a different sharkskin made at one time of triacetate, then of polyester, heavily delustered to give a dull, matte look, in filament yarn, plain weave, and used for sportswear; it has not been popular for some time.)

Many suitings are dobby weave to allow more complex patterns, such as birdseye. Birdseye worsted suiting also has color warp and weft yarns alternating with white, sometimes two at a time of each, to give a design with a center diamond and dot (see photo).

WEIGHT, USES Bottom weight, used for tailored suits; slacks.

NAMES Worsted takes its name from the village of Worstead, northeast of Norwich, England, where a high-quality wool cloth was being made by the twelfth century; birdseye has a small pattern with a center diamond and dot, resembling an *eye*; nailhead (pin check, pinhead, pin point) is a very fine pick-and-pick, looking like rows of nailheads or pinheads; a shark's skin does not have any scales as other fish do but is smooth—presumably the pick-and-pick look of this suiting resembles sharkskin.

ESSENTIALS Made of fine, smooth yarn, combed on the wool system; most is still made of wool or blends to give the durability and continuing good looks expected of garments worn by professionals day-in, day-out, such as suits.

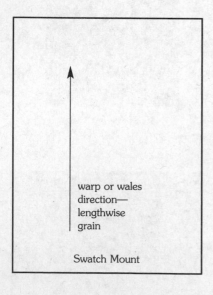

warp or wales
direction—
lengthwise
grain

Swatch Mount

Fabric Name

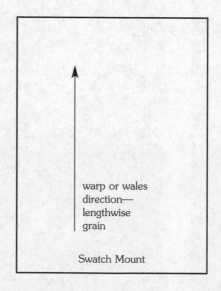

warp or wales
direction—
lengthwise
grain

Swatch Mount

Fabric Name

References and Resources

References

Anstey, Helen, and Terry Weston. *The Anstey Weston Guide to Textile Terms* (London: Weston Publishing, 1997). Short definitions of some 1,000 terms; aimed at those in the fashion and retail sectors.

Anquetil, Jacques. *Silk* (Flammarion, 1996). Translated from French. History of silk in Western Europe, lavishly illustrated in color.

Ashelford, Jane. *Care of Clothes* (UK, National Trust, 1997). Describes historical methods for clothes care, but includes tips on looking after old and valued items today; see www.psbooks.co.uk

Braddock, Sarah E., and Marie O'Mahony. *Techno Textiles: Revolutionary Fabrics for Fashion and Design* (London: Thames & Hudson, 1998). Application of information such as is found in Phillips *New Fibres*, but from a design viewpoint. Reference section and bibliography.

Colussy, M. Kathleen. *Fashion Design on Computers* (Upper Saddle River, NJ, Prentice Hall, 2000). Offers the basic concepts of CAD, including textile as well as apparel design, with practical, skill-developing exercises. Suited to any software. For details visit www.computersandfashion.com

Conway, George L. *Garment & Textile Dictionary* (Albany, NY: Delmar Publishers, 1997). This book has some helpful information, but technical developments date from the 1970s up to mid-1980s, so it is badly out-of-date.

Earnshaw, Pat. *A Dictionary of Lace* (Aylesbury, U.K.: Shire Publications Ltd., 1982).

———. *The Identification of Lace* (Aylesbury, U.K.: Shire Publications Ltd., 1984).

Encyclopedia of Textiles, American Fabrics (Englewood Cliffs, NJ: Prentice Hall, 3rd Ed., 1980).

Ginsberg, Madeleine (ed.). *The Illustrated History of Textiles* (London: Studio Editions, 1991). Varied yet authoritative treatments of the history of most kinds of Western textiles over 2,000 years, wonderfully illustrated.

Hardingham, Martin. *The Fabric Catalog* (New York: Pocket Books, 1978). Sadly, out of print; a uniquely useful fabric dictionary.

Harris, J. (ed.). *Five Thousand Years of Textiles* (London: British Museum, 2004). From prehistory to today, fabric development is presented by twenty-four specialists, with hundreds of color illustrations.

Harrison, Ned. Scottish *Estate Tweeds* (Elgin Scotland: Johnstons of Elgin, 1997). Newmill, Elgin, Moray IV30 4AF, UK; +44 (0) 134-355-4000.

Hearle, John. *Creativity in the Textile Industries: A Story from Pre-History to the 21ˢᵗ Century*. Manchester: The Textile Institute, The Mather Lecture, 2000. CD-ROM showing over 80 slides, voice-over by Prof. Hearle. *TEXTILES magazine* 2004, no. 3, recommends it as "interesting and instructive both to textile experts and to a general audience. ... of particular value to schools with courses in textiles or technology." www.textile-institute.com

Humphries, Mary. *Fabric Reference* (Upper Saddle River, NJ: Prentice Hall, Fourth Edition, 2009). *Fabric Reference* provides a condensed but complete and up-to-date exposition of fabric basics. This edition reveals the tremendous changes that have taken place in the industry world-wide, especially those aspects of advanced technology that may have started with research into advances for military, medical, space travel, or various industrial or high performance applications, but have proceeded rapidly to consumer use. In presentation, this book offers readily accessible information on textile fibers, yarn types, fabric constructions, and finishing, including dyeing and printing. Extensive sections on textiles and the environment, and fabric care. Coverage of fabric assessment, and use of metric units. Review questions and suggested student investigations for each section. Listing of most helpful current and some older references and resources. Comprehensive index, thorough cross-referencing of terms. Index also lists related pages in this *Fabric Glossary* where "name fabrics" connect to and illustrate virtually all aspects of fabric study. *See also Swatch Set* under Teaching Aids & Resources, and information/order page in back of this book.

Jerde, Judith. *Encyclopedia of Textiles* (New York: Facts On File, Inc., 1992). Considerably lacking in completeness or quality of information, although the illustrations are ravishing.

Kurella, Elizabeth. *Guide to Lace and Linens* (Dubuque, IA: Antique Trader Books, 1998). This is a superbly illustrated book, but just as importantly, the information on a complex yet fascinating textile is first organized rationally and meticulously to guide anyone through examination and identification of lace. Then there are 136 pages on individual laces, alphabetically arranged. The Lace Merchant, PO Box 244, Whiting, IN 46394. The author has other books as well; consult www.elizabethkurella.com

Lebeau, Caroline. *Fabrics: The Decorative Art of Textiles* (New York: Clarkson Potter, 1994). Sumptuous book explores textiles for interior designers, with glossary of terms and source listings.

Linton, G. E. *The Modern Textile and Apparel Dictionary* (Plainfield, NJ: Textile Book Service, 1973). Quite out of date in many respects, but still encyclopedic in coverage.

Paine, Melanie. *Textile Classics* (London: Mitchell Beazley London Ltd., 1990). Fabrics, their behavior and use for interior design, with glossary of textile terms.

Peigler, Dr. Richard S. "Wild Silks of the World." *American Entomologist,* Vol. 39, No. 3, Fall 1993: 151–161. Everything you ever wanted to know about wild silks; lucid, fascinating.

Scott, P. *The Book of Silk* (London: Thames & Hudson, 1993). History of silk worldwide.

Siegelaub, Seth (ed.). *Bibliographica Textilia Historiae* (New York: International General, 1997). Far-reaching listing of important general works on the history of textiles, but with more emphasis on European and Asian sources than North American. Artistic, technological, cultural, social, and economic aspects are all taken as part of history in this resource, the result of the editor's work at the Center for Social Research on Old Textiles in Amsterdam.

Textile Terms and Definitions. (Manchester: The Textile Institute, 11th ed., 2002). Standard terminology reference worldwide; includes many line drawings.

Tortora, Phyllis G., author, Robert S. Merkel, consultant. *Fairchild's Dictionary of Textiles* (New York: Fairchild Books & Visuals, 7th ed., 1996). Over 14,000 entries in this standard.

Catalogs

Fairchild Books & Visuals. Focus is on publications and aids for fashion, apparel, retailing, textiles. Printed catalog does not always specify date of each publication; 7 West 34th Street, New York, NY 10001; www.fairchildbooks.com

Textile Technology (year) Catalogue, Woodhead Publishing Ltd. Abington Hall, Abington, Cambridge, CB1 6AH, UK; www.woodhead-publishing.com. Some 35 pages listing and describing books covering textiles and clothing production; annual catalog.

Teaching Aids & Resources

Dictionary of Textile Terms. Order: Attn. Rowena, Dan River Inc., 1325 Sixth Avenue, 14th Floor, New York, NY 10019. US$2.50 each, prepaid (includes postage U.S. or to Canada). Not always accurate, but a good deal of information for students for the low price.

Fabric Link at fabriclink.com offers a "Fabriclink University," with information that is definitely shaped by its sponsor companies (e.g., trade mark names mentioned). However, there are sections on care, stain removal, and some coverage of new textiles. The dictionaries section gives surprisingly wide and accurate definitions for many terms.

The Phrontistery, fabric glossary created by: Stephen Chrisomalis, in association with Amazon.com, one section on *Textiles and Cloth*, at: http://phrontistery.info/fabric.html/. Lists 269 fabric names alphabetically, with a *very* brief definition of each, often too short to distinguish the fabric from many others. Occasionally gives a clue for an odd name, perhaps just the "fiber family," e.g., *canque* (silk).

Sally Queen & Associates publishes well-produced books on textiles for specific periods, as well as on costume (this is the firm which gets out the beautiful calendar with/for the Costume Society of America, featuring items on a given topic from different museum collections for each month). Publications listed on the website: *Textiles for Victorian and Edwardian Clothing 1880–1920; Textiles for Colonial Clothing; Textiles for Regency Clothing; Textiles for Early Victorian Clothing, 1850–1880.* There used to be swatched books, and some slide sets, but I could not discover if they are still available. Sally Queen & Associates, 2801 S. Joyce St., Arlington, VA 22202; sallyqueenassociates.com.

Samples of a wide variety of fabrics can be obtained from Whaley's of Bradford, UK: whaleys-bradford.ltd.uk/products.cfm

Swatch Set
Fabric Glossary Swatch Set has been designed to provide both name fabric samples for *Fabric Glossary*, and examples that can be used, dissected or tested for all aspects of fabric study, as they are referred to throughout *Fabric Reference*. There are 115 different samples, a specific one for each of 126 main *Fabric Files*. These files also cover some 600 textile names or terms. These Files also define or explain, describe, and provide black and white illustrations for some 600 textile names or terms. The illustrations are almost all scans or photographs of actual fabrics, chosen by the author, many unraveled or arranged to reveal structure, such as the relative closeness of warp yarns compared to weft, or differences between face and back. The selection has been designed to touch on all aspects of fabric production and behavior; to this end, eight pages of "applications" accompany the Swatch Set, so that examples are available to illustrate all major fiber types; most kinds of yarns including novelty yarns; all categories of weaves, knits, other constructions such as tufted, twisted lace, felt, nonwoven, stitchbonded, and others, as well as leather and fur; fabrics whose character is made by finishing, including examples related to dyeing, plus printing and other applied design. For order information, consult page in back of this book.

INDEX

Page numbers in boldface indicate pages with illustrations. Words capitalized, if not proper names, are usually trademark names.

Fabric Glossary
Swatch Set

Set of 115 Swatches, selected as examples of major fabric names in Fabric Glossary and to provide samples for textile study in Fabric Reference.

More detailed description can be found in References and Resources under Swatch Set.

To order go to:
www.swatchsets.com

or

www.maryhumphries.com

NOTE: Instructors whose students will be using the Fabric Glossary as a prescribed resource for a course are welcome to request a complimentary Swatch Set.

For more information please call or e-mail:

Susan Lichovnik
5694 Highway #7 East, suite 413
Markham, Ontario, L3P 1B4, Canada
phone & fax: (905) 471-0569
swatch.sets@gmail.com